Great Britons
Britain in Pictures

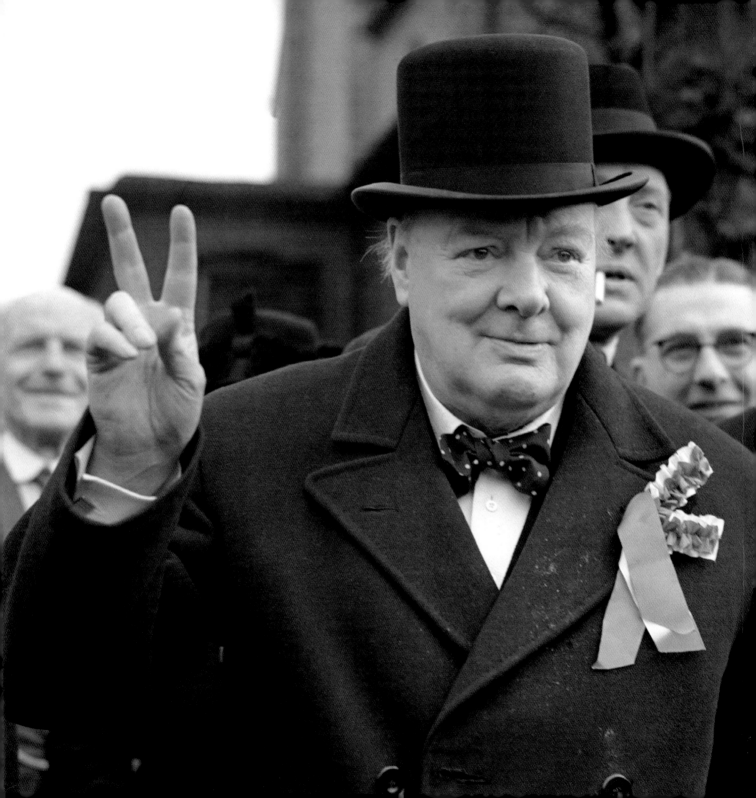

Great Britons
Britain in Pictures

AMMONITE PRESS

PRESS ASSOCIATION Images

First Published 2011 by
Ammonite Press
an imprint of AE Publications Ltd,
166 High Street, Lewes, East Sussex, BN7 1XU

Text © AE Publications Ltd
Images © Press Association Images
Copyright © in the work AE Publications Ltd

ISBN 978-1-906672-82-9

British Cataloguing in Publication Data. A catalogue
record of this book is available from the British Library.

Editor: Kenny Clements
Series Editor: Richard Wiles
Picture research: Press Association Images
Design: Gravemaker + Scott

Colour reproduction by GMC Reprographics
Printed and bound in China by C&C Offset Printing Co. Ltd

WINSTON CHURCHILL

Page 2: Giving his famous 'Victory' sign, Winston Churchill (1874–1965) tours his constituency, Woodford in Essex, on Polling Day, as he campaigns in the General Election. One of the great wartime leaders, Churchill served as Conservative Prime Minister of Great Britain twice: 1940–45 and 1951–55. During the Second World War, he popularized the 'V' sign as a gesture of defiance against Adolf Hitler's Germany.
23rd February, 1950

DAVID BECKHAM

Page 5: The world's most famous footballer, David Beckham confidently faces the press. The once shy and gawky young man has been replaced by a polished international marketing machine, whose constantly updated image ensures that sponsors will pay millions to have him endorse everything from sports gear, telephones and sunglasses to soft drinks, razor blades and underwear.
26th March, 2009

QUEEN ELIZABETH, THE QUEEN MOTHER

Page 6: With her daughter, Queen Elizabeth II, the Queen Mother, celebrates her 100th birthday at Buckingham Palace. Born Elizabeth Bowes-Lyon in 1900, she was known as 'the Smiling Duchess' before becoming Queen Consort to her husband, King George VI, in 1936. She continued with her public engagements until shortly before her death at the age of 101.
4th August, 2000

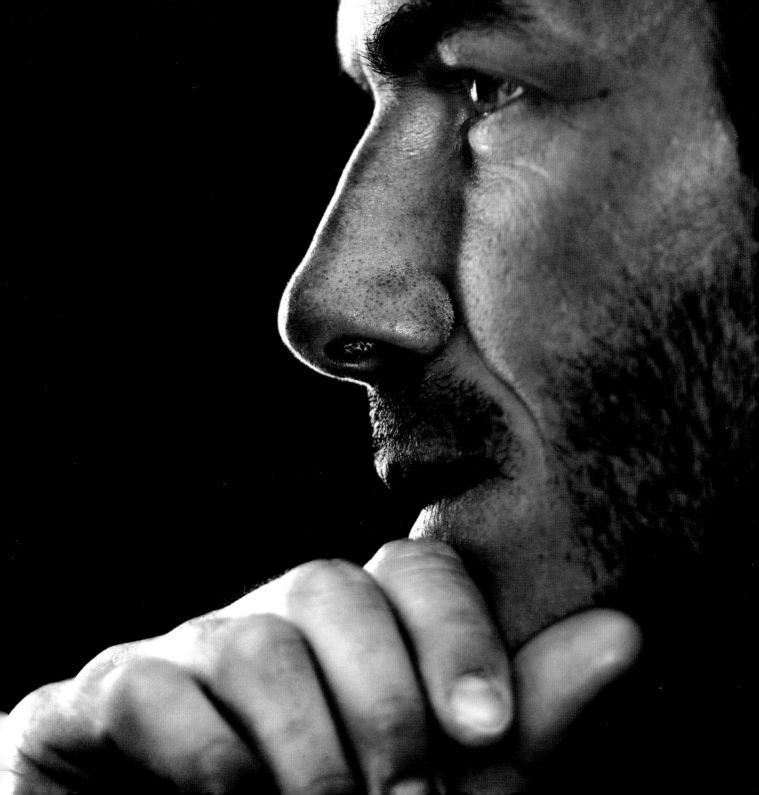

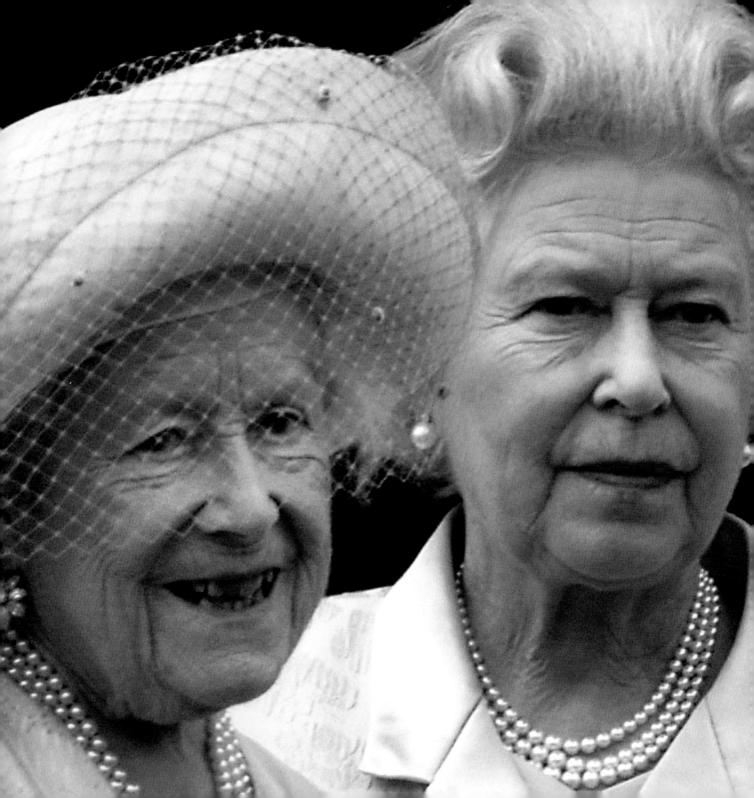

Introduction

Britain is indisputably one of the greatest nations on earth; a tiny island with a rich, vibrant culture that is comfortingly predictable yet bursting with contradictions. Cosy, traditional and nostalgic, yet full of boundary-pushing creative, innovative and scientific thinking. Wary and nationalistic, yet inclusive and tolerant of the new and the unknown. An easy-going, straightforward, no-nonsense nation, yet with deep-rooted customs and unspoken rules that are virtually impenetrable to visitors from other cultures.

Britain ruled the waves, literally and figuratively, for many centuries. And this tiny island, with its far-reaching influences, has much to celebrate, not least that it has given the world its main form of oral communication, the English language, and the main means by which it is now communicated: through TV, radio and the typewritten word. Quietly patriotic – unless there is a royal wedding, or a football or cricket match at stake – Britons shy away from the chest-swelling and boastfulness of some other proud nations, curiously preferring to sweep their countrymen's breathtaking achievements under the carpet rather than shout them from the rooftops.

Over the centuries, great Britons have contributed a host of ground-breaking innovations that have literally changed the course of history, among them parliamentary democracy; the industrial revolution; modern nursing; the telescope; the steam engine; the light bulb; the sandwich; tarmac; the typewriter; the sewing machine; the police force; photography; the telephone; radio; television; the sports of rugby, football and cricket; penicillin; pop music; the World Wide Web; internationally-renowned literature; the structure of DNA; the flushing toilet and even toilet paper. If Great Britain, with its seemingly endless list of outstanding achievements and global contributions, doesn't spring to mind as the greatest nation on earth, which other country could claim the title?

This book celebrates some of the most outstanding characters in British culture, from 1868 to the present time, through photographs selected from the vast archives of the Press Association. It rejoices in the drive and talent of a host of inventors, industrialists, entrepreneurs, medical innovators, writers, war heroes, sportsmen and women, explorers, politicians, actors, directors, composers, musicians, artists, photographers, fashion designers and 'ordinary folk' who have notched up extraordinary achievements. Each of the characters featured in these pages has contributed significantly to the concept of 'being British' and, without exception, each has earned their place among the ranks of our nation's Great Britons.

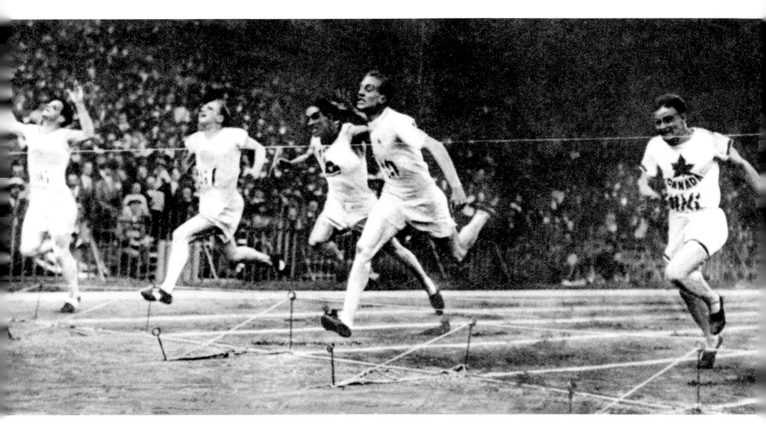

HAROLD ABRAHAMS
The moment immortalized in the 1981 Oscar winning movie *Chariots of Fire*: Great Britain's Harold M. Abrahams (second R) snatches the Olympic 100m sprint title from the American favourite, Charles Paddock (second L) in a record breaking time of 10.6 seconds. Abrahams (1899–1978) was the first Briton to win the coveted 100m race, which took place in the sweltering heat of a Parisian summer.
16th July, 1924

REBECCA ADLINGTON
Facing page: Great Britain's Rebecca Adlington celebrates winning the Women's 400m Freestyle Final at Beijing's National Aquatic Centre. She also clinched gold in the 800m, making her Britain's most successful Olympic swimmer in a century. Adlington, born in 1989, collected another gold for the 400m at the European Swimming Championships in Budapest, Hungary in 2010, and also took first place on the podium after the 800m race at the Commonwealth Games in New Delhi, India.
11th August, 2008

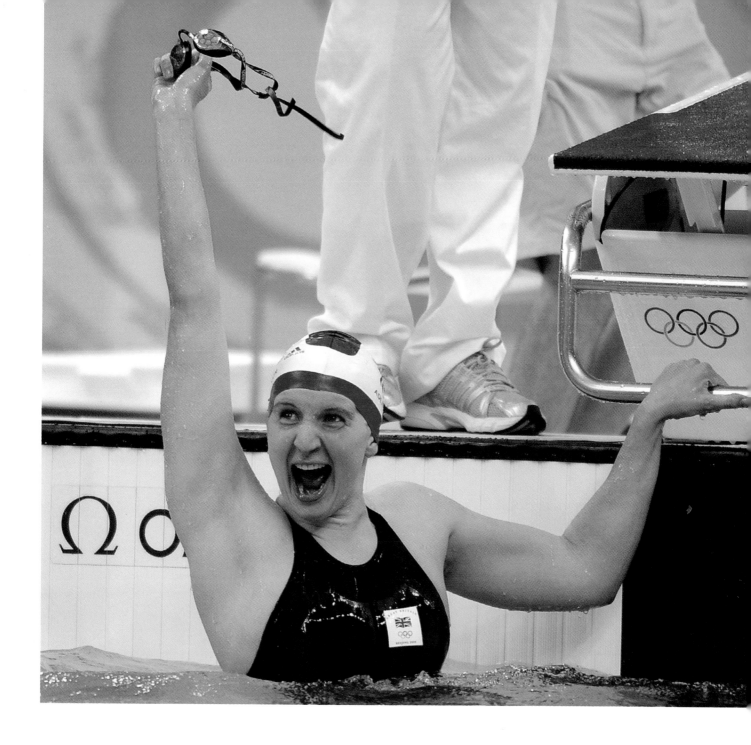

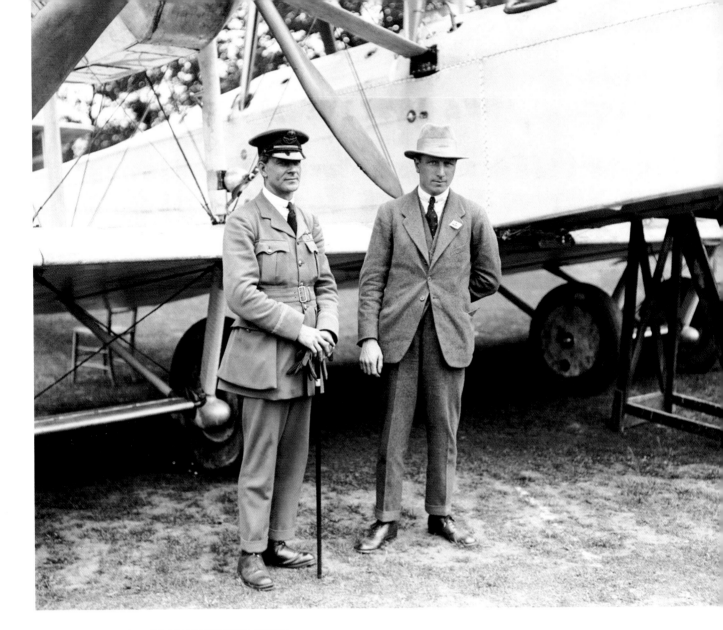

JOHN ALCOCK & ARTHUR WHITTEN BROWN

L–R: British aviators Captain John Alcock (1892–1919), pilot, and Lieutenant Arthur Whitten Brown (1886–1948), navigator, shortly after they had completed the first non-stop transatlantic flight from Newfoundland to Ireland in a Vickers Vimy bomber. The flight covered 1,890 miles in just over 16 hours. Both men were knighted for their contribution to aviation.

23rd August, 1919

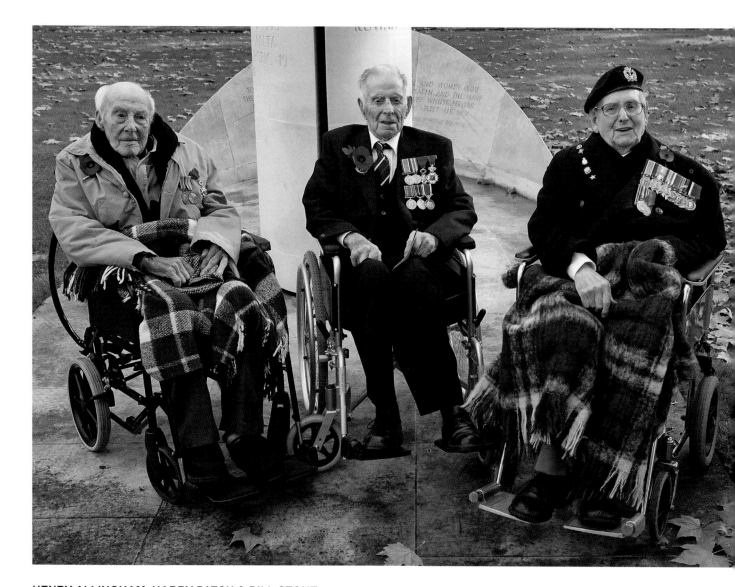

HENRY ALLINGHAM, HARRY PATCH & BILL STONE

L–R: First World War veterans Henry Allingham (112), Harry Patch (110) and Bill Stone (108) gather for the Armistice Day commemorations. Allingham was a founder-member of the Royal Air Force and fought at the Battle of Jutland; Patch was a 'Tommy' who fought in the trenches of the Western Front; and Stone served in the Royal Navy.

11th November, 2008

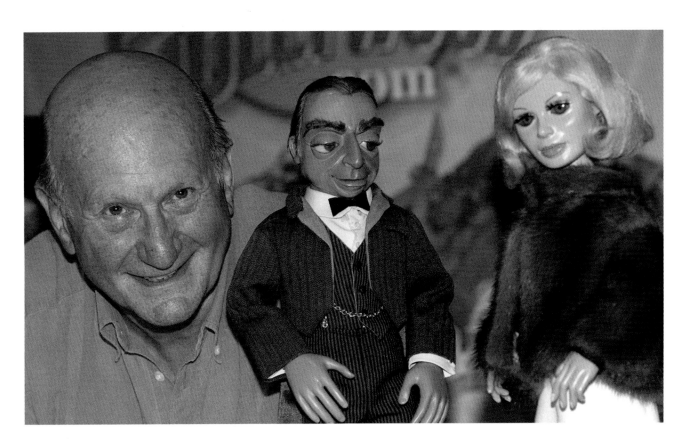

GERRY ANDERSON

Famous for his futuristic television programmes using modified marionettes – a process called 'Supermarionation' – pioneering producer, director and screenwriter Gerry Anderson's most successful show was the iconic 1960s *Thunderbirds*, which featured 'Lady Penelope' and her chauffeur, 'Parker' (star attractions at an auction of TV and movie memorabilia, fetching £16,000 and £38,000 respectively). In a career that began with the low-tech 1957 children's series *The Adventures of Twizzle*, in the 21st century octogenarian Anderson had embraced computer animation with a no-strings-attached production of *Gerry Anderson's New Captain Scarlet* featuring the eponymous indestructible hero.

24th July, 2001

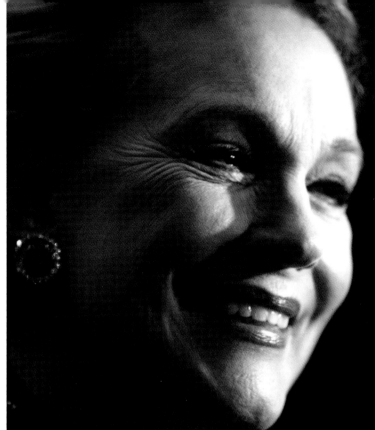

JULIE ANDREWS

Left: A fresh-faced Julie Andrews (born 1935) in panto as Cinderella at the London Palladium. Andrews made her debut in *The Boyfriend* at the age of 19 and appeared in some of the most memorable musicals of all time, on film and on stage. Her distinctive, four-octave voice and wholesome image gave *Mary Poppins* and *The Sound of Music* 'all-time greats' status. Five-times Golden Globe winner, she received an Oscar for her role as 'Poppins' in 1964.
12th December, 1953

Above: A radiant Dame Julie Andrews at the Mary Poppins Gala Charity Evening at London's Prince Edward Theatre. Famous for her roles in *The Sound of Music*, *Mary Poppins*, *Thoroughly Modern Millie* and *Victor/Victoria*, Andrews has been an admired stage and film performer for more than half a century.
17th March, 2005

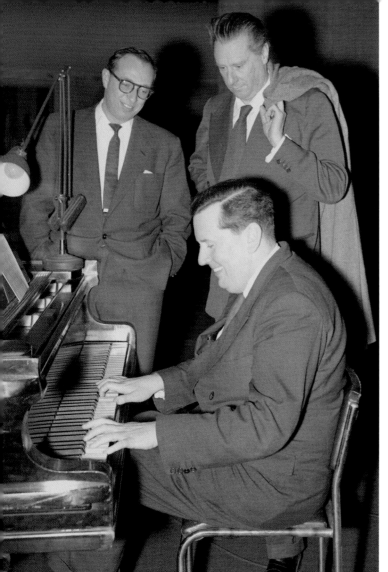

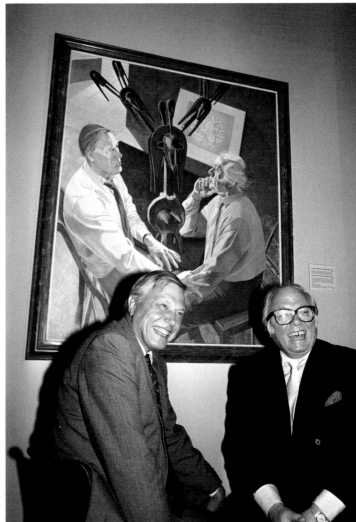

DAVID & RICHARD ATTENBOROUGH

Below: TV naturalist Sir David Attenborough (L) and his film actor-director brother, Sir Richard Attenborough, in front of a portrait of themselves at the National Portrait Gallery in London. The oil painting, by Norfolk artist Ivy Smith, was commissioned for £2,000 by the gallery as part of the John Player Portrait Award won by Smith in 1986.

15th February, 1990

MALCOLM ARNOLD

Above: Composer Malcolm Arnold plays his music from the film *The Key* to Carl Foreman (L), executive producer, and Sir Carol Reed (R), director. Arnold (1921–2006) wrote the score to the *St Trinian's* films and won an Oscar for his soundtrack to the movie *The Bridge Over the River Kwai*.

16th April, 1958

RICHARD ATTENBOROUGH

Below: actor, director and producer, Richard Attenborough (born 1923) has won two Academy Awards, four BAFTAs and three Golden Globes. His varied 30-year film career spans from *In Which We Serve* (1942) and *Brighton Rock* (1947) to Spielberg's *Jurassic Park* and its sequel (1993 and 1997). A producer since the 1950s, his credits include *The Angry Silence* (1960), *Whistle Down the Wind* (1961), and his portrayal of serial killer John Christie in *10 Rillington Place* (1971). Attenborough's feature film directorial debut was the all-star screen version of the hit musical *Oh! What a Lovely War* (1969), and he won the 1982 Academy Award for Best Director for the historical epic, *Gandhi*.

13th December, 1999

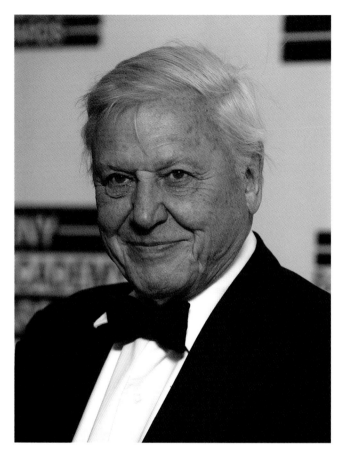

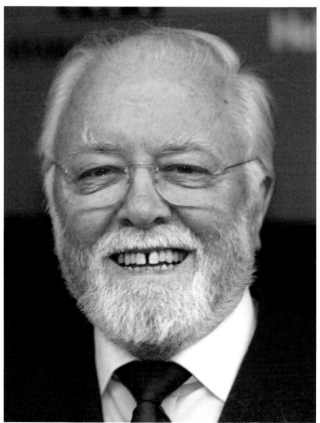

DAVID ATTENBOROUGH

Above: Sir David Attenborough arrives at the Sony Radio Academy Awards at London's Grosvenor House Hotel. Famous as the voice and face of BBC wildlife programming for 50 years – notably for writing and presenting the nine *Life* series – Attenborough (born 1926) also introduced the country to colour television as controller of BBC2 in the 1970s. In addition, he served as director of programming for BBC Television in the 1960s and 1970s.

10th May, 2010

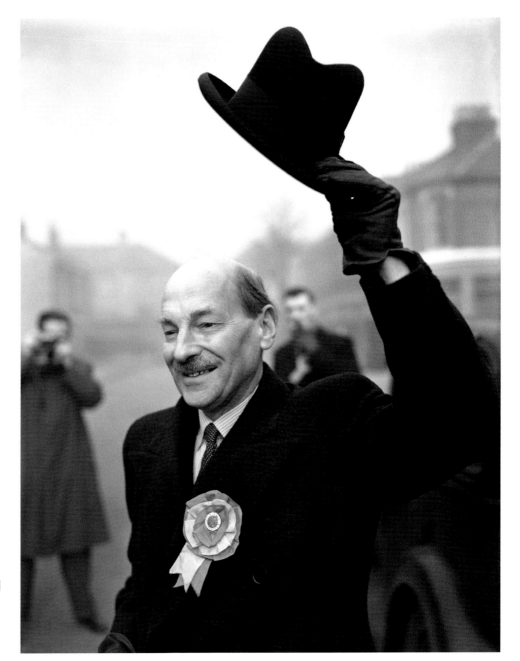

CLEMENT ATTLEE

Prime Minister Clement Attlee (1883–1967) doffs his hat to his Walthamstow constituents during the General Election campaign. Attlee led the Labour Party for 20 years and presided over more reforms than any other British government of the 20th century. He nationalized the Bank of England, the coal and steel industries, civil aviation, electricity, road transport and the railways, set up the National Health Service and gave India independence. He was Prime Minister for six years and 92 days.

22nd February, 1950

ROBERT BADEN-POWELL

Decked out in hiking gear and clutching a stout stave, 52-year-old Lieutenant-General Robert Baden-Powell (1857–1941), founder of the world Scout movement, exemplifies the Scout motto: 'Be prepared!' B-P, as he liked to be called, honed his own scouting skills among the Zulu while stationed in South Africa in the early 1880s. Back in Blighty, he sold 150 million copies of his book, *Scouting for Boys*, and went on to establish the largest multicultural youth network ever seen.

30th June, 1909

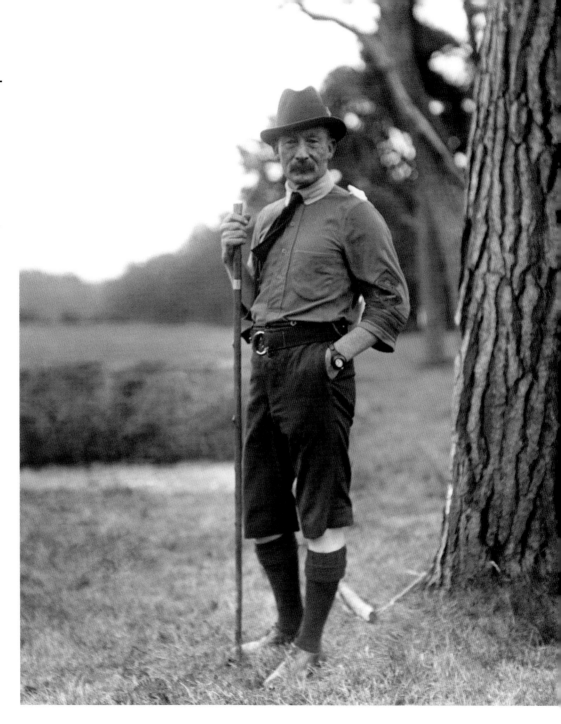

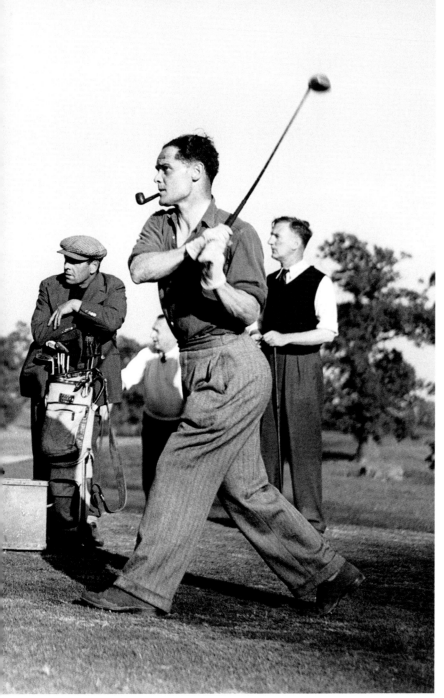

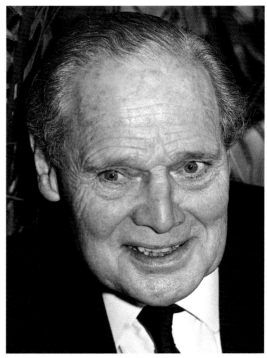

DOUGLAS BADER

Left: Group Captain Douglas Bader (1910–82) drives the ball during an RAF Golf Association meeting at Moor Park in Hertfordshire. Bader was a Royal Air Force fighter ace in the Second World War, despite having had both legs amputated after an earlier plane crash. He survived a mid-air collision over France in 1941, but was captured, then escaped and eventually was incarcerated in the notorious Colditz prison near Dresden. Bader was immortalized in the 1956 biopic *Reach for the Sky*.
10th October, 1945

Above: Pictured a few months before his death, Sir Douglas Bader, who died in September 1982.
3rd March, 1982

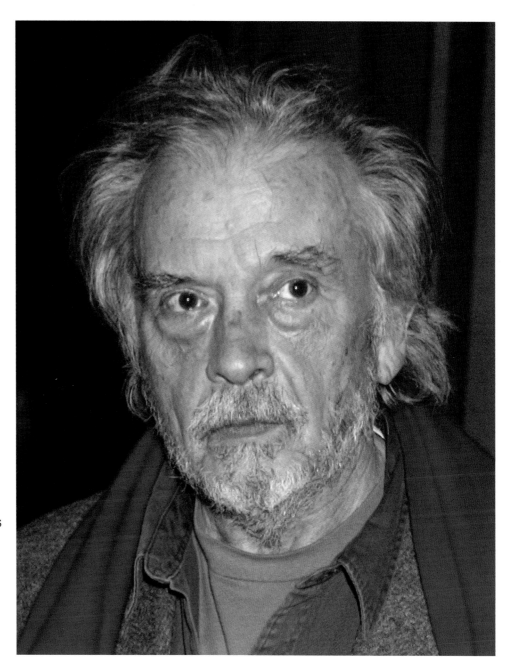

DAVID BAILEY
Veteran photographer David Bailey arrives at the Design Museum on the South Bank in London for 'Unseen Vogue: The Secret History Of Fashion Photography'. Bailey (born 1938), with his model muse Jean Shrimpton, epitomized 1960s London and changed the face of fashion photography for ever. Married four times, he continues to be booked as a top photographer and claims of his work: *"I always go for simplicity."*
31st October, 2002

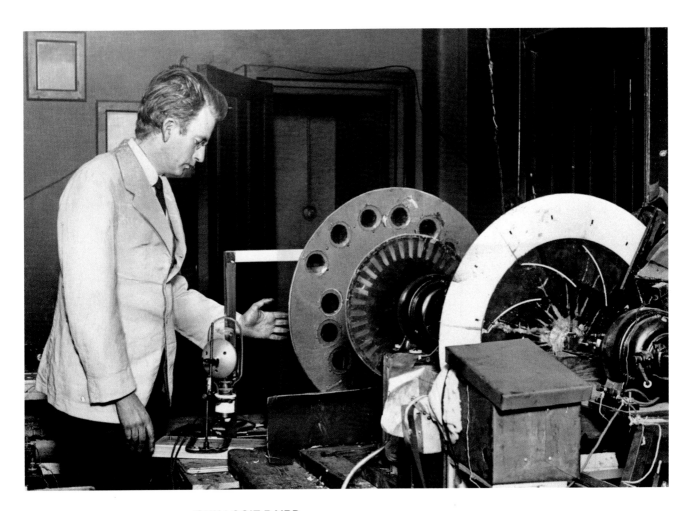

JOHN LOGIE BAIRD
In his workshop in London, Scots engineer John Logie Baird
(1888–1946) changed our view of the world forever when he
transmitted the first television images using a ventriloquist's
dummy called 'Stocky Bill'. While seeking publicity for
his invention, Baird marched into the offices of the *Daily
Express*, but failed to convince the duty editor, who declared:
*"Go down to reception and get rid of the lunatic who's down
there. He says he's got a machine for seeing by wireless!"*
26th January, 1926

JANET BAKER
Opera singer Janet Baker prepares for her charity appearance in the Sadler's Wells Opera gala performance of Monteverdi's *The Coronation of Poppea*. The English mezzo-soprano (born 1933), famed for her dramatic interpretations, was made a Dame of the British Empire in 1976.
22nd November, 1971

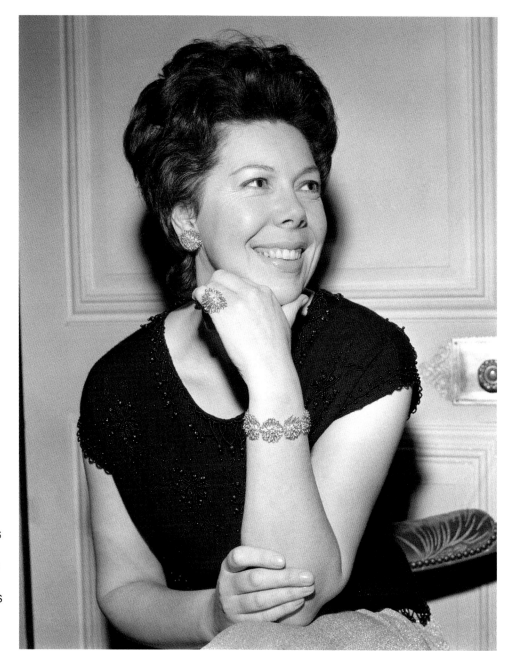

JOAN BAKEWELL

Broadcaster Joan Bakewell, who received a CBE for services to broadcasting, journalism and the arts, in the Queen's Birthday Honours List of 1995. The veteran broadcaster (born 1933), once dubbed *"the thinking man's crumpet"*, was a regular on the news programmes *Late Night Line-Up*, *Newsnight* and *4 PM* on BBC Radio 4. Bakewell had a well-publicised affair with the author Harold Pinter and now campaigns for the rights of senior citizens.

15th March, 1995

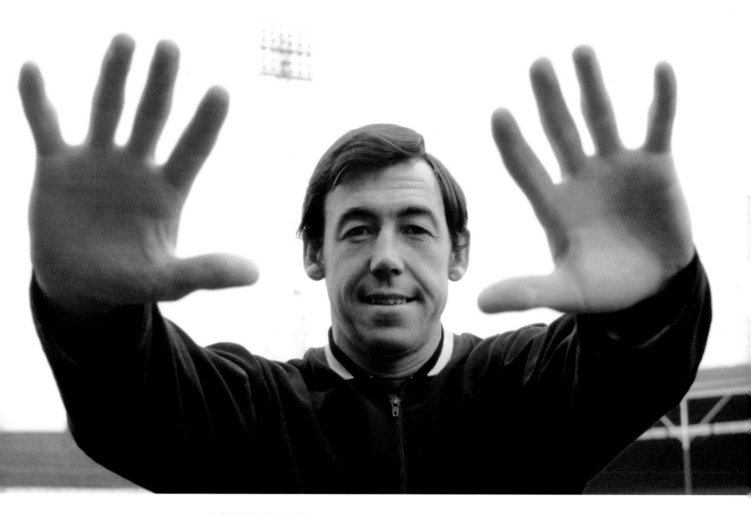

GORDON BANKS
Stoke City goalkeeper Gordon Banks (born 1937) displays
his greatest assets. Voted second best goalkeeper of
the 20th century (after the Russian Lev Yashin) by the
International Federation of Football History & Statistics,
Banks played in the England squad that lifted the 1966 World
Cup. His performance gave rise to the saying, *"Safe as the
Banks of England."*
30th April, 1971

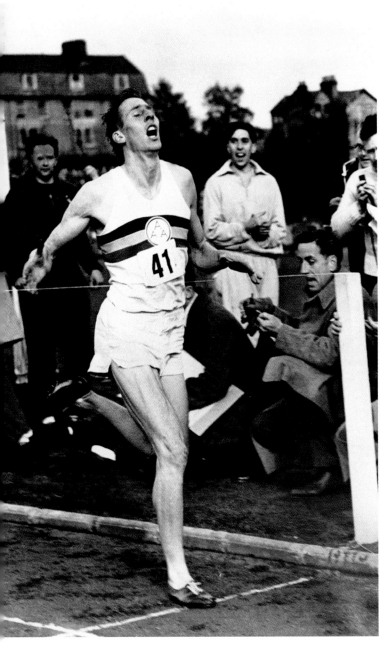

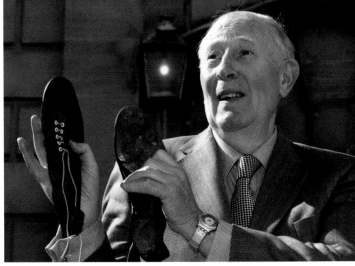

ROGER BANNISTER

Left: An exhausted Roger Bannister crosses the line as excited onlookers check their watches to confirm that he has become the first person to run a mile in less than four minutes. In front of 3,000 spectators, the 25-year-old medical student (born 1929) set a record time of 3 minutes 59.4 seconds at Iffley Road in Oxford. His feat was commemorated 50 years later on the reverse of a 50p coin.
6th May, 1954

Above: Photographed with his original running shoes, Sir Roger Bannister celebrates the 50th anniversary of his historic sub-four-minute mile at Pembroke College, Oxford.
6th May, 2004

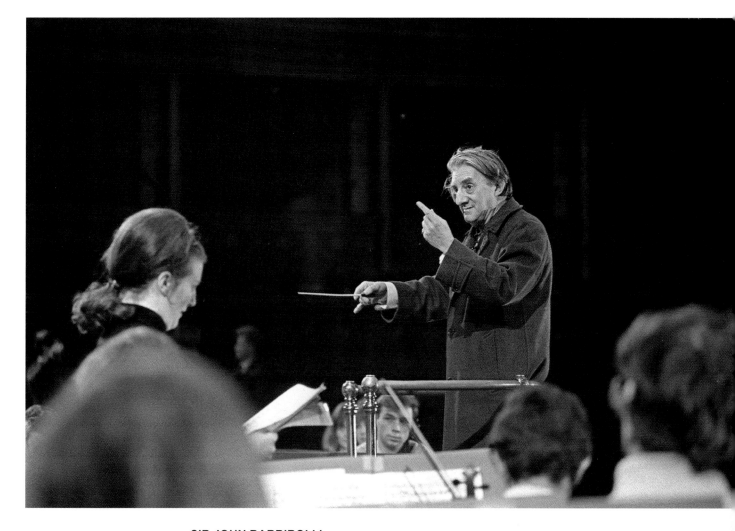

SIR JOHN BARBIROLLI
Conductor Sir John Barbirolli (1899–1970) during a rehearsal
at the Royal Albert Hall of Verdi's *Requiem*, which was
performed in front of the Queen to mark the centenary of the
birth of Sir Henry Wood, founder of the Promenade concerts.
Vaughan Williams gave Barbirolli the nickname 'Glorious
John', which stuck throughout his distinguished career.
3rd March, 1969

ALBERT BARNES

Dunkirk veteran Albert 'Joe' Barnes holds a photograph of himself as an 18-year-old able seaman. The 75-year-old former bus driver received a medal at the Golden Hero Awards in London, having waited more than 60 years for his heroism to be recognized. As a 14-year-old galley boy working on a tugboat during the Second World War, Barnes had helped save the lives of hundreds of British soldiers on the beaches at Dunkirk in 1940.

19th March, 2001

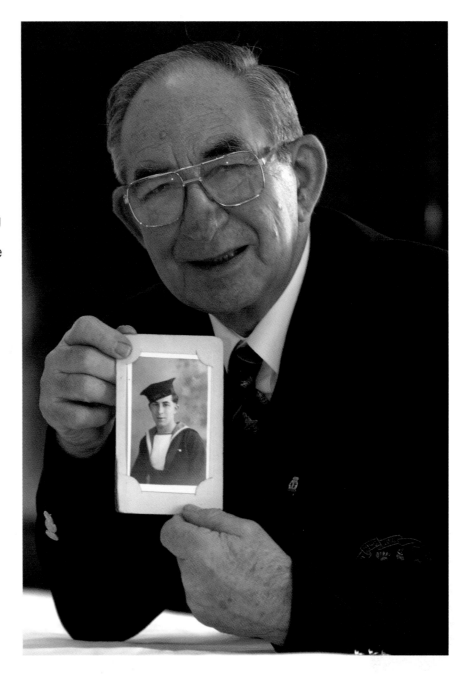

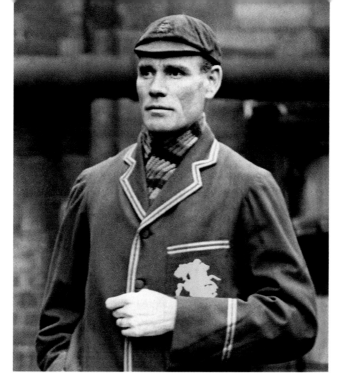

SYDNEY FRANCIS BARNES

In 27 Test matches against Australia and South Africa, Sydney Francis Barnes (1873–1967) took 189 wickets at an average of 16.43 runs each. Many observers and professional players consider him to be the finest bowler in the history of cricket. He holds the distinction of being the only bowler to have been selected to appear for England while playing league and minor cricket.

1925

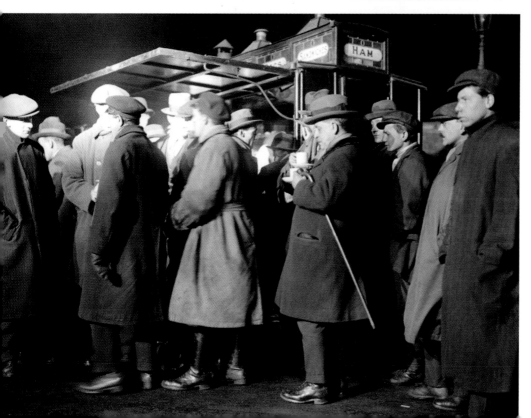

SIR JAMES MATTHEW BARRIE

Lost in thought, the elderly man goes unnoticed amid the evening throng at this Charing Cross coffee stall. He is the eminent Scottish journalist, playwright and creator of 'Peter Pan' Sir James Matthew Barrie (1860–1937). The year 1921 was poignant for Barrie, who felt deeply the untimely loss of his ward, Michael Llewellyn-Davies, who had inspired the character of 'Peter Pan', following a drowning accident.

2nd December, 1921

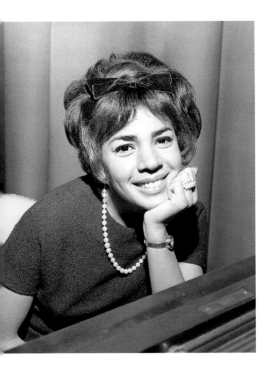

SHIRLEY BASSEY
Above: The 25-year-old singing sensation from Tiger Bay in Cardiff, Shirley Bassey, prepares to open at the Talk of The Town cabaret in London. One of Britain's most distinctive and charismatic performers, Bassey (born 1937) has sold an estimated 135 million records and still packs arenas around the world. She attained mega-stardom when she sang an unprecedented three James Bond movie theme tunes (*Goldfinger*, *Diamonds Are Forever*, *Moonraker*) and was made a Dame of the British Empire in 1999.
26 September, 1962

Above: Headlining at London's Roundhouse, for the BBC's Electric Proms, Dame Shirley Bassey sings numbers from her album, *Performance*, which includes songs written for her by such UK artists as Gary Barlow, the Kaiser Chiefs and the Pet Shop Boys.
23rd October, 2009

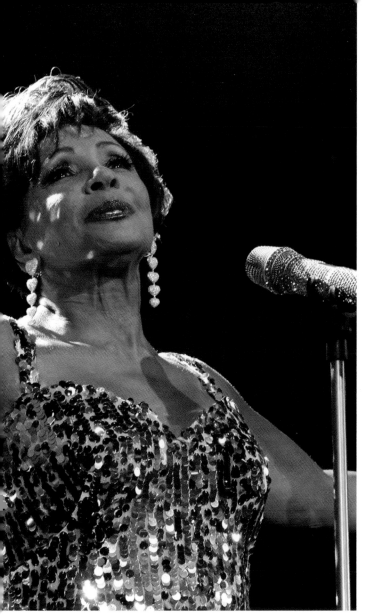

TREVOR BAYLIS

Inventor Trevor Baylis with his clockwork radio, which won the BBC Award for Best Product and Best Design in 1996. Baylis (born 1937) invented the wind-up radio to enable the spread of information about AIDs to remote parts of Africa without the need for electricity or batteries. The former stunt man, who lives on Eel Pie Island in the River Thames, was also honoured with the World Vision Award for Development Initiative.
12th January, 1996

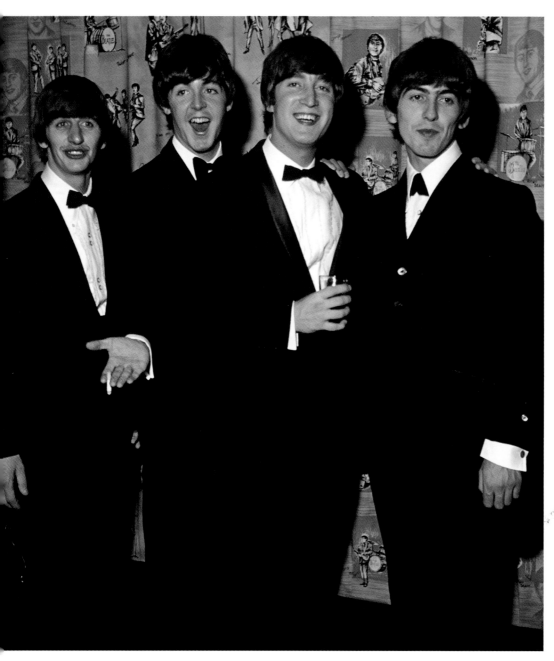

THE BEATLES

Left: The Beatles, (L–R) Ringo Starr, Paul McCartney, John Lennon and George Harrison, attend the premiere of their film *A Hard Day's Night* in London. The most commercially and critically successful band of all time, the Liverpool lads are pictured at the height of 'Beatlemania'. Described as a *"comic fantasia with music"*, the film was a huge financial success.
6th July, 1964

Right: Three years on, and The Beatles adopt a different image as they prepare to appear on the BBC's *Our World*, the world's first live satellite television link-up, which was watched by 400 million people across five continents. The band performed *All You Need is Love*, which was specially written for the occasion, surrounded by other British celebrities of the day, among them Mick Jagger, Marianne Faithfull, Eric Clapton and Graham Nash. Stars from 19 nations took turns performing in the live link-up during the psychedelic 'Summer of Love'.
1st June, 1967

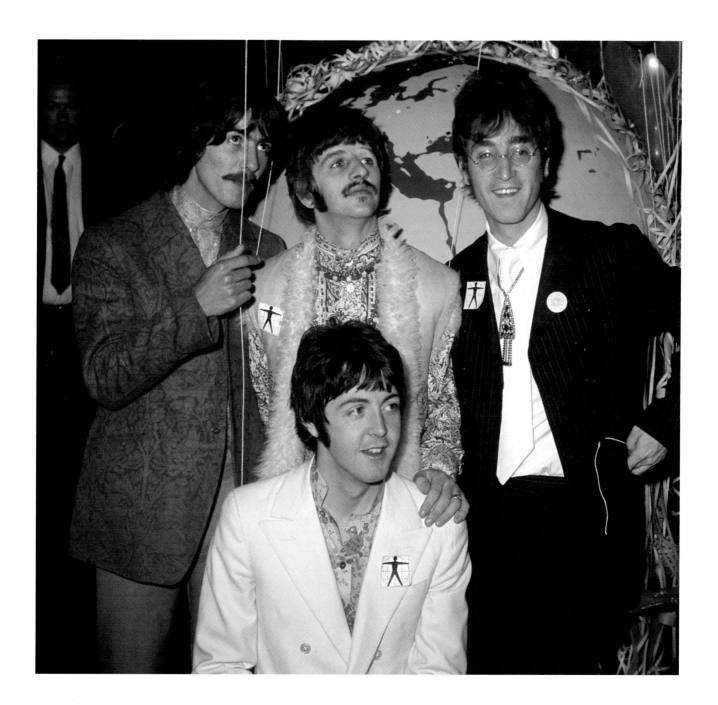

CECIL BEATON

Looking perky in a straw hat, photographer and costume designer Cecil Beaton (1904–80) departs from London Airport. He was flying to New York en route to Dallas to receive the Neiman-Marcus Award for the elaborate costumes he had designed for the stage musical *My Fair Lady*; he also won an Oscar for the film version in 1964. Beaton's fashion photography regularly graced the pages of *Vogue* and *Vanity Fair*, and he was one of the Queen Mother's favourite portrait photographers.

29th August, 1956

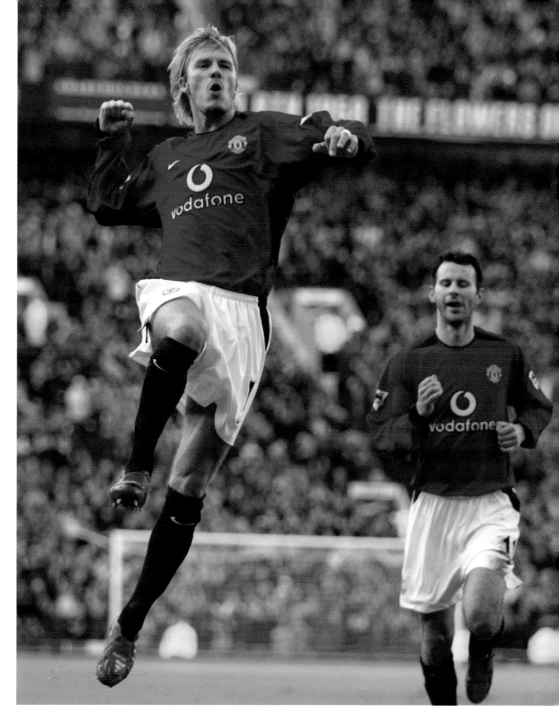

DAVID BECKHAM

Manchester United's David Beckham (L) celebrates after scoring against Portsmouth during an FA Cup third-round match at his team's Old Trafford ground. Beckham (born 1975) served as England captain 58 times between 2000 and 2006, and holds 115 caps for playing outfield for his country. He is one half of arguably the most famous and heavily marketed couple in the world: the footballer and his wife, the former Spice Girl Victoria Adams – jointly known as 'Brand Beckham' – are worth an estimated £125m.

4th January, 2003

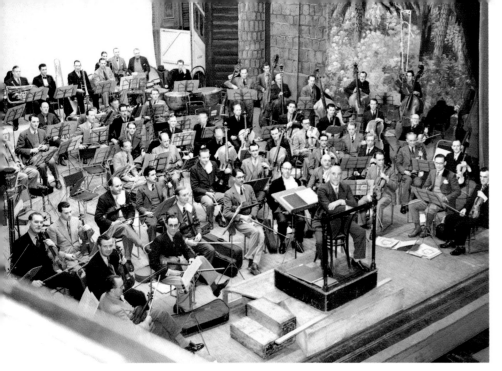

THOMAS BEECHAM

Left: Renowned British conductor Sir Thomas Beecham (1879–1961) with his symphony orchestra in London. While at Covent Garden, Beecham encouraged everyone of repute to perform in England, bringing the music of Wagner, Handel, Bizet and Strauss to the masses. He conducted the New York, London and Royal Philharmonic orchestras, and his conducting was matched only by his legendary wit, confounding critics with brilliant quips such as, *"The English may not like music, but they absolutely love the noise it makes."*
10th April, 1939

Right: Sat at the microphone, Sir Thomas Beecham prepares to record for Columbia in New York City. Beecham was the first British conductor to enjoy an international reputation. This invited sniping from slightly less famous English conductors, who described him variously as *"an upstart"* (Wood), *"repulsive"* (Boult) and *"not to be trusted"* (Barbirolli). A staunch Yorkshireman with a sharp wit, Beecham countered: *"In my county, where I come from, we're all a bit vulgar, you know."*
14th June, 1949

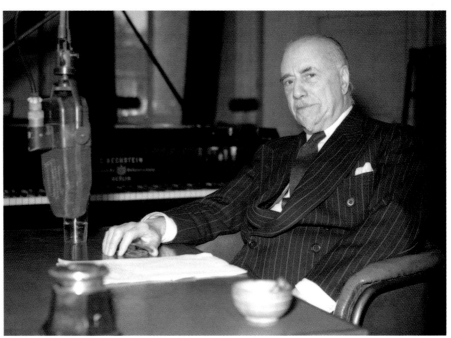

TONY BENN
Puffing on his pipe, Anthony Neil Wedgewood Benn, formerly 2nd Viscount Stansgate, enjoys a cuppa on a visit to the Royal Society of Chemistry in London. Tony Benn was born in 1925 and served in the Labour government under Harold Wilson from 1964 to 1970. He played a large part in the creation of the Peerage Act, which allowed hereditary peers to give up their right to sit in the House of Lords, which he did immediately the Act became law. He is Labour's second longest serving MP (after John Parker).
24th June, 2003

ALAN BENNETT

Writer Alan Bennett (born 1934) accepts his award for Best Play for *The History Boys* during the Evening Standard Theatre Awards at the National Theatre, London. Bennett is one of Britain's best-loved playwrights; his droll delivery, sharp humour and downtrodden, 'ordinary' characters make his work resonate with the public. His other famous works include the *Talking Heads* monologues, *The Lady in the Van*, and the play and screenplay of *The Madness of George III*.

13th December, 2004

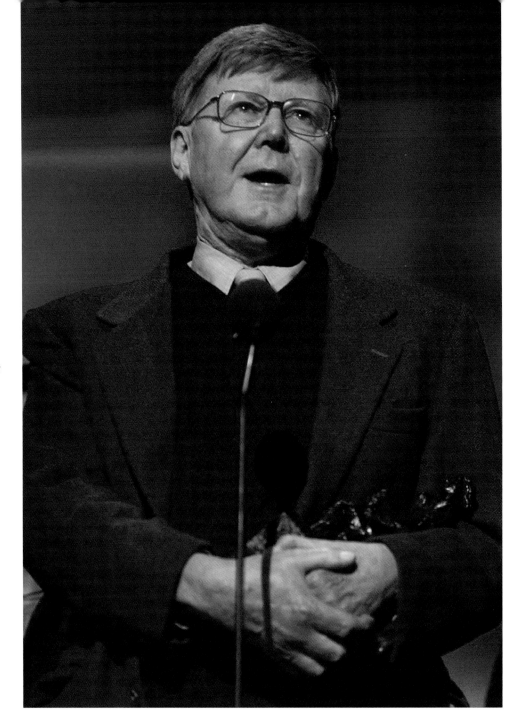

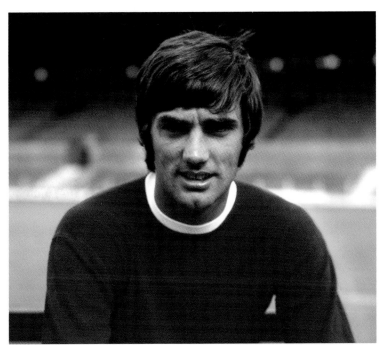

GEORGE BEST

Left: Manchester United footballer George Best (1946–2005) was one of the first celebrity players. A naturally gifted genius on the wing, the Northern Ireland lad's antics off the pitch often eclipsed his skill, and he struggled with alcohol addiction for most of his life. TV appearances and dalliances with several Miss World winners cemented his place in popular culture, but his hedonistic lifestyle eventually ended his career and cut short his life.
1st July, 1968

Footballer George Best of Manchester United – a winger who combined pace, acceleration, perfect balance, two-footedness, goalscoring and the ability to beat defenders – was elected Footballer of the Year by the members of the Football Writers' Association. He polled 60 per cent of the votes to become, at 21, the youngest player ever to receive the honour.
25th May, 1968

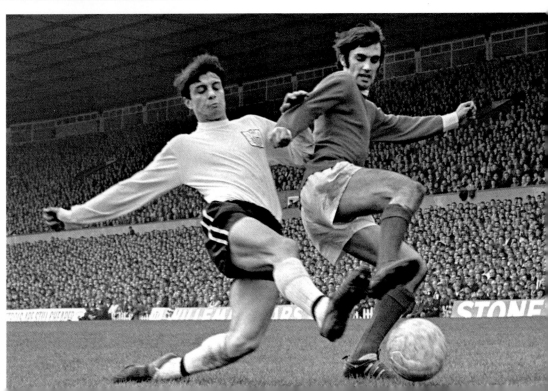

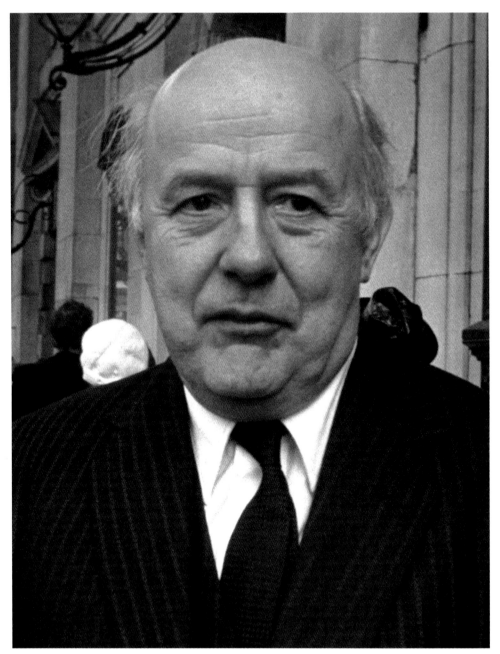

JOHN BETJEMAN

Broadcaster and poet John Betjeman (born 1906) began his career in the 1930s with guide books and articles on architecture, while publishing volumes of poetry. Admired for his highly accessible and wryly comic verse, the man who described himself in *Who's Who* as a *"poet and hack"* was made Poet Laureate in 1972. His image of a bumbling fogey endeared him to the public. In 1973 he made an acclaimed documentary for BBC TV called *Metro-land*. Passionate about architecture, he was a founding member of the Victorian Society, and instrumental in helping to save the façade of St Pancras railway station, London. For the last decade of his life, Betjeman suffered from Parkinson's Disease, and he died at his home in Trebetherick, Cornwall on 19th May, 1984.

11th November, 1996

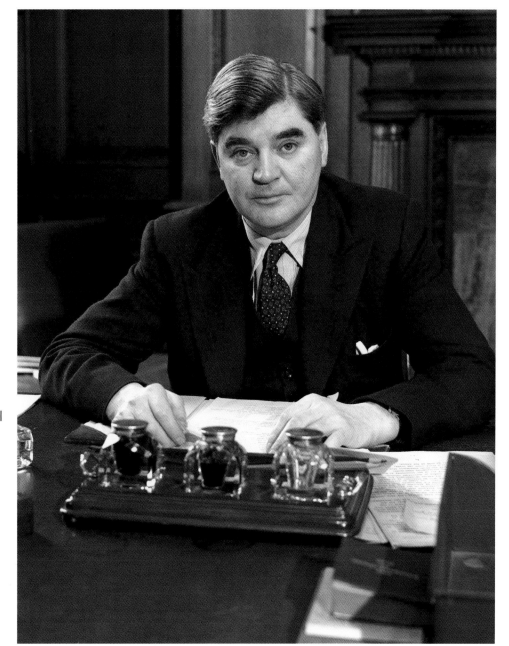

ANEURIN BEVAN

Seen in his office at the Ministry of Health in Whitehall, Aneurin 'Nye' Bevan (1897–1960) was the Welsh Labour politician who spearheaded the establishment of the National Health Service, providing free medical care to all Britons. He was one of the most important ministers of the post-war era. Bevan resigned from government in protest in 1951, when prescription charges were levied on dental and optical care. Elected deputy leader of the Labour Party in 1959, he died from cancer one year later.

20th March, 1946

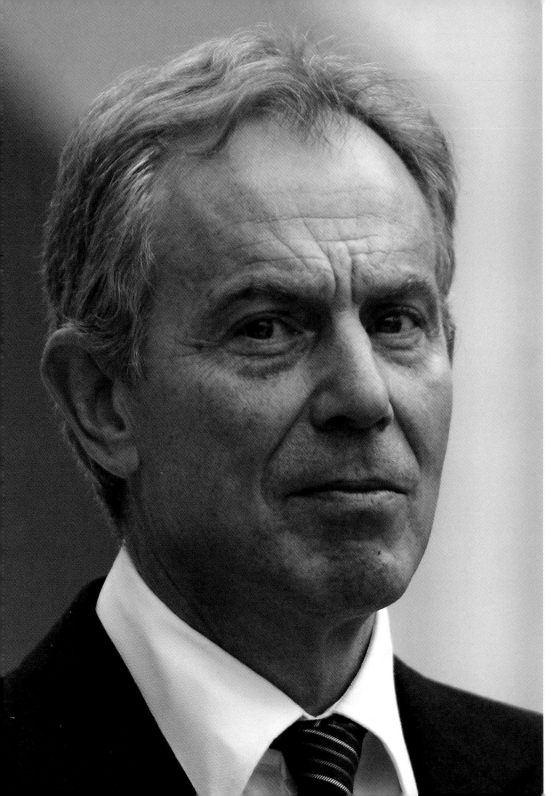

TONY BLAIR

Left: A careworn former Prime Minister Tony Blair (born 1953), following a Service of Commemoration at St Paul's Cathedral in honour of UK military and civilian personnel who had served in the Iraq War. Blair was Labour Prime Minister for ten years (1997–2007) and took the controversial decision in 2003 to send British troops to invade Iraq on – so far unfounded – UK and US intelligence that Iraq possessed weapons of mass destruction. The UK formally ended combat operations in Iraq in 2009.
9th October, 2009

PETER BLAKE

Right: Pop artist Sir Peter Blake (born 1932) carries his most famous piece – the album cover for The Beatles' *Sgt Pepper's Lonely Hearts Club Band*, for which he was paid the princely sum of £200 – while setting up an exhibition of his work. Blake and his collage work appeared in Ken Russell's film *Pop Goes the Easel*, and he mixed with the cultural icons of the 'Swinging Sixties'.
1st August, 2003

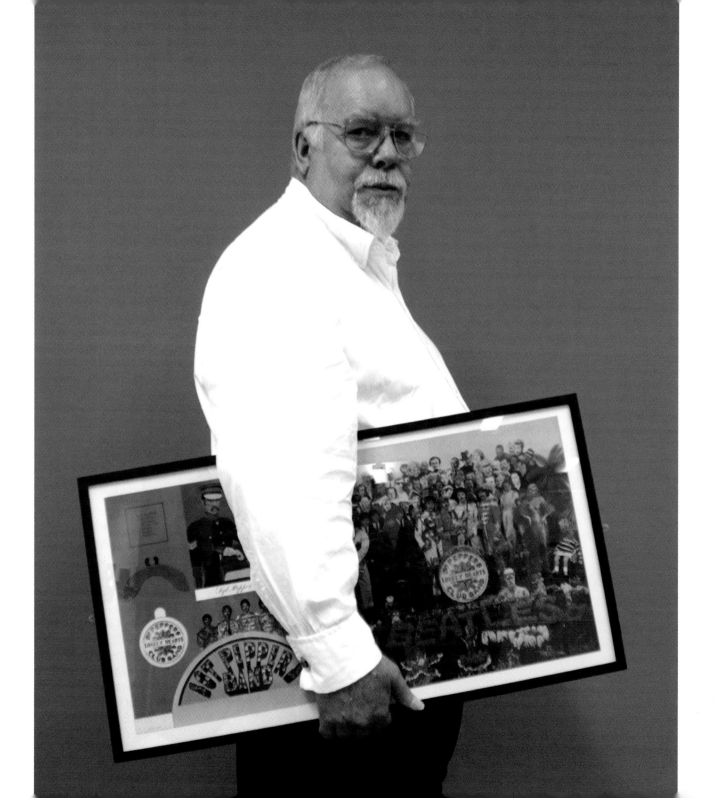

ENID BLYTON
Resplendent in fur stole, children's author Enid Blyton (1897–1968) at St James Church, London. A writer since the early 1920s, Blyton captured an idyllic notion of the 1940s in a time capsule for future generations with her phenomenally successful *Famous Five*, *Secret Seven*, *Mallory Towers* and *Noddy* series. She wrote more than 700 books, short stories, poems and songs, and became a very wealthy woman. Blyton developed dementia and died in a nursing home at the age of 71.
17th August, 1957

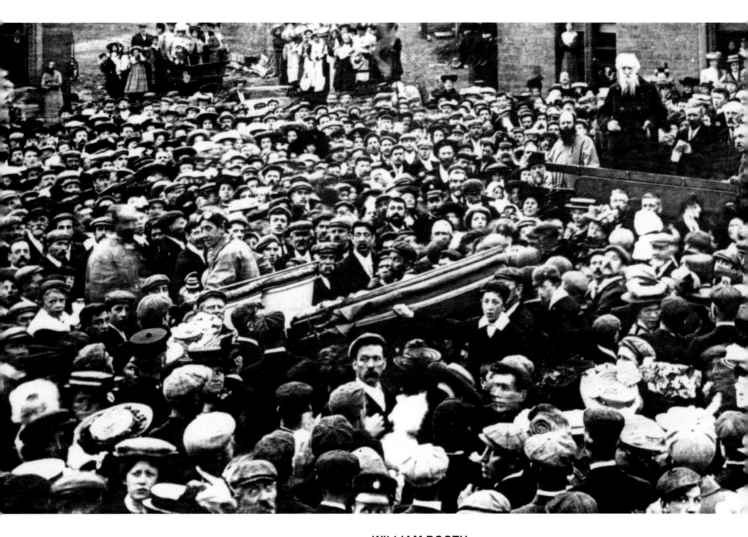

WILLIAM BOOTH
Identifiable by his distinctive white beard, General William
Booth (1829–1912), the Methodist preacher who founded the
Salvation Army movement, is surrounded by an expectant
throng as he preaches in the Yorkshire village of Denby Dale.
Dedicated to abolishing vice and poverty, Booth established
'the Sally Army' in 58 countries during his lifetime.
15th July, 1907

BETTY BOOTHROYD
The former Speaker of the House of Commons, Baroness Betty Boothroyd, dons her ermine in the robing room before her introduction into the House of Lords. Boothroyd (born 1929) was the first female Speaker of the House, serving between 1992 and 2000. Known for her down-to-earth, no-nonsense approach, the former dancer and Labour MP was renowned for bringing the unruly 'boys' club' atmosphere of the House of Commons to order in the effective manner of an old-fashioned matron.
16th January, 2001

IAN BOTHAM

Ian Botham bowls for England in the Second One Day International against Australia at Edgbaston. Known as 'Beefy', Botham (born 1955) still holds the record for the highest number of wickets taken by an England bowler. He was a genuine all-rounder and a '*Boy's Own*' hero. Since retiring from professional cricket, Botham has been a high-profile fund raiser, once walking 900 miles from John o' Groats to Land's End to raise money for charity.

6th June, 1981

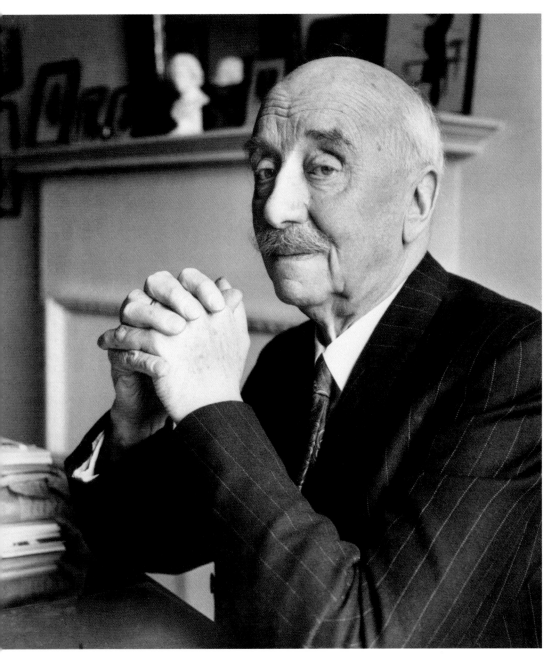

ADRIAN BOULT

Britain's most senior composer, Sir Adrian Boult (1889–1983), who celebrated his 90th birthday in 1979. Born in Chester, north-west England, Boult founded the BBC Symphony Orchestra and was its chief conductor. When he was forced to retire from the BBC in 1950, he refused to lead a quiet life and became the chief conductor of the London Philharmonic Orchestra.

6th April, 1979

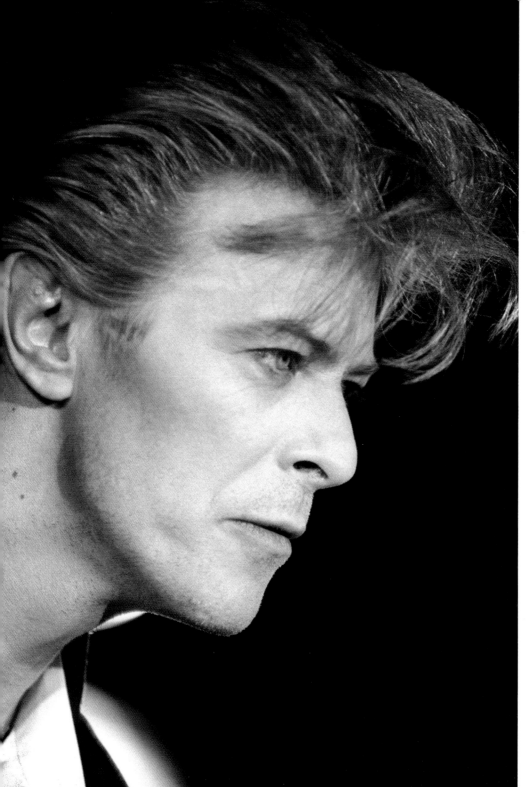

DAVID BOWIE

Pop superstar David Bowie, who shot to fame in the early seventies with his alter-ego album, *The Rise and Fall of Ziggy Stardust and the Spiders From Mars*. Bowie (born 1947) went on to combine music with a successful acting career, making his debut in 1976 with *The Man Who Fell to Earth*. Widely regarded as a musical innovator, Bowie (real name David Jones) has sold an estimated 136 million albums in a career spanning five decades.

10th April, 1987

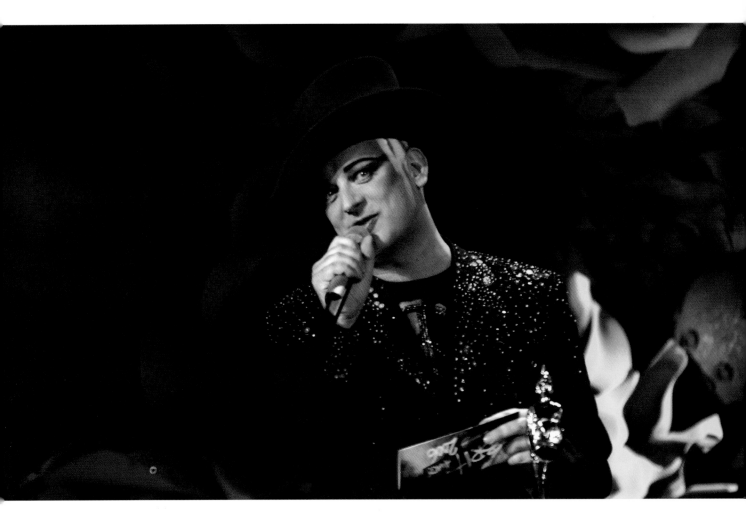

BOY GEORGE

Iconic eighties singer-songwriter Boy George (real name George O'Dowd) on stage at the 2006 Brit Awards at Earls Court in London. Part of the New Romantic movement of the 1980s, George was conspicuous for his androgynous appearance as lead singer with Culture Club, performing a 'blue-eyed soul' blend of rhythm and blues and reggae. The 1982 single *Do You Really Want to Hurt Me?* from the debut album *Kissing to be Clever* became an international hit, and was followed by *Time (Clock of the Heart)* and *I'll Tumble 4 Ya*. Two more chart-topping albums and singles followed, but the band ultimately split. George enjoyed a second career as a DJ, notably with London's Ministry of Sound. Despite battling drugs and an ignominious prison sentence, the one-time nightclub cloakroom attendant endures his 'dark periods' and continues to delight audiences.

15th February, 2006

GEOFFREY BOYCOTT

Former Yorkshire and England cricketer, Geoff Boycott (born 1940) was one of the most successful opening batsmen in a playing career that lasted from 1962 to 1986. Since his international debut in a 1964 Test match against Australia, he proved to be a big scorer, and is the fourth highest accumulator of first-class centuries in history, and the first English player to average over 100.00 in a season. An ambitious player, he ended his international career in 1982 after 108 Test match appearances for England as the leading scorer with over 8,000 runs. He was awarded an OBE for services to cricket. After his playing career, Boycott became an outspoken and controversial cricket commentator on radio and TV. A hiatus occurred in 2002 when, diagnosed with throat cancer, he underwent treatment, returning to the commentary box in 2003.
19th June, 2007

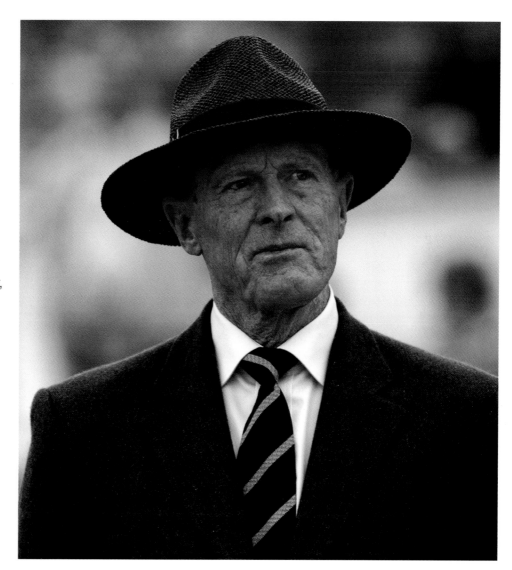

RICHARD BRANSON

Left: The young Richard Branson, in his capacity as organiser of the Students Advisory Service, perched on the arm of a chair at his desk in London. Now 'Sir Richard', the entrepreneur (born 1950) is head of Virgin Group, which owns more than 360 companies. He is reputedly the 212th richest person in the world.
31st July, 1969

Right: Richard Branson at the launch of Virgin Health Bank, the world's first dual – private and public – umbilical cord blood stem cell banking service, at the British Medical Association, London. The facility will take blood stem cells from babies when they are born and store them for use in the future should the child become ill with diseases such as leukaemia.
1st February, 2007

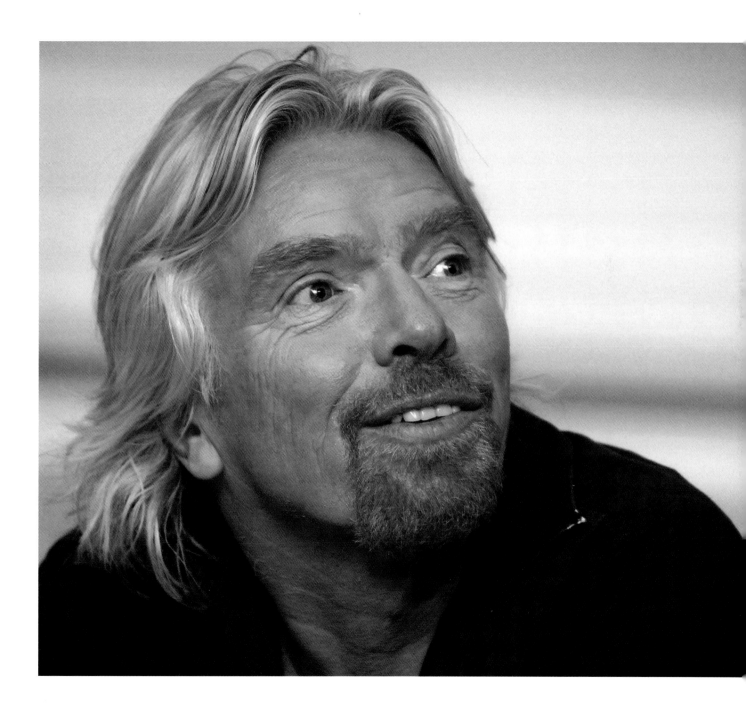

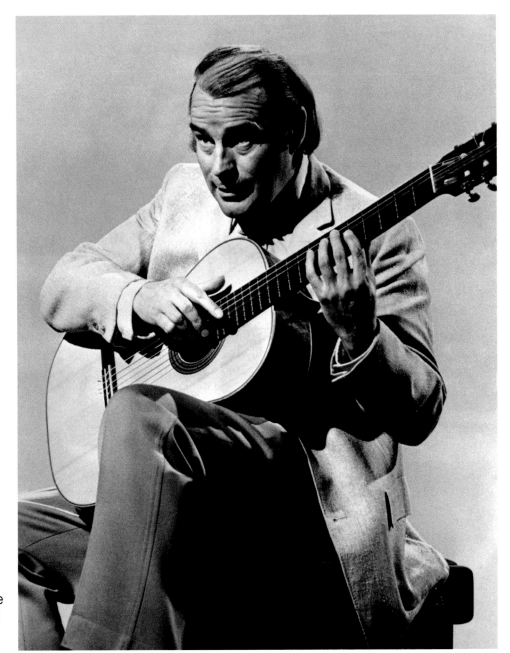

JULIAN BREAM

One of the most distinguished English classical guitarists of the 20th century, Julian Bream (born 1933) made his performing debut at the age of 12. Such is his profile that several composers have written music especially for him, including Benjamin Britten's *Nocturnal* (1963). Bream was also credited with raising awareness of the Renaissance lute. He retired in 2002.

15th December, 1970

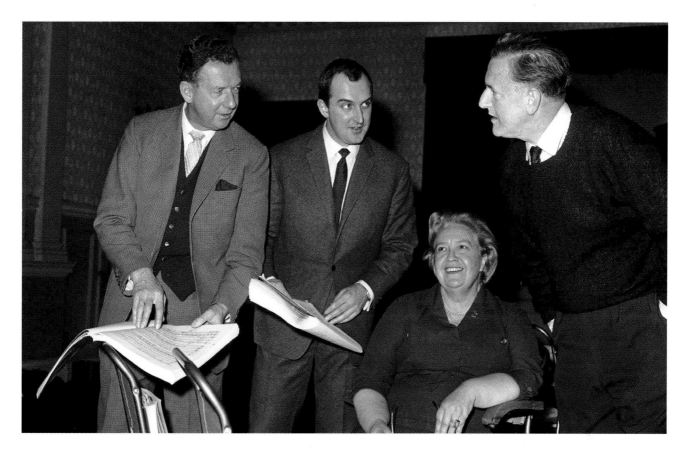

BENJAMIN BRITTEN

Composer, conductor and pianist Edward Benjamin Britten (L) discusses the score with producer Colin Graham (second L) and principal soloists Sylvia Fisher and Peter Pears (R), during rehearsals in London for the performance of Britten's opera *Gloriana* at the Royal Festival Hall. Britten (1913–76) was an early musical talent, composing *Quatre Chansons françaises* for soprano and orchestra at the age of 14. After the success of his opera *Peter Grimes* in 1945, he composed a number of operas that are now standards on the international stage. Originally distrusted by critics, Britten is regarded as one of the greatest composers of the 20th century.

20th November, 1963

TIM BERNERS-LEE

Prime Minister Gordon Brown (L) listens to Internet founder Sir Tim Berners-Lee, as he addresses a Downing Street seminar on smarter government. Known as 'TimBL', the British engineer and computer scientist (born 1955) first proposed the worldwide web while working at CERN, the European Organization for Nuclear Research, in 1989. Initially, it was used exclusively by the US military.

17th November, 2009

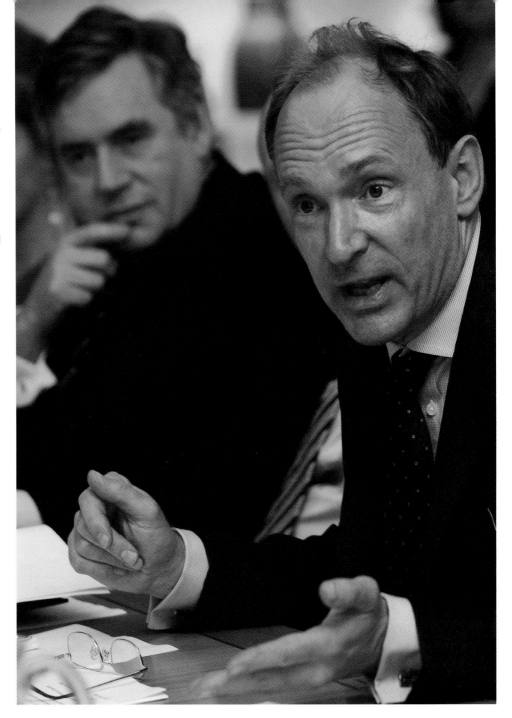

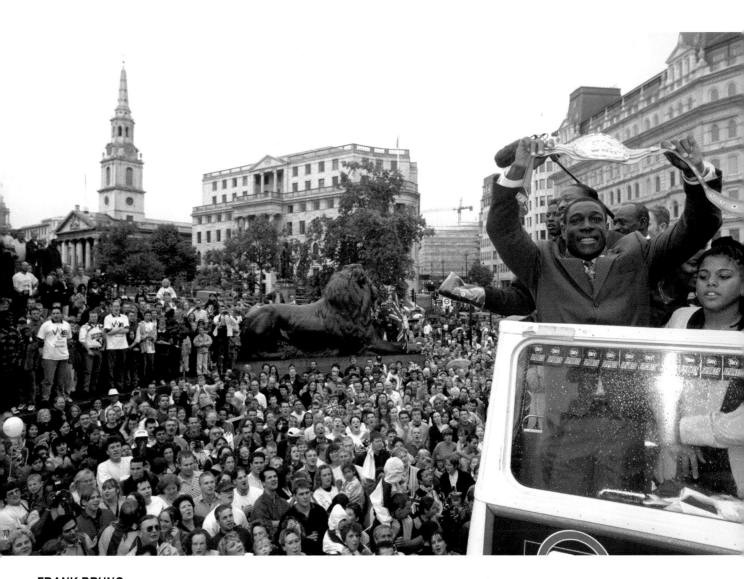

FRANK BRUNO

Britain's world heavyweight boxing champion, Frank Bruno, with his daughter, Rachel, displays his WBC belt after beating the American Oliver 'The Atomic Bull' McCall. The bus carried Bruno (born 1961) and his family from Marble Arch to Trafalgar Square during a parade dubbed VB Day – 'Victory for Bruno Day'. He fared less well in his next bout, against Mike Tyson: the fight was stopped in Tyson's favour. Now retired, Bruno occasionally appears in pantomime.

10th September, 1995

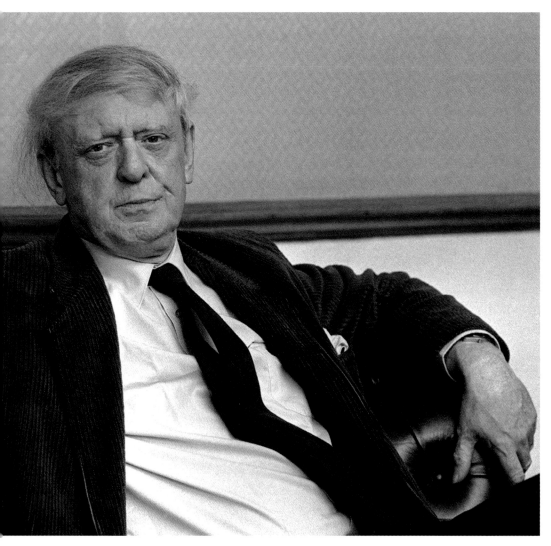

ANTHONY BURGESS
Author Anthony Burgess (1917–93) in London to talk about his new book, *The Piano Players*. His most famous novel, *A Clockwork Orange*, attained iconic status after it was made into a movie by Stanley Kubrick in 1971. Burgess was also an accomplished musician, composing more than 250 pieces, and writing screenplays for the films *Jesus of Nazareth* and *Samson and Delilah*. A trained linguist, his published translations include *Cyrano de Bergerac* and *Carmen*.
26th November, 1986

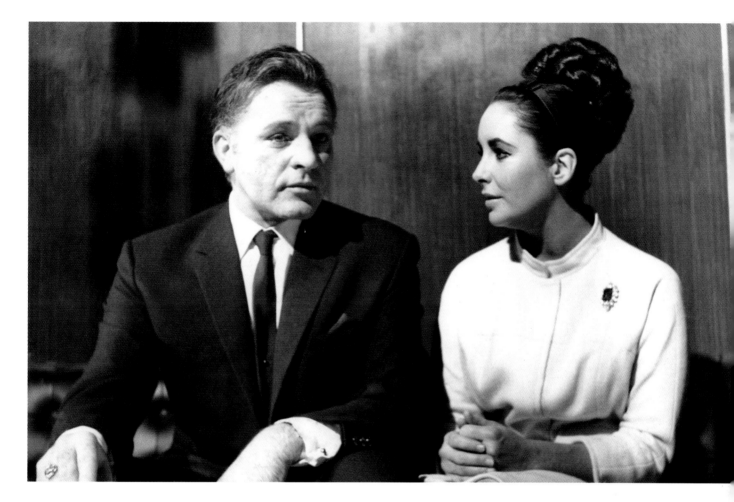

RICHARD BURTON

On- and off-screen lovers Richard Burton (1925–84) and Elizabeth Taylor during the filming of *The VIPs* at Borehamwood Studios, in which they starred as an unhappy husband and wife. The British drama received critical acclaim. Burton (born Richard Walter Jenkins) was the 12th of 13 children in a Welsh-speaking household from Pontrhydyfen, Wales, who, adopting the surname of the teacher who became his ward, discovered a talent for acting. A stage and cinema actor in the UK during the 1940s and 1950s – interrupted during the war years, when he was a navigator in the RAF – Burton made the successful transition to Hollywood leading man. He was nominated seven times for an Academy Award (although never won) and was at one time the highest-paid actor in Hollywood. He remains closely associated in the public consciousness with his second wife, actress Taylor; the couple's turbulent relationship was rarely out of the news

20th December, 1962

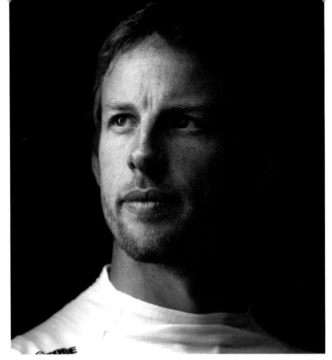

JENSON BUTTON

Left: Formula One champion Jenson Button, and (below) in his McLaren-Mercedes during the Spanish Grand Prix. Button (born 1980) signed a three-year deal with McLaren for a reported £6m per season, competing alongside his team-mate and rival, Lewis Hamilton. Button is known for his smooth driving style and intelligent pit-stop strategies, which have drawn similarities with former French grand prix champion Alain Prost.

May, 2010

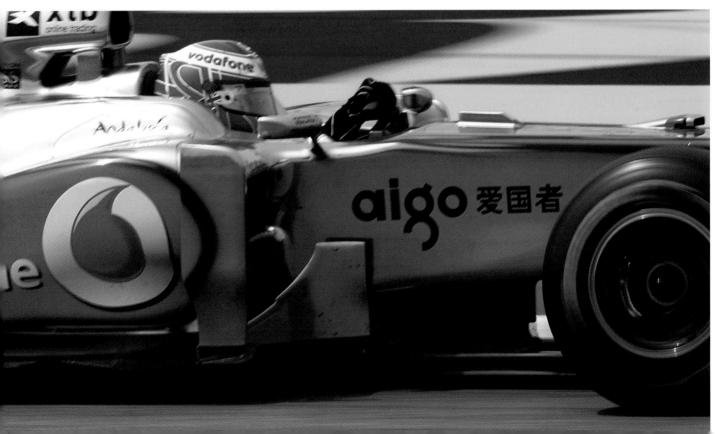

MICHAEL CAINE
Actor Michael Caine
arrives at Heathrow Airport
after filming his latest spy
movie, *The Billion Dollar
Brain*; it was his third role
as the character 'Harry
Palmer'. Born in 1933, the
charismatic icon with the
unmistakable voice is one of
only two actors nominated
for an Oscar in every decade
since the 1960s (the other
being Jack Nicholson); he
has appeared in over 100
films. Renowned for quoting
the *Guinness Book of World
Records*, he is famous for
the catchphrase: *"Not a lot of
people know that."*
28th June, 1967

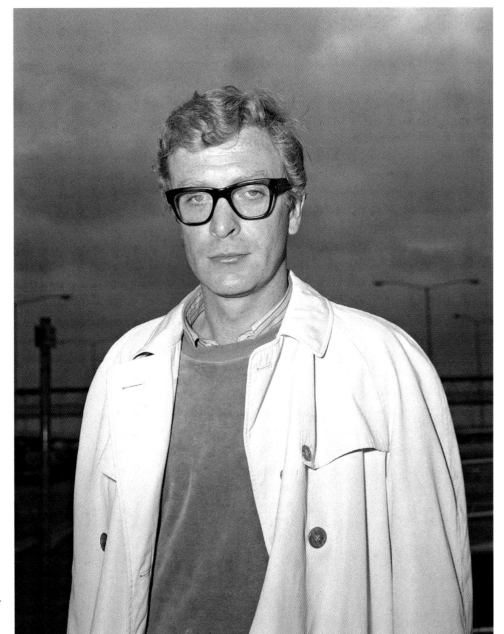

MICHAEL CALVERT

Brigadier Michael 'Mad Mike' Calvert (1913–98) stands at the foot of Pagoda Hill, the mound that he and his men had to clear in 1944 when he was commander of the Chindit Brigade in Burma. Britain's wartime Chindit heroes were completing their first hazardous pilgrimage to the epic jungle battlefields in the treacherous terrain of northern Burma, more than 50 years after they had helped conquer the Japanese invaders. Calvert was one of the most unorthodox commanders in the Second World War, with a flair for analysing complex situations and devising risky countermeasures. In March 1945, Calvert was appointed to command the Special Air Service (SAS) brigade, a position he held until it was disbanded in October 1945.

12th March, 1997

DON CAMERON

Scottish founder of Bristol-based Cameron Balloons, the world's largest hot-air balloon manufacturer, Don Cameron was the first man to fly across the Sahara Desert and the Alps, in 1971, in *Golden Eagle,* a specially designed hot-air balloon. He also took second place in the first ever Transatlantic Balloon Race from Maine, USA, to Portugal in 1992. Cameron (born 1939) has received the gold, silver and bronze medals of the British Royal Aero Club for his ballooning achievements, which include making the first flight between the UK and what was then the USSR in 1990.

10th December, 2001

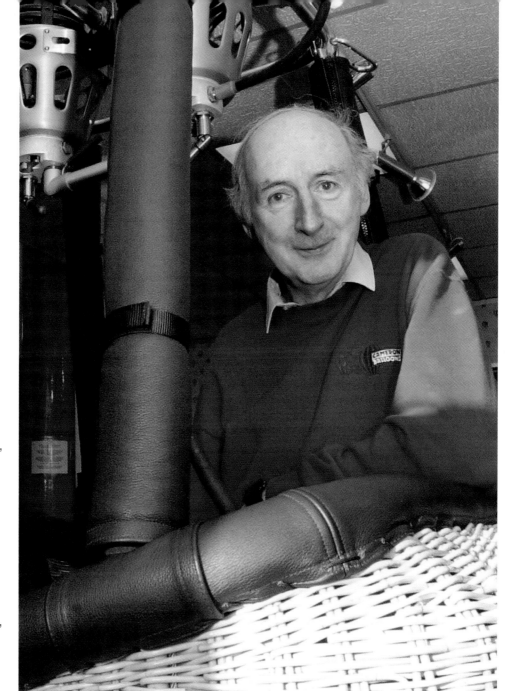

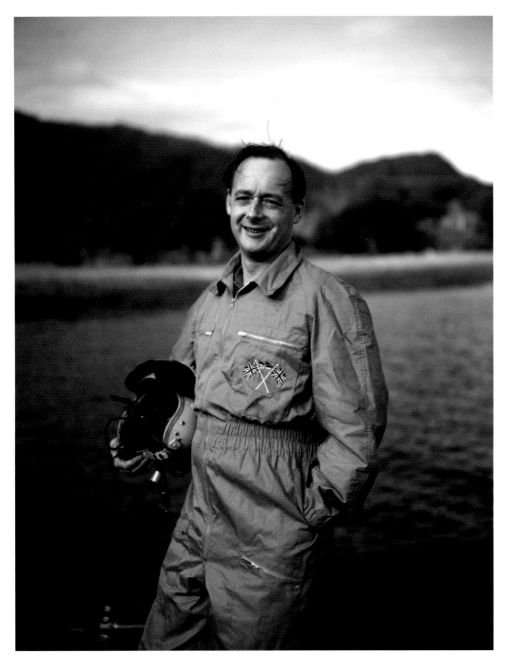

DONALD CAMPBELL

Left: World water speed record breaker Donald Campbell (1921–67) at Coniston Water just before setting the water speed record at 248.62mph in 1958. Campbell broke eight world speed records, and in 1964 became the only person to have smashed the land and water records in the same year.
November, 1958

Right: Donald Campbell's jet hydroplane *Bluebird* hurtles across Coniston Water in the Lake District. Campbell died in the wreckage of the boat in January 1967, while attempting to break his own water speed record of 276.33mph, set in 1964. He reached a top speed of 320mph before the craft flipped over and cartwheeled across the lake. The wreckage containing Campbell's body was finally recovered in 2001 and he was laid to rest in Coniston cemetery.
1st December 1966

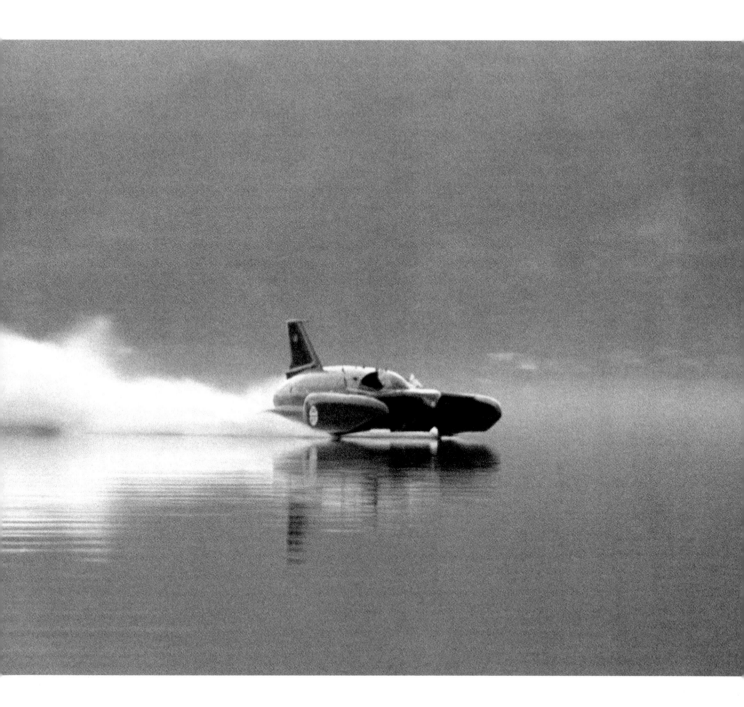

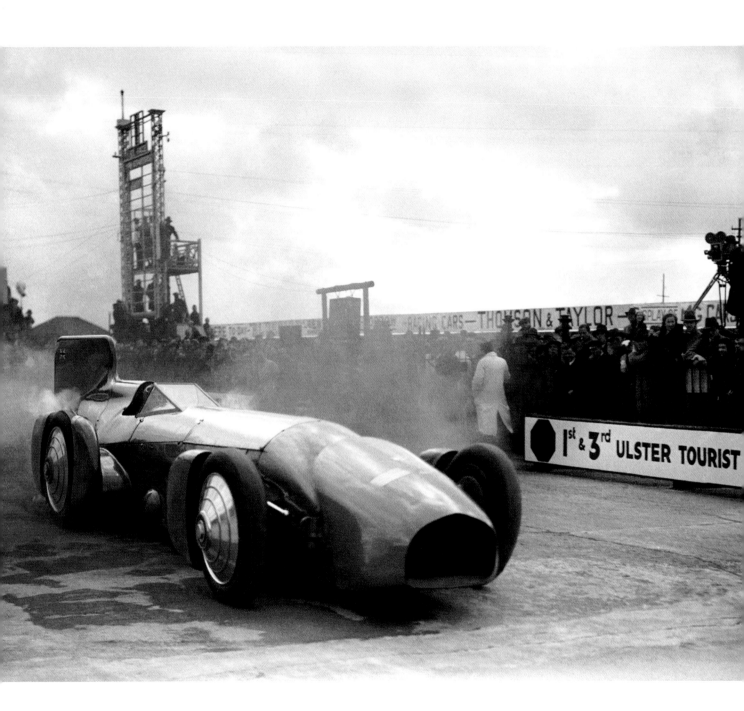

MALCOLM CAMPBELL

Left: Exhaust smoke billowing as the supercharged engine roars, the Campbell-Napier-Railton *Blue Bird* car, holder of the world land speed record, revs up at Brooklands circuit in Surrey. Driven by Sir Malcolm Campbell, the car smashed its own world record on 24th February, 1932, reaching 253.97mph at Daytona Beach, Florida.
20th April, 1932

Right: Sir Malcolm Campbell (1885–1948) at the wheel of his Campbell-Napier-Railton *Blue Bird*. A true '*Boy's Own*' hero, Campbell – father of Donald Campbell – broke the world land speed record on nine occasions between 1924 and 1935, reaching a top speed of 301.337mph. He also set the water speed record four times, hitting 141.740mph. When he was not smashing records, appearing in ads for Dunlop and Castrol, and the Tintin comic strip, or sailing the South Seas in search of treasure, Campbell relaxed by collecting old china.
17th April, 1933

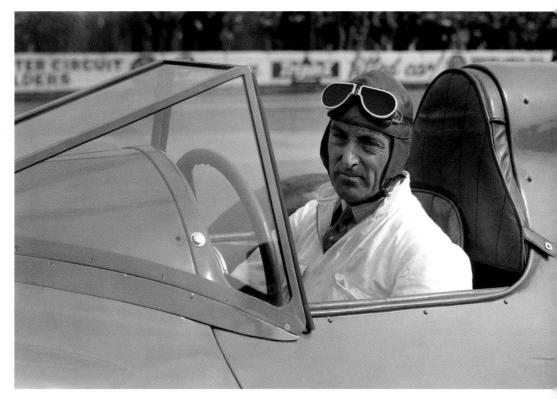

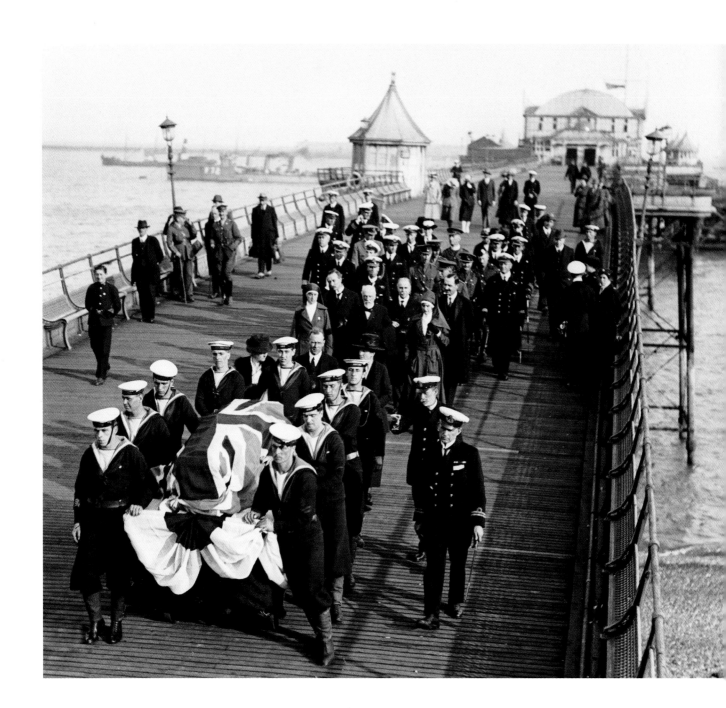

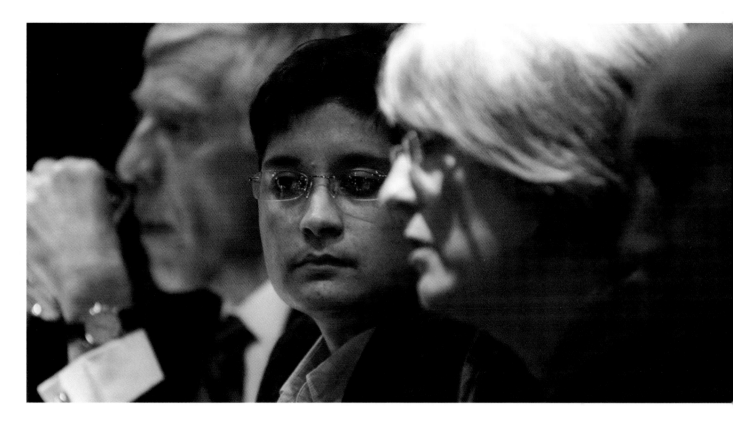

EDITH CAVELL

Left: The coffin of war heroine Edith Cavell (1865–1915) is landed at Dover for reburial on Life's Green, at Norwich Cathedral. The British Red Cross nurse was executed by a German firing squad in Brussels during the First World War for aiding stranded Allied soldiers. Of her courage, she said, *"Had I not helped, they would have been shot."*

1st May, 1919

SHAMI CHAKRABARTI

L–R: Lord Chancellor and Secretary of State for Justice Jack Straw, Liberty director Shami Chakrabarti and Home Secretary Jacqui Smith attend a fringe meeting during the Labour Party Conference in Bournemouth. On discussion was Human Rights in a Time of Heightened Security, following the London bombings by four Muslim extremists in July, which had killed 52 commuters and left 784 people wounded. Chakrabarti, CBE, born in 1969 to Hindu-Bengali parents in the suburb of Kenton in the London borough of Harrow, has been the director of Liberty, a British human rights pressure group, since September 2003. Having qualified as a barrister in 1994, she worked at the Home Office from 1996, before joining Liberty.

25th September, 2007

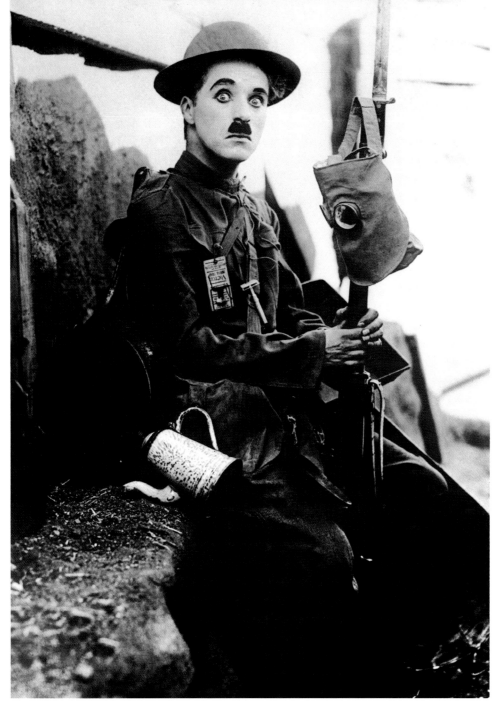

CHARLIE CHAPLIN

Wearing the familiar painted face of the 'sad clown', English silent-screen superstar Charlie Chaplin (1889–1977) appears in a still from the movie *Shoulder Arms*, set in France during the First World War. Chaplin played 'Doughboy', American slang for 'soldier', and a dual reference to the chalky dust that coated marching soldiers and Chaplin's white pancake make-up. Chaplin did enlist to join the British Army, but was rejected for being underweight and too short at 5ft 5in.

1918

Actor and director Charlie Chaplin poses on the roof of the Carlton Hotel in London, following the release of his latest movie, *City Lights*. Chaplin resisted pressure to make the film a 'talkie', so it silently told the touching story of a little tramp (Chaplin) who falls in love with a blind flower girl (Virginia Cherrill). In 2008, the American Film Institute ranked *City Lights* as its number-one romantic comedy. Chaplin received a knighthood in 1975.

19th February, 1931

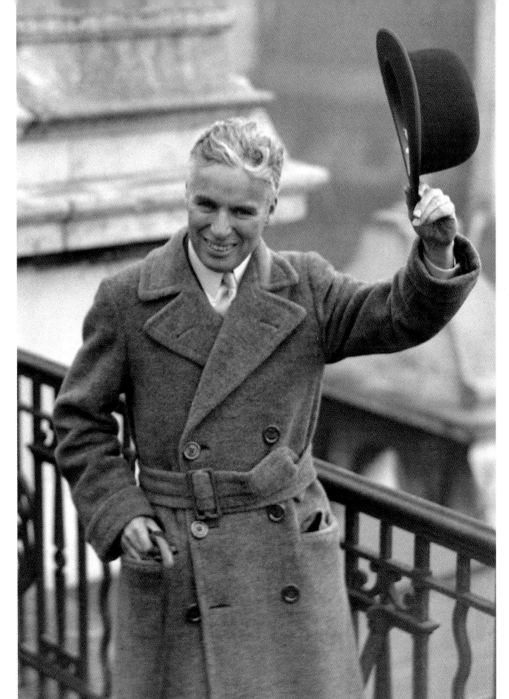

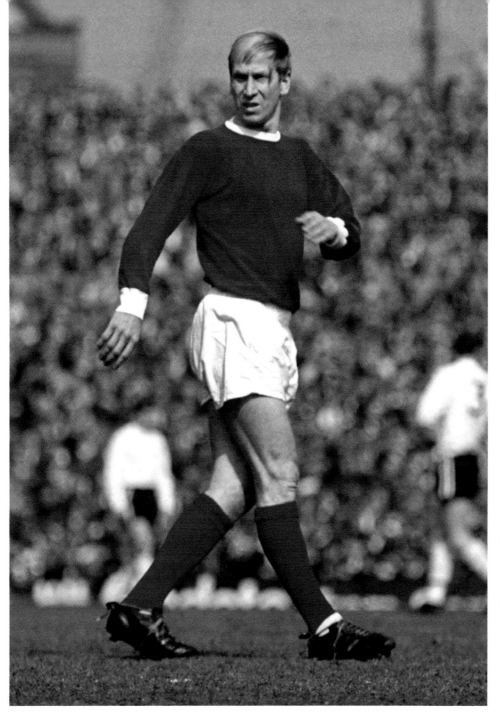

BOBBY CHARLTON

Sporting the most famous comb-over in football, Manchester United's Bobby Charlton performs in the European Cup Final against Portugal's Benfica at Wembley Stadium. United won by a convincing 4–1 and Bobby (born 1937), who scored two goals, lifted the trophy as team captain. He was a member of England's World Cup winning team in 1966, and in the same year, he was voted European Footballer of the Year. At the time he retired from the England team, in 1970, Bobby was England's most capped player. Many consider him to be one of the greatest English footballers of all time.

15th April, 1968

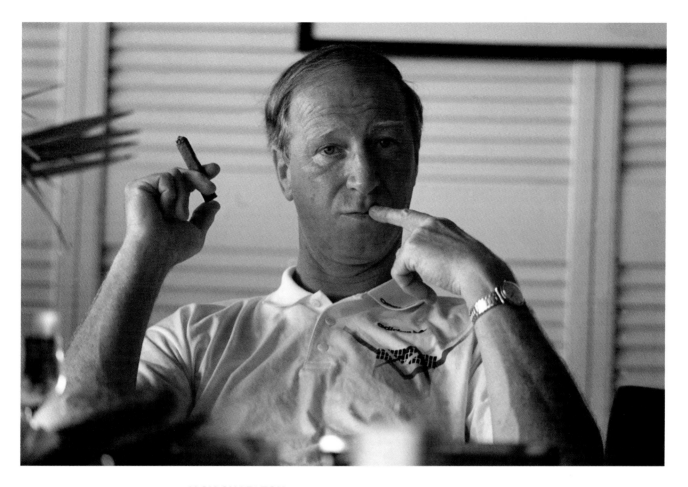

JACK CHARLTON

Ireland manager Jack Charlton relaxes with a cigar. Jack (born 1935) was a member of the famous England squad that clinched the 1966 World Cup. Part of a footballing family, including younger brother Bobby, Jack did not play for his country until he was almost 30, and was 31 when England won the title. As manager, he took Ireland to the World Cup for the first time in 1990. The team eventually lost to Italy in the quarter-final, but they received a heroes' welcome back home in Dublin.

1st June, 1990

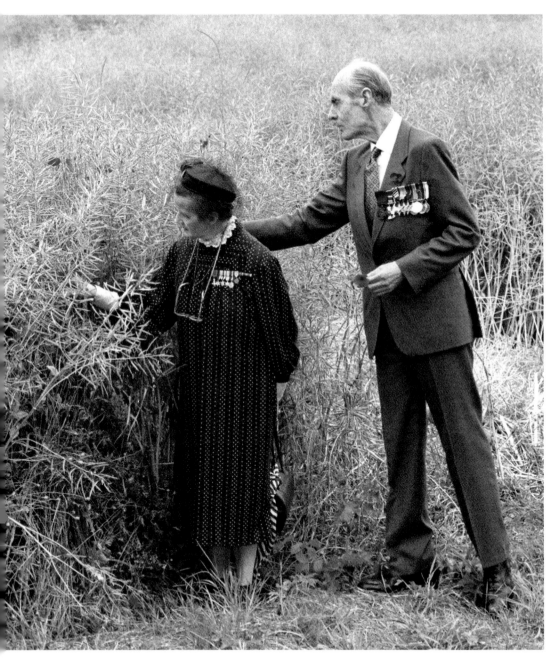

LEONARD CHESHIRE

Second World War hero Group Captain Leonard Cheshire, later Lord Cheshire (1917–92), and his wife Lady Cheshire (charity founder Sue Ryder, 1923–2000) pay their respects to the War dead among the poppies near the Lochnagar Crater on the Somme, France. The former bomber pilot was awarded the Victoria Cross for gallantry and succeeded Guy Gibson as commander of the legendary No 617 'Dambusters' squadron in 1943. After the war, Cheshire set up the charity now known as Leonard Cheshire Disability.

4th July, 1989

FRANCES CHICHESTER

Facing page: Yachtsman Sir Francis Chichester (1901–72) prepares his boat, *Gipsy Moth IV*, at Beaulieu, Hampshire, for his 4,000-mile voyage from Bissau in Portuguese Guinea to Juan del Norte in Nicaragua. Chichester was the first man to sail around the world solo with just one stop in Sydney.

1st December, 1970

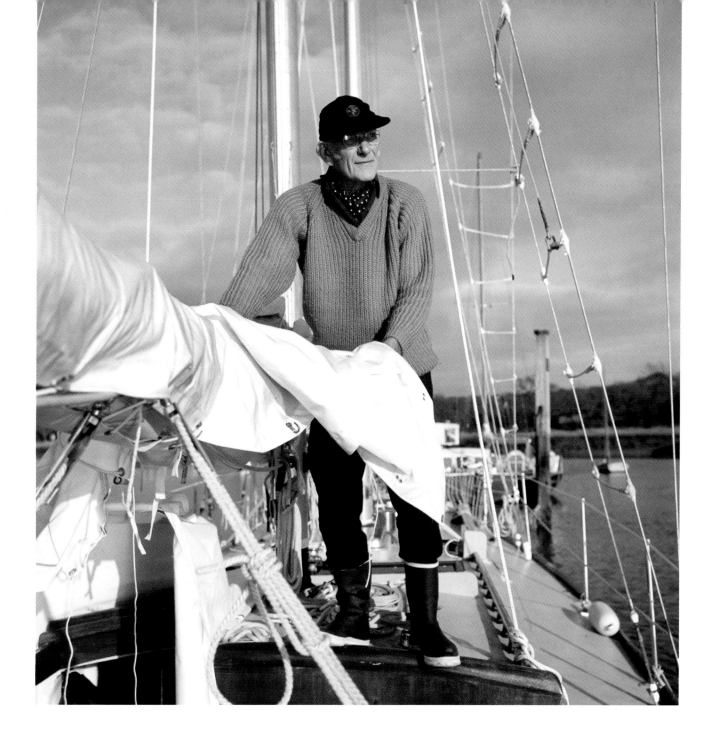

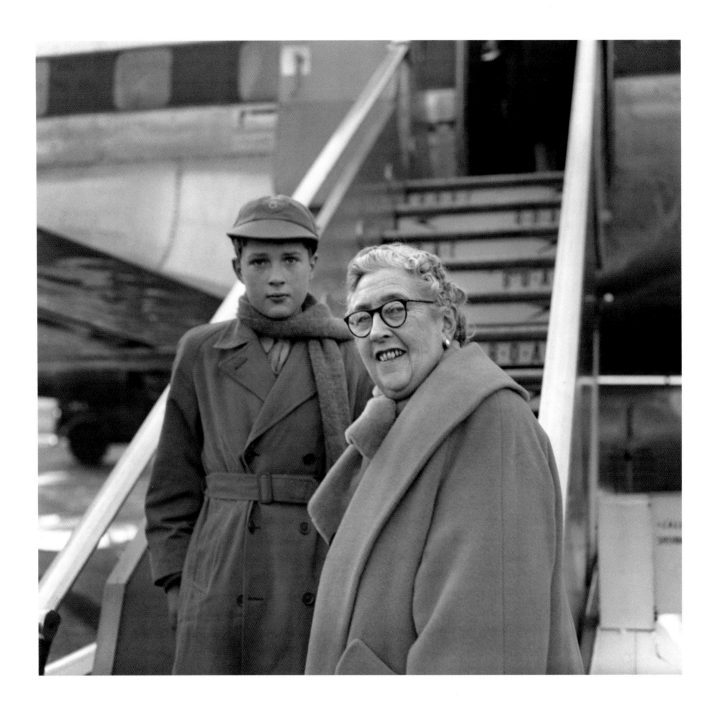

AGATHA CHRISTIE

Facing page: Novelist and playwright Agatha Christie (1890–1976) and her grandson, Matthew Pritchard, leave London Airport for Christmas in Tripoli. The best-selling author of all time, Christie – the 'Queen of Crime' – wrote 80 novels, more than a dozen plays and numerous short stories in a dazzling career that spanned half a century. Her work has been translated into nearly 50 languages and her most famous crime-busting characters, Miss Marple and Poirot, continue to thrill audiences in countless film and TV adaptations.

21st December, 1955

LINFORD CHRISTIE

British athlete Linford Christie, in a leopardskin bodysuit, acknowledges the crowd before the Men's 100m sprint at the National Championships in Sheffield. Christie is the only British man to have won gold in the 100m race at the Olympic, World, European and Commonwealth games, and he has collected more medals than any other British athlete. His reputation was tarnished when he tested positive for drugs in 1999, but he continues to coach.

16th September, 1990

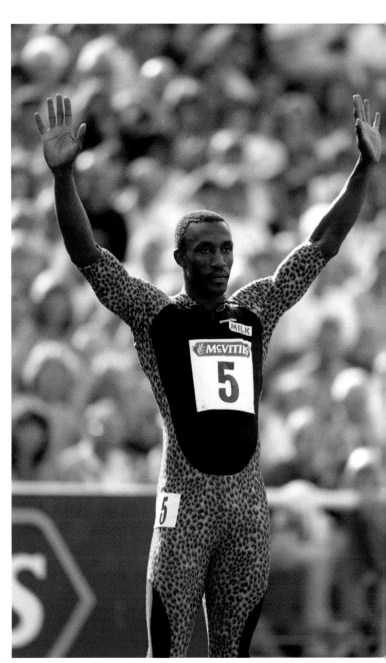

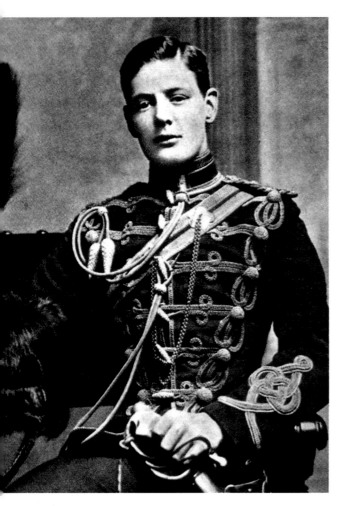

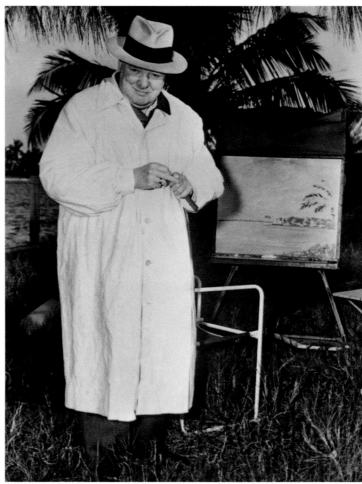

WINSTON CHURCHILL

The youthful Winston Churchill as a cornet (second lieutenant) in the 4th Queen's Own Hussars. Stationed in Bangalore, in India, Churchill developed a keen interest in educating himself, something Harrow School had failed dismally to achieve. He set about studying Plato, Gibbon and Aristotle, and pored over thousands of transcripts of parliamentary debates.

1895

British Prime Minister Winston Churchill (1874–1965) takes a break from his painting to pose for the camera while on holiday in Florida. Churchill took up painting in the latter 40 years of his life and it became a lasting passion. Some of his artwork was highly acclaimed and at least 500 known Churchill paintings are held in collections around the world. He famously stated of his hobby: *"I know of nothing which, without exhausting the body, more entirely occupies the mind."*

3rd February, 1954

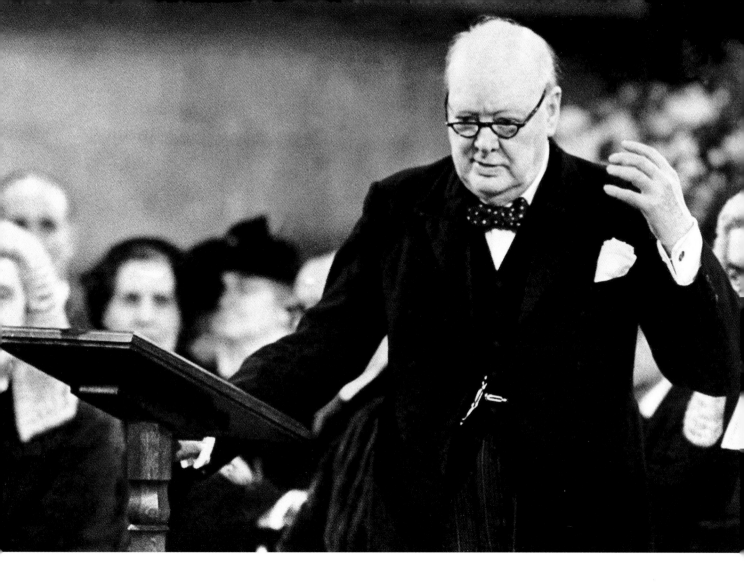

Prime Minister Sir Winston Churchill speaks after receiving a commemorative book during his 80th birthday ceremony at Westminster Hall. Churchill was one of the greatest orators of the 20th century but, interestingly, had been born with a speech impediment, which he fought hard to overcome. His rousing *"We shall fight on the beaches…"* speech in the House of Commons, following the evacuation of Dunkirk, has gone down in history as one of the most powerful monologues ever delivered.

30th December, 1954

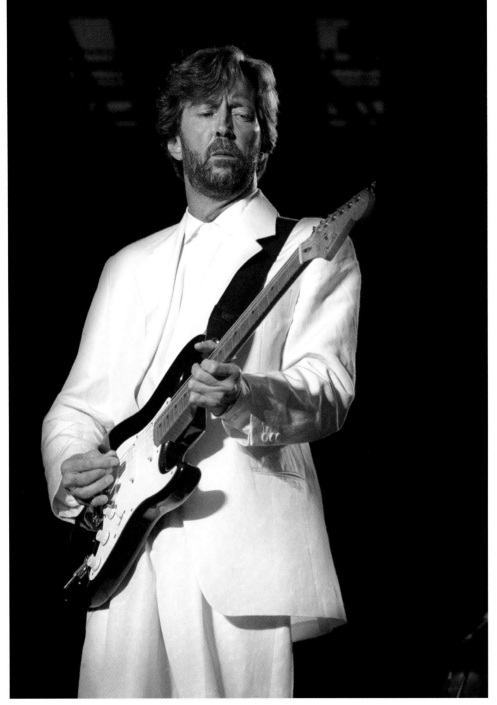

ERIC CLAPTON

Rock Legend Eric Clapton on stage during the first of three concerts with Elton John at Wembley Stadium in London. Clapton holds the distinction of having been inducted to the Rock and Roll Hall of Fame three times – as a solo artist and as a member of the bands Cream and the Yardbirds. Clapton (born 1945) tops numerous polls for his incredible rock-blues guitar playing and is best known for the iconic hits *Layla* and *Wonderful Tonight*.
26th June, 1992

JIM CLARK

Facing page: World Champion Formula One racing driver Jim Clark (1936–68), winner of two championships (1963 and 1965), perches on his Lotus. Killed in a racing accident in Germany, the versatile Scottish driver had achieved more pole positions than any other racing driver and had won 25 grand prix titles by the time he died at the age of 32.
24th September, 1963

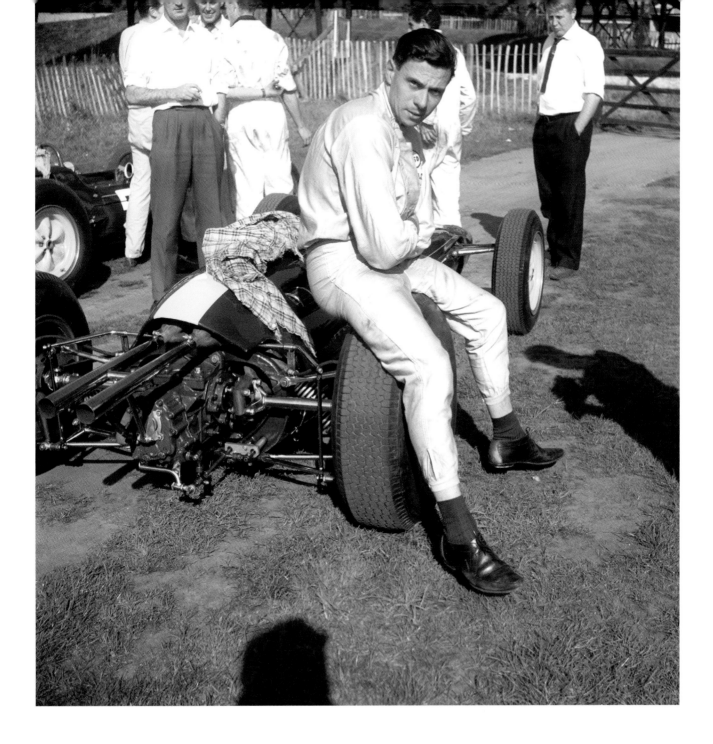

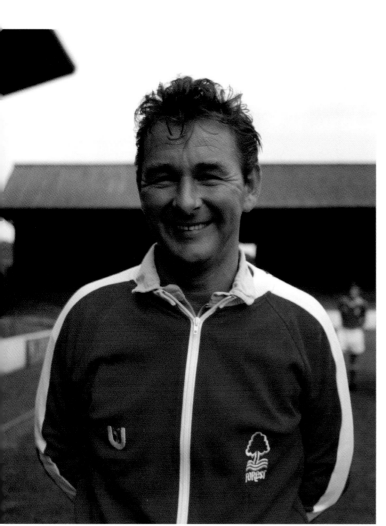

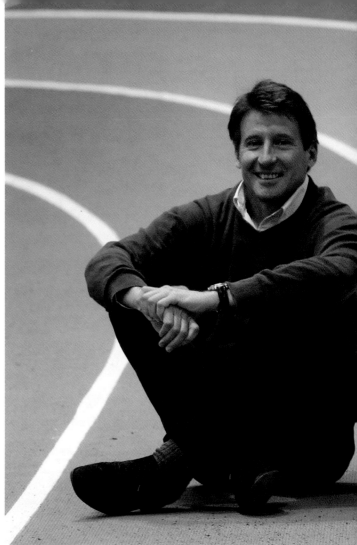

BRIAN CLOUGH

"I wouldn't say I was the best manager in the business. But I was in the top one." Outspoken Nottingham Forest manager Brian Clough (1935–2004) made football history by taking his relatively provincial team to victory in two European Cup matches and signing the first £1m player, Trevor Francis. Clough is often described as the greatest English manager never to have managed the England squad.

15th July, 1976

SEBASTION COE

Baron Sebastian Coe, chairman of the London Organising Committee for the 2012 London Olympic Games, marks the 1,000-day countdown to the opening ceremony. Coe led London's successful bid to host the games. The eight-times Olympic and European Championships medal winner dominated athletics in the 1980s, along with his British rivals, Steve Ovett and Steve Cram. Following his retirement from athletics, Coe (born 1956) served as a Conservative MP and became a life peer in 2000.

31st October, 2009

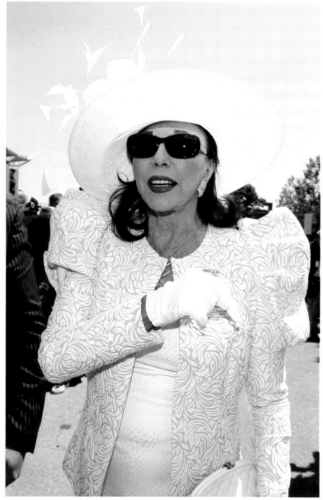

JOAN COLLINS

English actress, author and columnist Joan Collins, OBE (born 1933), attends Ladies Day during the Royal Ascot Meeting. She is as flamboyant in her personal life as she is in her role as 'Alexis Colby' in the American TV series *Dynasty*. Collins made her film debut in 1952 in *I Believe in You* and was a popular magazine pin-up in the UK in the 1960s. In the 1970s, she starred in softcore film versions of her sister Jackie Collins' racy novels, *The Stud* and *The Bitch*

17th June, 2010

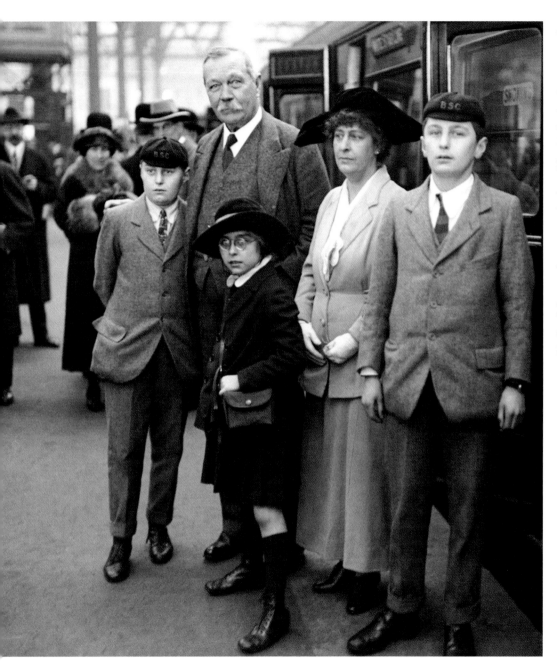

ARTHUR CONAN DOYLE

Bound for the United States, Edinburgh-born Sherlock Holmes creator Sir Arthur Conan Doyle (1859–1930) and his second wife, Lady Jean, pose with their rather serious children, Denis, Adrian and young Jean, at Waterloo Station, London. A qualified doctor as well as a prolific writer, Conan Doyle was one of the most highly-paid authors of the 1920s. His exploits on this trip were later published under the title *Our Second American Adventure* (the first 'American Adventure' occurred in 1921).

28th March, 1923

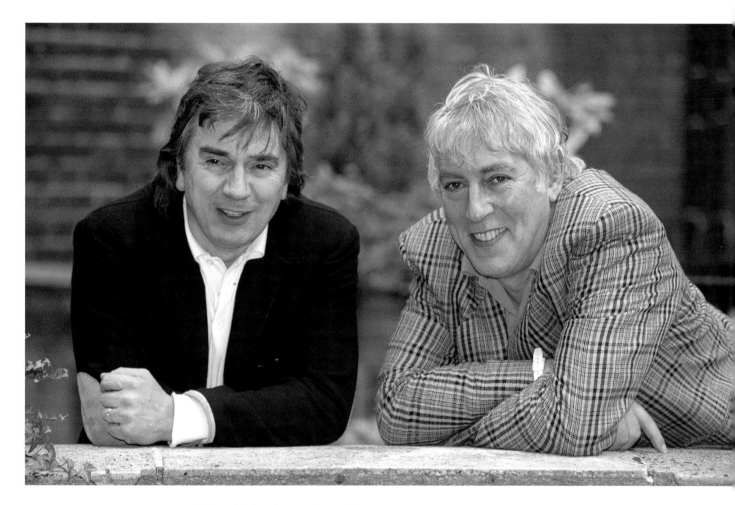

PETER COOK & DUDLEY MOORE

L–R: Comedians Dudley Moore and Peter Cook appear together in London to launch the video release of their vintage comedy series *Not Only...But Also...* Cook (1937–95) was influential in the British satire boom of the 1960s, while Moore (1935–2002) was one of the four writer-performers in *Beyond the Fringe*. Their comedy partnership included the characters 'Pete and Dud' and their more adult counterparts, 'Derek and Clive'.

5th November, 1990

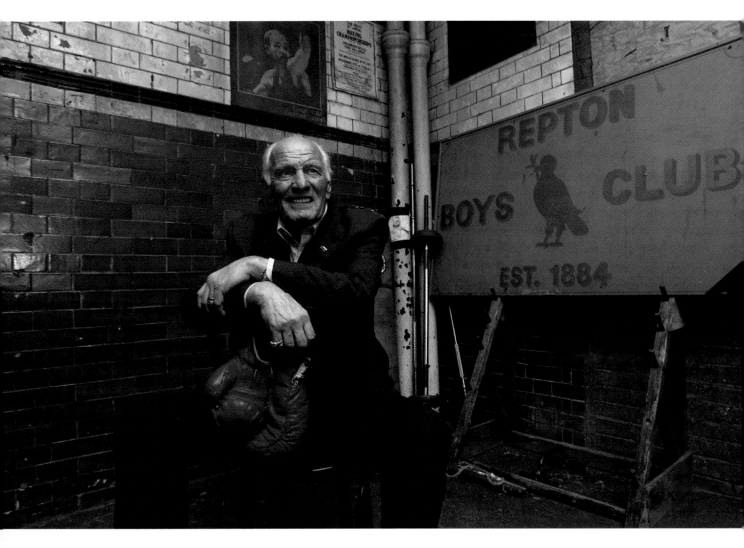

HENRY COOPER

Sir Henry Cooper at Repton Boys' Club in London. One of boxing's most loved and respected figures, 'Our 'Enry' (born 1934) is most famous for his bout with Cassius Clay (Muhammad Ali) in 1963, when Cooper knocked Clay down in the fourth round with an angled left hook. He eventually lost to the American in the next round, but Clay stated later in interviews that Cooper had hit him so hard *"that my ancestors in Africa felt it."*
7th May, 2009

TOMMY COOPER

Often described as 'the funniest man who ever lived', comedy magician Tommy Cooper (1921–84) is pictured at home. A charismatic performer, Cooper's constant battle with stage fright, alcohol and pills was largely unknown until late in his career. He collapsed and died in the middle of a 'live' television performance on *Live From Her Majesty's*. The audience laughed, thinking it was a joke. Twenty years after his death, a *Reader's Digest* poll crowned him 'Funniest Briton of All Time'.

7th October, 1953

Right: Wearing his trademark fez, comedian and magician Tommy Cooper appears on stage in front of the Queen and Prince Philip at the 39th Royal Variety Performance. Although many of the tricks he performed seemed to go wrong, in fact Cooper was a respected member of the Magic Circle.

13th November, 1967

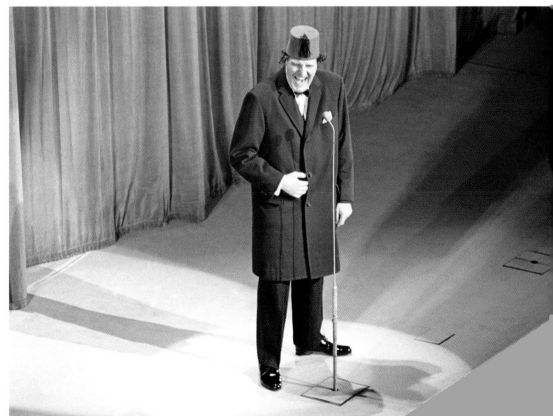

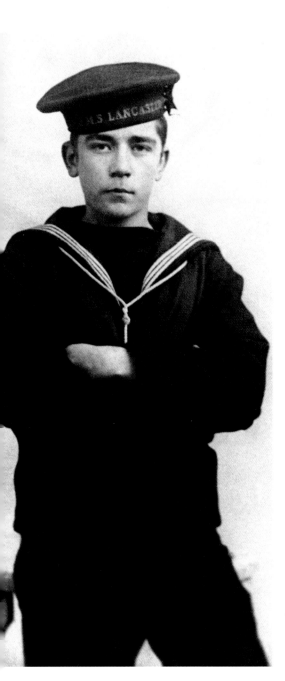

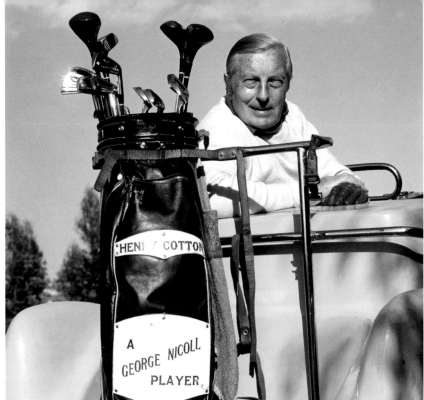

HENRY COTTON

Above: Professional golfer Henry 'the Maestro' Cotton (1907–87) pictured with his clubs. Equal parts flamboyant showman and sharp hitter, Cotton won three British Open Championships (1933, 1937, 1948) and held the position of captain of the Ryder Cup team in 1947 and 1953. Quoted as saying, *"The best is always good enough for me",* he embraced the champagne lifestyle that came with success. Cotton designed golf courses after his retirement from competition and planned Le Méridien Penina in Portugal.

1st June, 1962

JOHN TRAVERS CORNWELL

Left: Having joined the Royal Navy as a boy sailor, John Travers Cornwell (1900–16) served aboard HMS *Chester* in 1916 during the Battle of Jutland, off the coast of Denmark. 'Jack' Cornwell was mortally wounded in the battle but, with dead crew all around him, he remained at his post, awaiting orders, until battle ceased. Cornwell died from his injuries and was posthumously awarded the Victoria Cross. He is buried in the City of London Cemetery.

1916

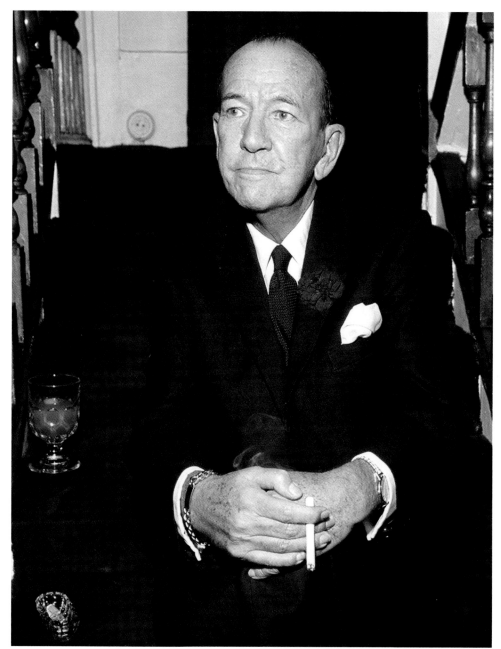

NOËL COWARD

Playwright and theatrical all-rounder Noël Coward (1889–1973) faces the press prior to his appearance in his new trilogy of plays, *Suite in Three Keys*. Struggling with memory loss during performances, however, he retired from acting soon after. Teddington-born Coward wrote more than 50 plays, most set in the high society circles in which he mixed. Works such as *Hay Fever*, *Private Lives* and *Blithe Spirit* have become classics in theatre repertoire. In the 1950s, he enjoyed success in cabaret, performing his own songs, such as *Mad Dogs and Englishmen*. Coward will always be remembered for, in the words of *Time* magazine, *"a sense of personal style, a combination of cheek and chic, pose and poise."*
10th March, 1966

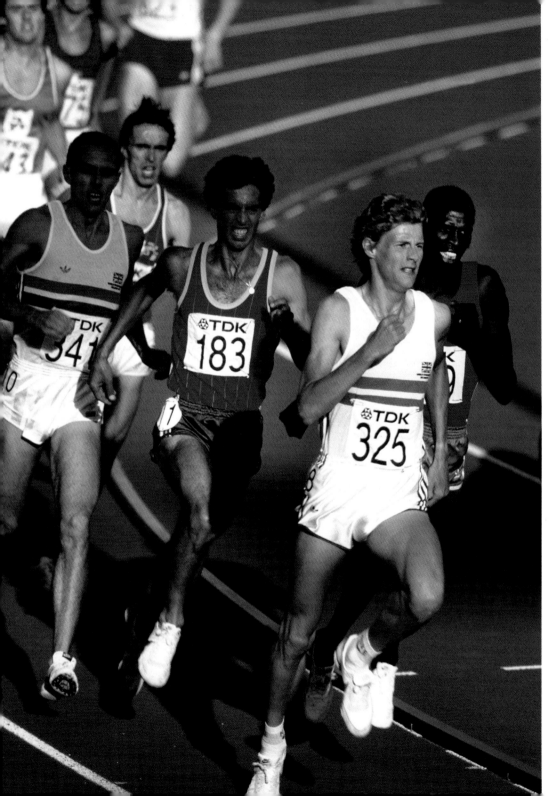

STEVE CRAM
Britain's Steve Cram leads the pack in the Men's 1500m World Championships in Helsinki, where he took the gold and set a new world record. The lanky athlete (born 1960) was one of the fastest middle distance runners of the 1980s, taking silver in the 1500m race at the 1984 Los Angeles Olympic Games. Together with Sebastian Coe and Steve Ovett, Cram dominated British and world athletics and was voted International Athlete of the Year in 1985.
22nd August, 1983

FRANCIS CRICK

Above: Pictured at Cambridge is Dr Francis Crick (1916–2004) who, along with American Dr James Watson, was awarded the Nobel Prize for Medicine for one of the most important biological discoveries of the 20th century: the molecular structure of DNA. They proposed that the DNA molecule consisted of two spirally intertwined helical chains and demonstrated how genetic information is passed on through DNA in the genes. The discovery had enormous impact in the fields of medicine, crime solving and cloning.

18th October, 1962

QUENTIN CRISP

Below: Gay campaigner Quentin Crisp (real name Denis Pratt), author of the autobiographical book *The Naked Civil Servant*, at Heathrow Airport, London. Crisp (1908–99) was a trailblazer for gay equality and his unorthodox appearance provoked strong reactions in some people. He was often attacked in the street for his overtly effeminate garb. Crisp became a celebrity when the actor John Hurt played him in the 1975 film version of his book. He relocated to New York in 1981.

13th September, 1981

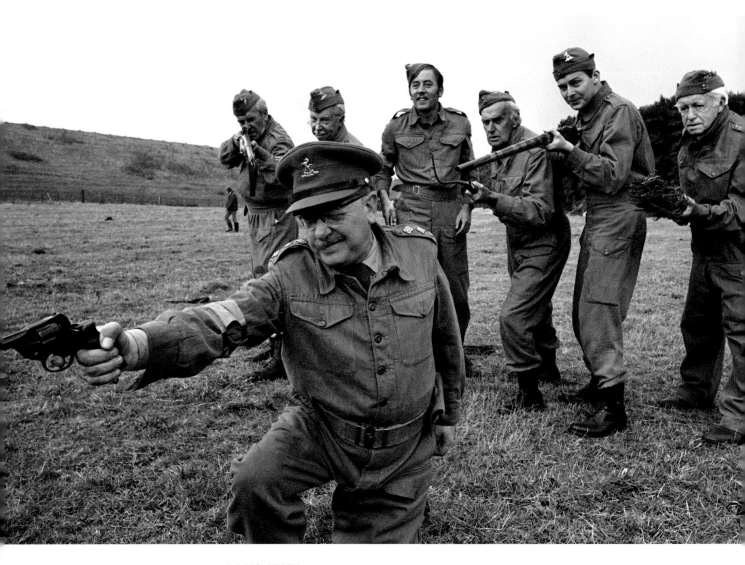

DAD'S ARMY
The cast of the classic BBC comedy *Dad's Army*, film an episode on location for the popular series. Pictured are Arthur Lowe (foreground) and (background L–R) John Le Mesurier, Clive Dunn, James Beck, John Laurie, Ian Lavender and Arnold Ridley. The show ran for 80 episodes between 1968 and 1977, and re-runs continue to be shown on television today.
20th August, 1970

LAWRENCE DALLAGLIO

London Wasps captain Lawrence Dallaglio roars instructions to team-mates during a rugby union match against Llanelli at Twickenham. Dallaglio (born 1972) was made England captain in 1997, but resigned in 1999 following drugs allegations in the *News of the World*, which he denied. He was a crucial member of the England squad that won the 2003 Rugby World Cup, and he was reinstated as captain in 2004, when Martin Johnson retired. Dallaglio received an OBE in 2008.

9th April, 2006

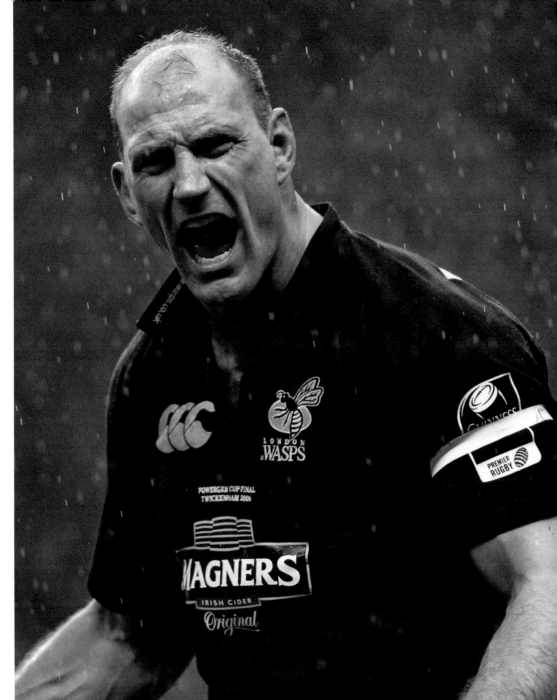

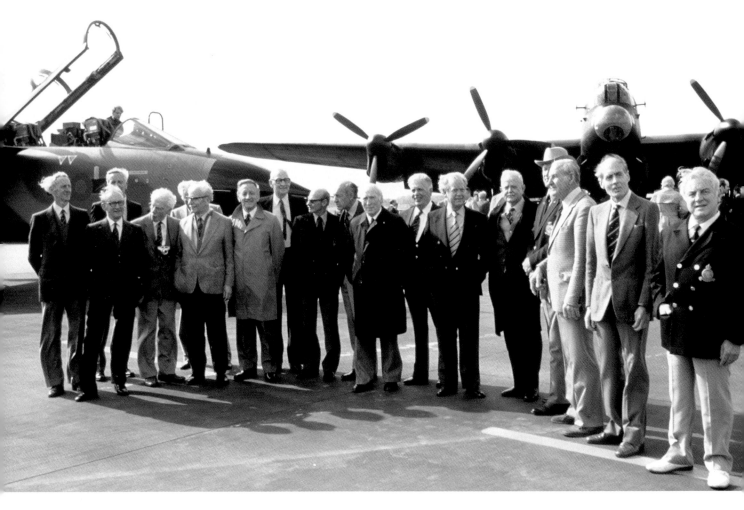

DAMBUSTERS SQUADRON
Surviving members of the heroic wartime No. 617 Squadron, the 'Dambusters', stand in front of a Lancaster bomber and its modern counterpart, a Tornado, at RAF Marham in Norfolk during a reunion. Attacks on German dams during Operation Chastise on 16–17th May, 1943 used 'bouncing bombs' developed by Barnes Wallis (*see page 290*) and were intended to destroy the production of hydroelectric power, to deprive industry, cities and canals of water and to cause devastating flooding. The Möhne and Eder dams were breached, flooding the Ruhr valley and villages in the Eder valley, while the Sorpe dam sustained minor damage.
16th May, 1983

JOHN DANKWORTH

Jazz musician and composer Sir John Dankworth (1927–2010), photographed with his saxophone at home in Hertfordshire. Dankworth was a mainstay of the British music scene for more than 60 years, working with some of the all-time jazz greats, including Ella Fitzgerald and Dizzy Gillespie. He wrote the scores for the films *Saturday Night, Sunday Morning* and *Modesty Blaise* in the 1960s, as well as the theme tunes for the iconic TV shows *The Avengers* and *Tomorrow's World*.

30th December, 2005

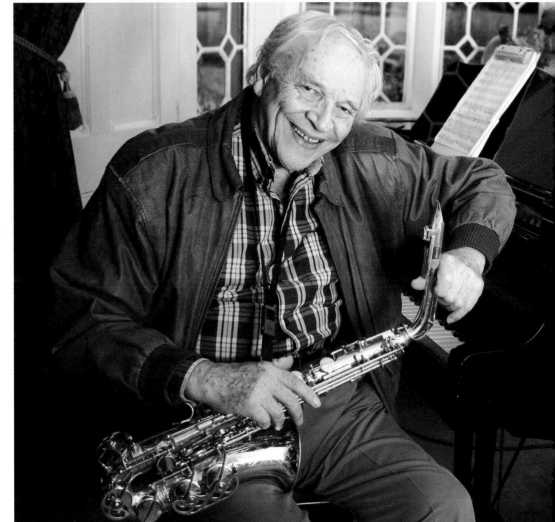

ELIZABETH DAVID

Celebrity TV cook Elizabeth David relaxes between takes in her kitchen. Credited with introducing the British to Italian and French cuisine, David (1913–92) was scathing of bland British fare after the Second World War and often featured ingredients that were unavailable in the UK. She famously instructed her viewers to buy olive oil, used in the treatment of earache, from a chemist shop to use in their recipes.

1st March, 1969

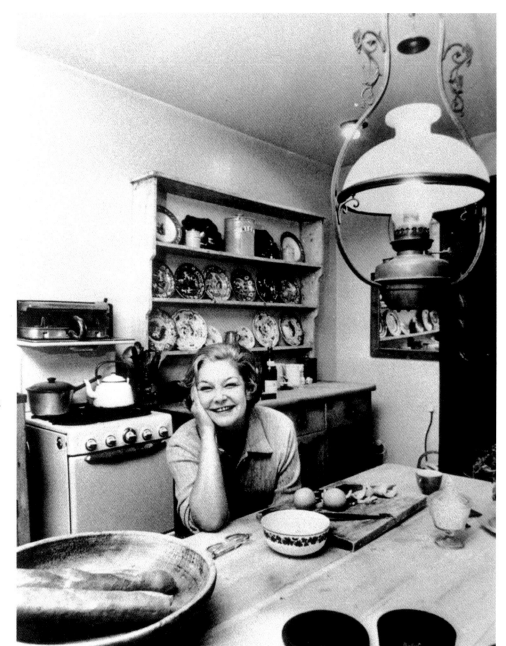

BILL 'DIXIE' DEAN

The incomparable Everton striker Bill 'Dixie' Dean (1907–80) shoots for goal at Goodison Park. He scored a total of 383 goals for Everton, including 37 hat tricks. Dean is still the only English player to have scored 60 league goals in one season (1927–28), cementing his place in football history. A statue of Dixie was erected outside Goodison Park in 2001, bearing the inscription: *Footballer, Gentleman, Evertonian.*

20th October, 1930

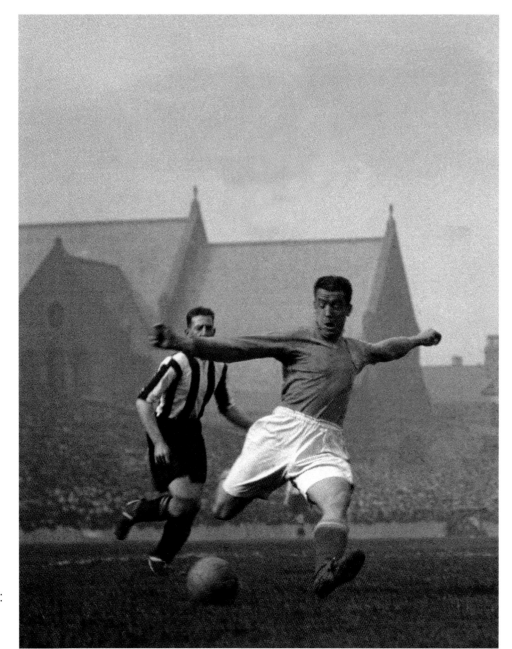

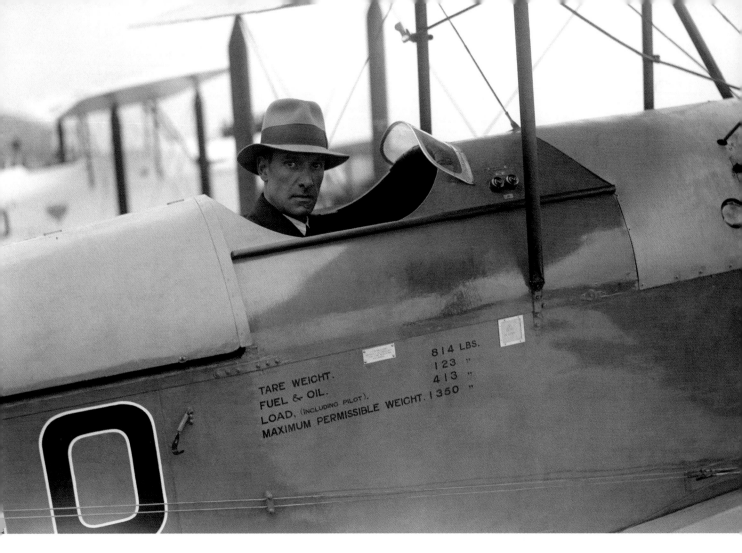

GEOFFREY DE HAVILLAND

Captain Geoffrey de Havilland (1882–1965), British aviation pioneer, pictured in his de Havilland DH.60 Moth at the Kings Cup Air Race. His company also built the Mosquito, one of the most valuable weapons available to the Allied forces during the Second World War, and the world's first jet airliner, the Comet. He was awarded a knighthood in 1944 and, incidentally, was the cousin of the squabbling Hollywood siblings Olivia de Havilland and Joan Fontaine.

9th July, 1926

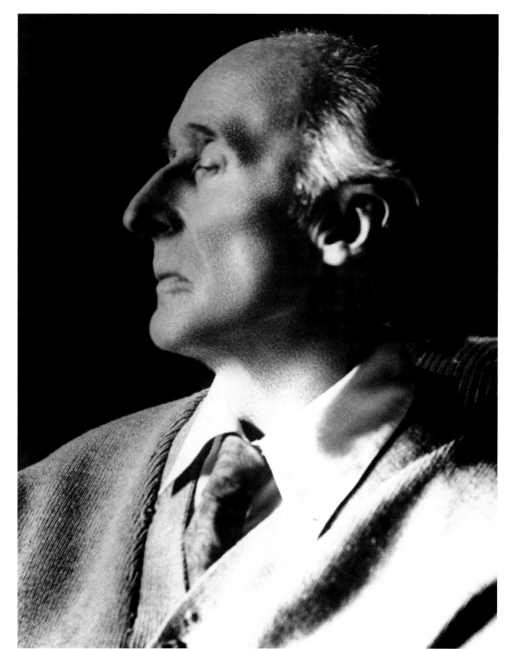

FREDERICK DELIUS

The noble profile of composer Frederick Delius (1862–1934), whose syphilis-induced blindness and physical paralysis in later life did little to stem the flow of his music. The most important works of the Yorkshireman's latter years – including *A Song for Summer*, *Caprice* and *Elegy and Idyll* – were dictated to his personal assistant, Eric Fenby. Fenby's account of his extraordinary life with Delius was made into a movie, *Song of Summer*, by the controversial director Ken Russell in 1968.

30th January, 1932

JUDI DENCH

Below: Clad in fishnet tights, Judi Dench in her provocative role as the amoral 'Sally Bowles' in the musical *Cabaret* at the Palace Theatre, London. The much-loved British star created the role on the West End stage, although she was so nervous that she auditioned hiding in the wings. She went on to become Britain's leading actress, earning an Oscar, ten BAFTAs, seven Olivier Awards, two Golden Globes, two Screen Actors Guild Awards and a Tony.

27th February, 1968

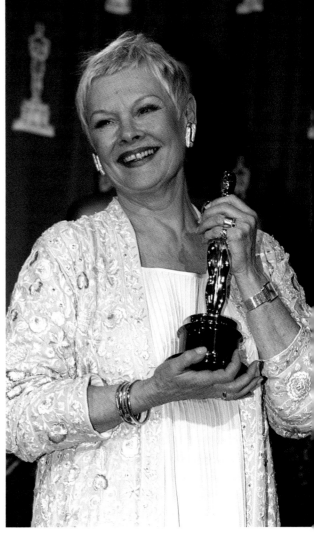

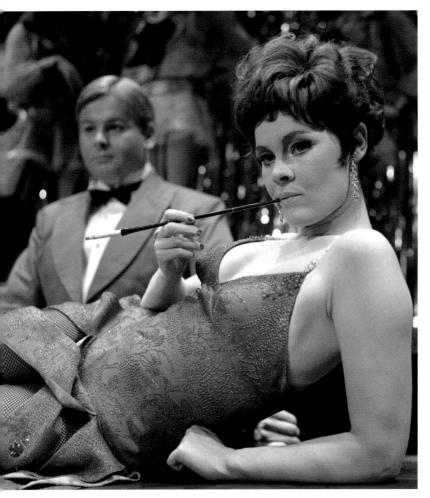

Above: Dame Judi Dench (born 1934) with her Oscar for Best Supporting Actress at the 71st annual Academy Awards ceremony in Los Angeles. Dame Judi won the award for her role as Queen Elizabeth I in the romantic comedy *Shakespeare in Love*.

22nd March, 1999

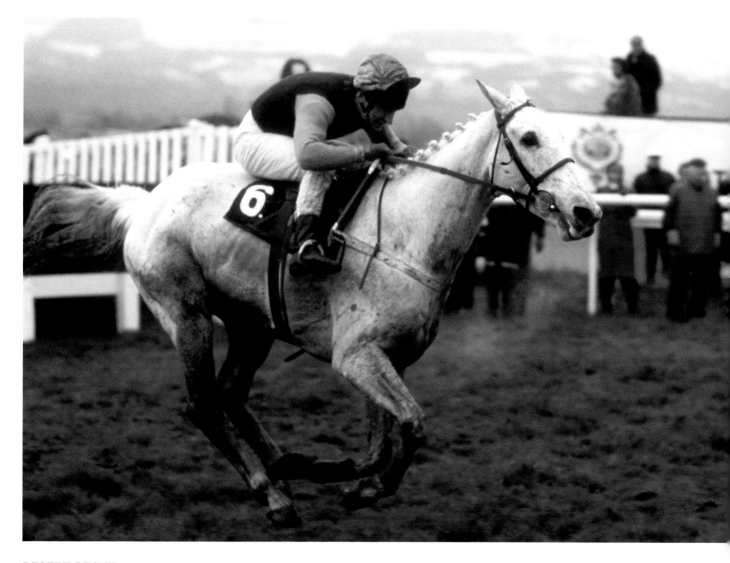

DESERT ORCHID
Desert Orchid, ridden by Simon Sherwood, races to victory in the Cheltenham Gold Cup. 'Dessie' (1979–2006) won 34 of his 70 races and epitomised a modern top-class chaser. He retired in 1991 and raised thousands of pounds for charity through personal appearances and racing calendars. When he died, the horse's ashes were scattered near his statue at Kempton Park Racecourse.
16th March, 1989

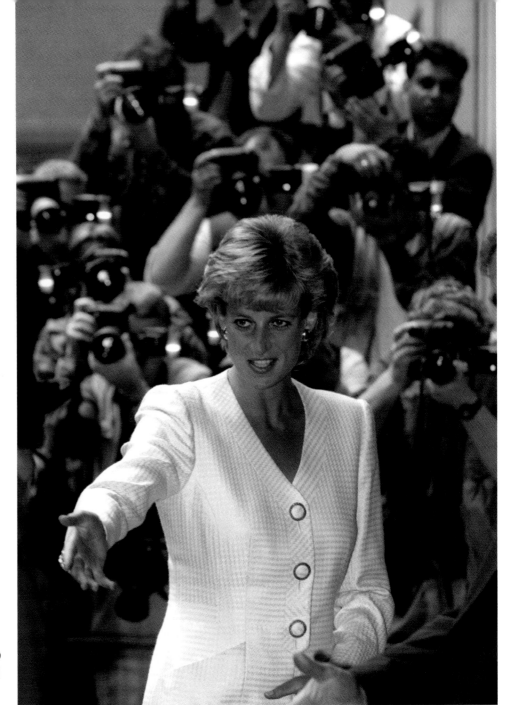

DIANA, PRINCESS OF WALES

'The People's Princess', HRH Princess Diana visiting the Mortimer Market Centre, a clinic for HIV/ AIDS sufferers in London, where she met some of the patients. The Princess (1961–97) had a special interest in health-related matters and was patron of many charities set up to help the homeless, children, drug addicts and the elderly.

27th June, 1996

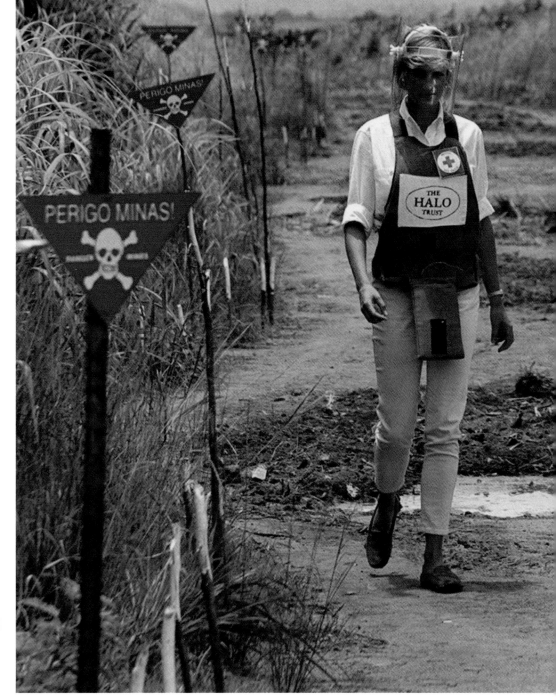

Diana, Princess of Wales, wearing body armour, cuts a lonely figure as she walks through a minefield during a visit to Huambo in Angola. Her high-profile support of the International Campaign to Ban Landmines led to the campaign being awarded the Nobel Peace Prize a year after her untimely death in 1997.

15th January, 1997

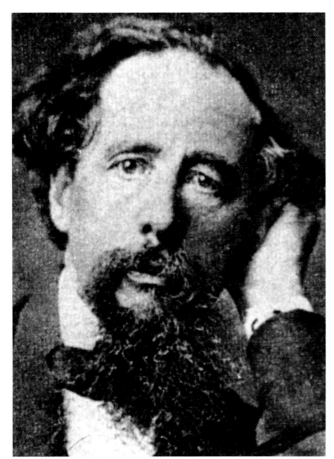

BENJAMIN DISRAELI

Below: Benjamin Disraeli (1804–81), the 1st Earl of Beaconsfield, held the position of Prime Minister twice in his long and distinguished career as a Conservative politician. He was elected following Prime Minister Edward Stanley's resignation in 1868, but the Conservatives were trounced by William Gladstone's Liberal party in the General Election that followed. After six years in opposition, Disraeli again became Prime Minister in 1874 and introduced a number of key social reform bills that improved the security of workers.
1873

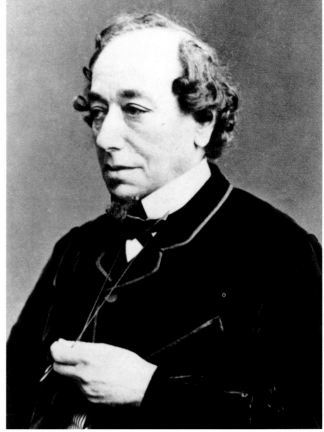

CHARLES DICKENS

Above: The books of prolific author Charles Dickens (1812–70), whose novels graphically portray social deprivation in Victorian London, are considered to be among the finest works of literature ever written. The photograph was taken two years before his untimely death at the age of 58, following a stroke. Dickens did not complete his final novel, *The Mystery of Edwin Drood*, and so the identity of the murderer in this classic detective story remains a tantalizing mystery.
9th June, 1870

DIANA DORS

British film actress, Diana
Mary Fluck (1931–84)
– Diana Dors to her
fans – poses in a daring
green dress. The blonde
bombshell's undoubted
acting talent was eclipsed
by her raunchy image
and shameless quest for
newspaper headlines. She
made more than 70 films
and married three times –
always in a blaze of publicity
– but as she became older
and her figure filled out, her
genuine talent as a character
actress emerged.
1958

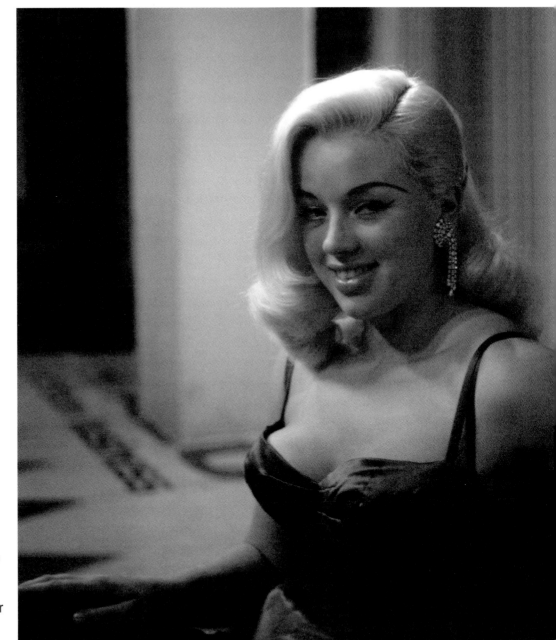

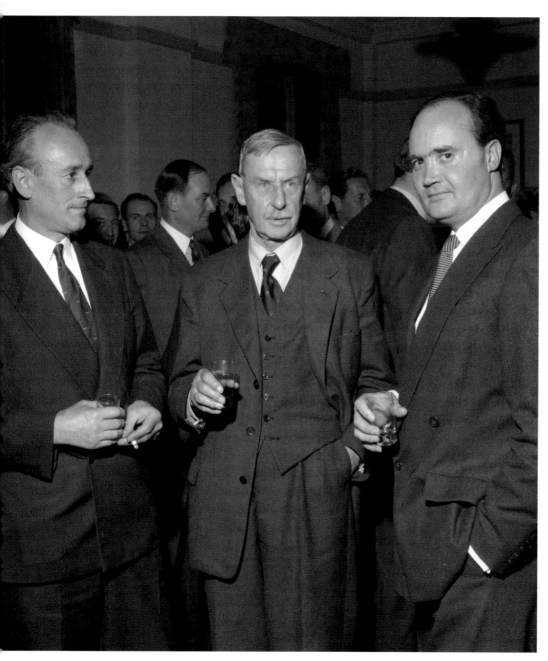

HUGH DOWDING

Air Chief Marshal Sir Hugh Dowding (C) flanked by Wing Commander J.G. 'Sandy' Sanders (L) and Group Captain Brian Kingcome (R) attend the RAF World War II Annual Reunion at RAF station Biggin Hill. All three were highly commended heroes of the Battle of Britain. Dowding, 1st Baron Dowding (1882–1970), was the commander of RAF Fighter Command during the battle. Nicknamed 'Stuffy' by his airmen, Dowding displayed meticulous preparation of Britain's air defences for the assault by the German *Luftwaffe*, and prudent management of resources. He is widely credited for Britain's victory in the battle.

15th September, 1954

GEOFF DUKE

Right: Geoff Duke (born 1923) in action at Silverstone race circuit on his Norton motorcycle. 'The Duke', as he was affectionately known, dominated motorcycling in the 1950s. He won six world motorcycle championships and changed the look of racing by being the first rider to wear all-in-one leathers, which he had run up by a local tailor. He was declared Sportsman of the Year in 1951 and received the OBE two years later. Duke became a businessman after retiring from racing.
22nd April, 1950

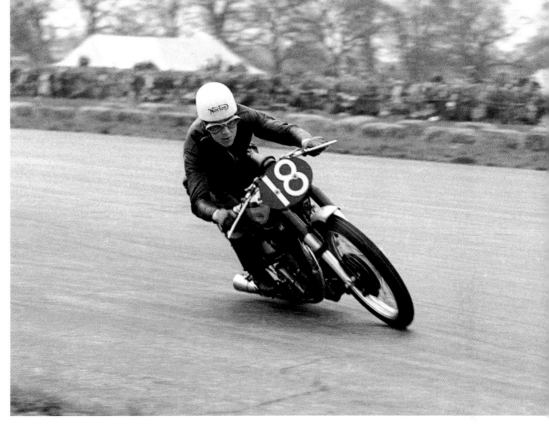

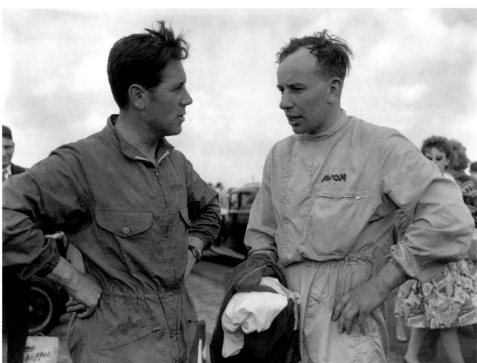

Left: Former motorcycle champion Geoff Duke (L) chats to World Champion motorcyclist John Surtees, after both had taken part in a Formula Junior car race at Silverstone Circuit. Unlike Surtees, who went on to become a Formula One champion racing driver, Duke's career racing cars never took off.
14th May, 1960

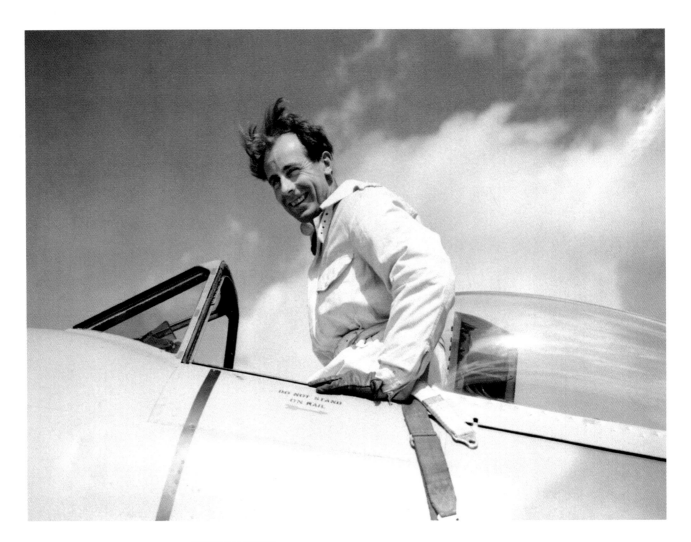

NEVILLE DUKE

Squadron Leader Neville Duke, DSO, in the cockpit of a Hawker Fury fighter plane. Duke (1922–2007) was an RAF ace fighter pilot who made the first flight of the prototype Hawker Hunter at Boscombe Down in Wiltshire. The Hunter was Britain's most successful post-war fighter design and became the standard RAF fighter of the 1950s. In 1953, Duke set a new world air speed record of 727.63mph flying the Hunter WB188 and was awarded the OBE for his efforts.

31st December, 1952

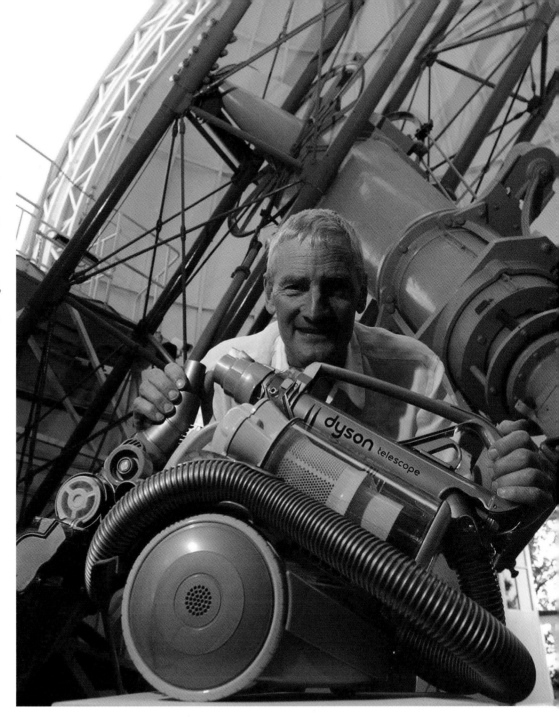

JAMES DYSON

Inventor Sir James Dyson with his new Telescope Dyson Cleaner, photographed inside the Royal Observatory at Greenwich. In the late 1970s, Dyson (born 1947) created a bagless vacuum cleaner that used cyclonic separation to pick up dirt without losing suction power. Unable to convince any major manufacturers of its potential, he decided to set up his own manufacturing company. The Dyson was an instant hit and he is now estimated to be worth £1.1bn.

17th September, 2003

EDDIE 'THE EAGLE' EDWARDS

Britain's top ski jumper Eddie 'The Eagle' Edwards takes advantage of his new-found fame at the Winter Olympics in Calgary. Edwards (born 1963) had the dubious distinction of coming last in both the 70m and 90m jumps, but his amateurish performance and goofiness endeared him to millions. At the closing of the games, the 100,000-strong crowd chanted his name. Following his crushing defeat, the ski jump entry rules were changed to avoid an embarrassing repeat performance.

16th February, 1988

GARETH EDWARDS
Gareth Edwards in action for Wales against Scotland in the Five Nations Championship at Cardiff Arms Park. During the golden age of Welsh rugby, the scrum-half (born 1947) was declared by the BBC to be *"the greatest player ever to don a Welsh jersey."* Will Carling, former England rugby captain, also named him as his *"greatest ever player"* in 2007, while *The Daily Telegraph* gushed, *"He played in the 1970s, but if he played now he would still be the best."*
25th March, 1972

EDWARD ELGAR

"I've got a tune that will knock 'em – knock 'em flat! A tune like that comes once in a lifetime." Thus prophesized the composer Sir Edward Elgar OM, GCVO (1857–1934), pictured at Crowborough, Sussex, of his five Pomp and Circumstance Marches. He was proved correct. The middle section evolved into the perennial Proms standard and heart-swelling British crowd pleaser, *Land of Hope and Glory.*

19th August, 1922

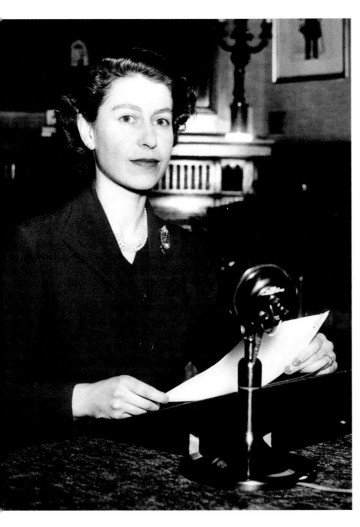

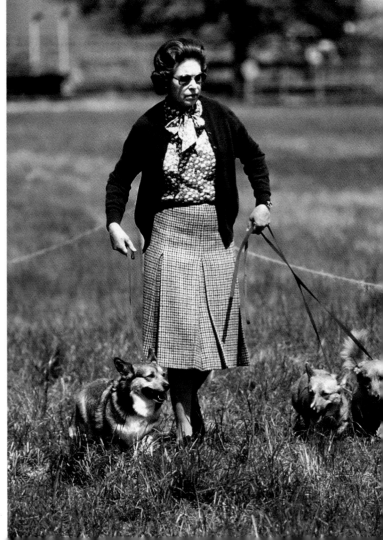

The Queen with her corgis walking the cross-country course during the second day of the Windsor Horse Trials. Animal lover Queen Elizabeth II (who's also an expert equestrian) elevated the Welsh corgi to icon status, after her father, King George VI, brought the breed into the family in 1933
17th May, 1980

QUEEN ELIZABETH II
Above: HRH Queen Elizabeth II (born 1926) makes her first Christmas radio broadcast at Sandringham House. Elizabeth was crowned Queen of the United Kingdom, and Head of the Commonwealth, in Westminster Abbey on 2nd June, 1953 at the age of 27, the 40th monarch since William the Conqueror, and the great-great granddaughter of Queen Victoria.
26th December, 1952

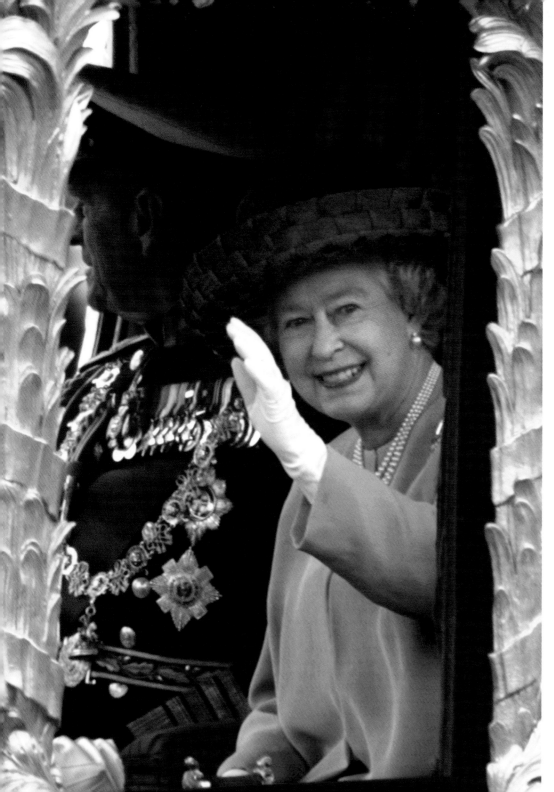

QUEEN ELIZABETH II

A smiling Queen Elizabeth II waves to the crowd as she travels from Buckingham Palace to St Paul's Cathedral for a service of Thanksgiving to celebrate her Golden Jubilee. The Gold State Coach was built for King George III in 1762, and has only been used by the Queen twice before – for her Coronation and her Silver Jubilee. Later, more than one million people gathered for the Party in the Palace concert, held in the Queen's honour. She celebrated her 80th birthday in 2006, and in 2012 will celebrate 60 years on the throne, equalling Victoria as the only British monarch to have celebrated a Diamond Jubilee.

4th June, 2002

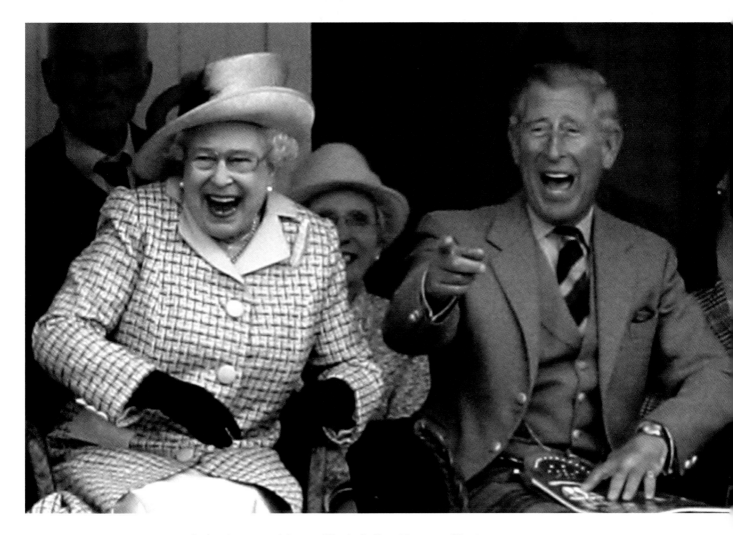

A clearly amused Queen Elizabeth II and her son, Charles, Prince of Wales, attend the Braemar Highland Games at the Princess Royal and Duke of Fife Memorial Park in Aberdeenshire. The royals have been regular visitors to the Games since Queen Victoria first attended in 1848.

2nd September, 2006

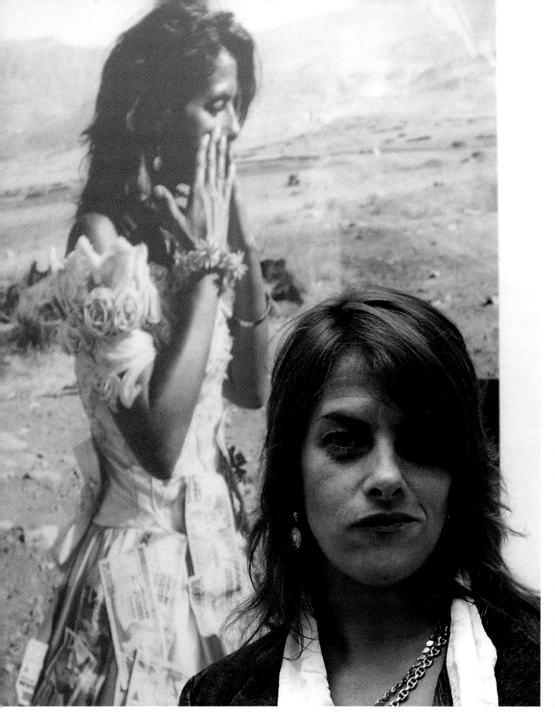

TRACEY EMIN

Artist Tracey Emin (born 1963) poses in front of a still from her film, *Sometimes the Dress is Worth More Money Than the Money,* part of her new exhibition in west London. The controversial artist regularly uses her personal experiences in her work: a pack of cigarettes held by her uncle when he was decapitated in a car accident, her soiled bed and a blue tent appliquéd with the names of all the people she had ever slept with.
21st May, 2004

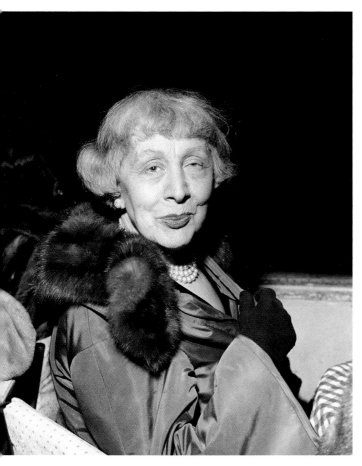

EDITH EVANS

Dame Edith Evans (1888–1976) as the formidable 'Lady Bracknell' in *The Importance of Being Earnest*. An experienced Shakespearian actor, Evans was forever associated with the role of 'dragon lady' following her performance in the 1952 film, something she found frustrating. Oscar-nominated twice, she showed her versatility in *The Nun's Story* and *Look Back in Anger*. Childless, she offered the opinion that *"actresses do not, perhaps, make ideal parents."*

15th November, 1962

MARTIN EVANS

Winner of the Nobel Prize for Medicine, Sir Martin Evans, in Cambridge. The British scientist was one of three people awarded a Nobel Prize for work on the 'knockout mouse', which revolutionized biomedicine. Evans (born 1941), a professor of mammalian genetics at Cardiff University, played a key role in the creation of genetically engineered mice that can replicate human diseases and thus aid scientists in finding new medical treatments.

8th October, 2007

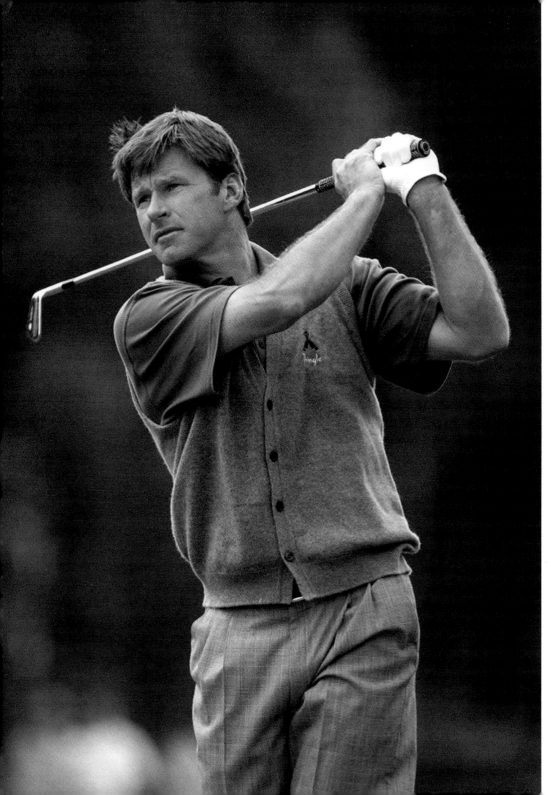

NICK FALDO
British golfer Nick Faldo
rose to prominence in the
1980s–90s, emerging as
one of Europe's greatest
players, with success in the
US Masters, British Open,
US Open and Professional
Golfer's Association
Championship. Faldo (born
1957) won the Masters and
British Open titles three
times and at one point was
ranked the world's number-
one golfer. Divorced several
times, Faldo is now a sports
commentator. He was
knighted in 2009.
29th May, 1995

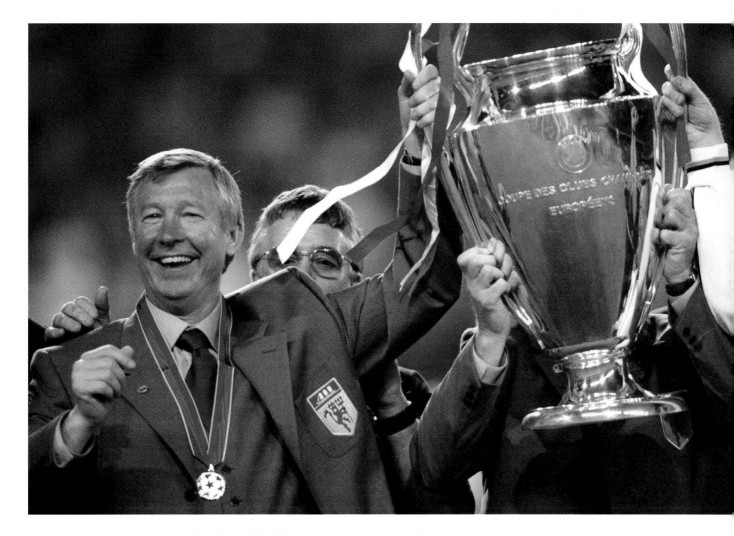

ALEX FERGUSON

Manchester United manager Alex Ferguson celebrates with officials after his team beat Bayern Munich in the UEFA Champions League Final. The team's manager since 1986, Ferguson (born 1941) is the second longest-serving manager in Manchester United's history (after Sir Matt Busby). He has collected numerous awards during his tenure, including winning the title of Manager of the Year more times than anyone else. The Glaswegian was knighted in 1999.

26th May, 1999

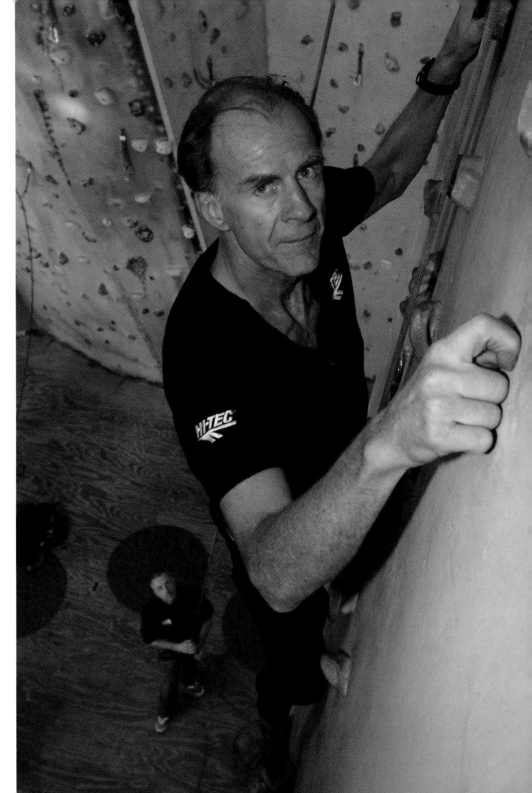

RANULPH FIENNES
British explorer Sir Ranulph Fiennes, during a training session at Bristol's undercover rock climbing centre. The 62-year-old was preparing for one of his most difficult challenges, an attempt to climb the notorious 6,000ft North Face of the Eiger in Switzerland, despite having a morbid fear of heights. The adventurer (born 1944) raised £1.5m for Marie Curie Cancer Care when he successfully conquered the perilous mountain.
5th December, 2006

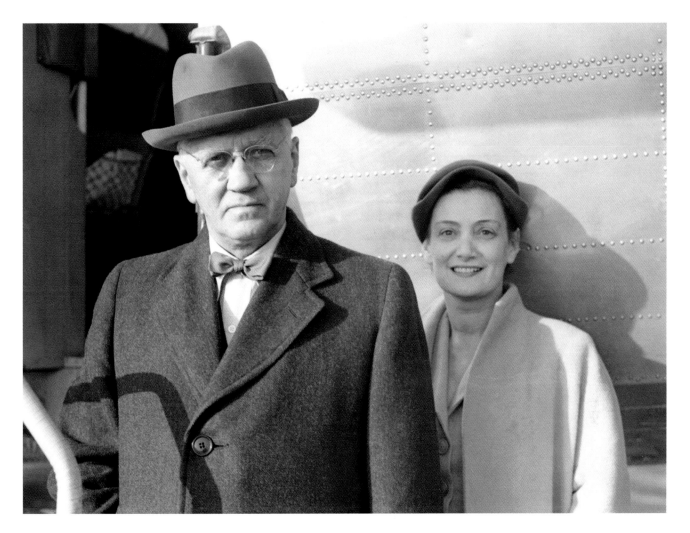

ALEXANDER FLEMING

Sir Alexander Fleming (1881–1955), the Scottish bacteriologist who discovered penicillin, pictured with his wife, Lady Fleming, boarding a flight from London to Paris in the year he died. Penicillin reversed a myriad of life-threatening bacterial infections, including tuberculosis and syphilis. Awarded the Nobel Prize for his contribution to medicine a decade earlier, Fleming was named one of the 100 Most Important People of the 20th Century by *Time* magazine in 1999.

1955

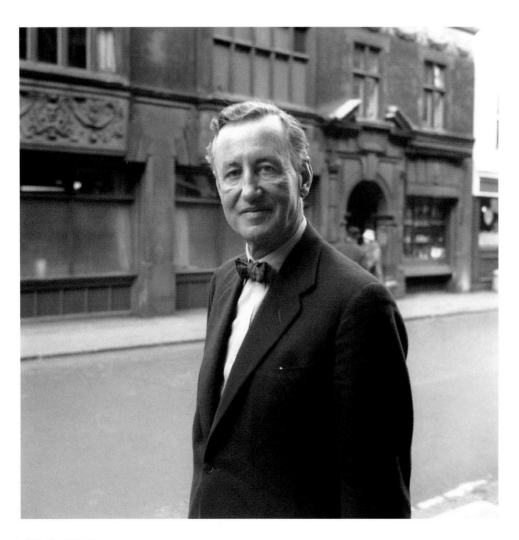

IAN FLEMING

Suave in bow tie, Ian Fleming (1908–64), creator of the James Bond spy books, stares into the lens. After failing to enter the Foreign Service, Fleming became a Reuters journalist, then a banker, before joining Naval Intelligence in Whitehall. He purchased his Jamaican hideaway, 'Goldeneye', in 1946 and began writing some of the most successful thrillers ever published – *Casino Royale*, *Doctor No* and the 1961 offering *Thunderball* among them. He also wrote the children's fantasy *Chitty Chitty Bang Bang*.

24th March, 1961

ANDREW FLINTOFF

England's Andrew 'Freddie' Flintoff cannot disguise his joy after dismissing Australia's Shane Warne in the Third Test of The Ashes at Old Trafford. The final result of the series was a 2–1 win for England, with Flintoff declared Man of the Match. The fast bowler, slip fielder and batsman (born 1977) became a key member of the England cricket squad in 1998 and was made captain of the team in 2006. He retired from cricket due to injury in 2010.

15th August, 2005

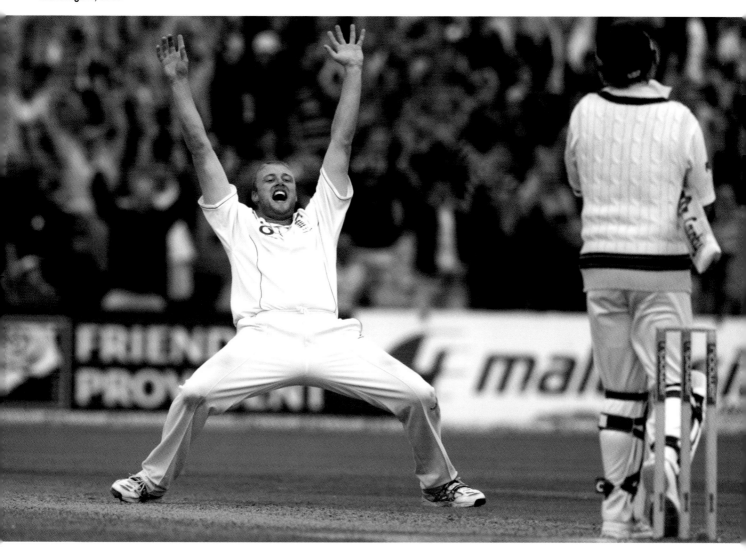

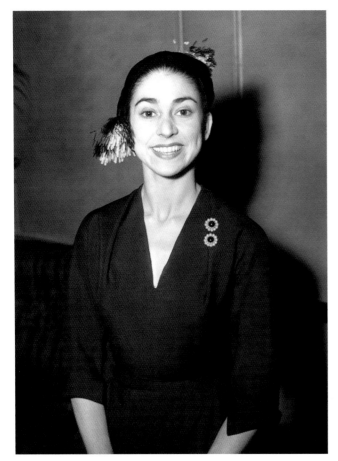

Below: Margot Fonteyn, Ballerina Absoluta, and her dancing partner Rudolf Nureyev in the Roland Petit ballet, *Pelleas et Melisande*, composed by Claude Debussy. Fonteyn and Nureyev were close friends and fiercely protective of one another. The Russian once said of the British dancer, *"When she left the stage in her great white tutu, I would have followed her to the end of the world."*
24th March, 1969

MARGOT FONTEYN

Margot Fonteyn (1919–91), *première danseuse* of the Sadlers Wells Ballet, looks elegant in Covent Garden, wearing a velvet hat trimmed with sprays. Fonteyn was one of the greatest dancers of the age and the prima ballerina of the second half of the century. Despite their 20-year age difference, her stellar partnership with Rudolf Nureyev is the stuff of legend, while the exploits of her husband, the controversial Panamanian diplomat 'Tito' de Arias, kept her life on the front pages.
24th August, 1950

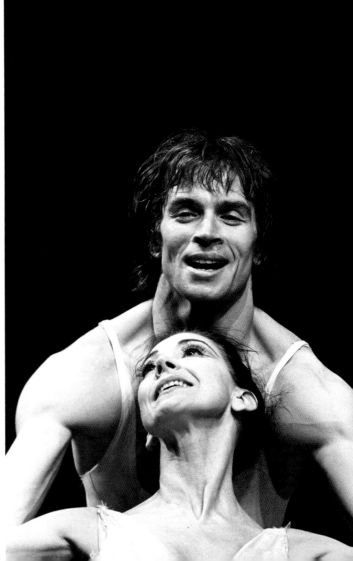

BRUCE FORSYTH

The veteran entertainer Bruce Forsyth is joined by Miss Puerto Rico (L) and Miss England to celebrate his 80th birthday at the Dorchester Hotel in London. 'Brucie' (born 1928) has been a household name in Great Britain for more than half a century, fronting a string of hit family shows, including *The Generation Game*, *Play Your Cards Right* and *Strictly Come Dancing*. The consummate showman is famous for his many catchphrases, among them *"Didn't they do well?"*

22nd February, 2008

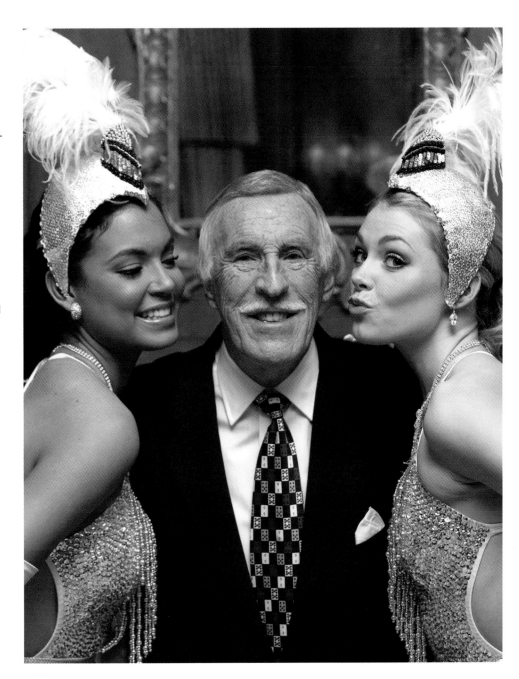

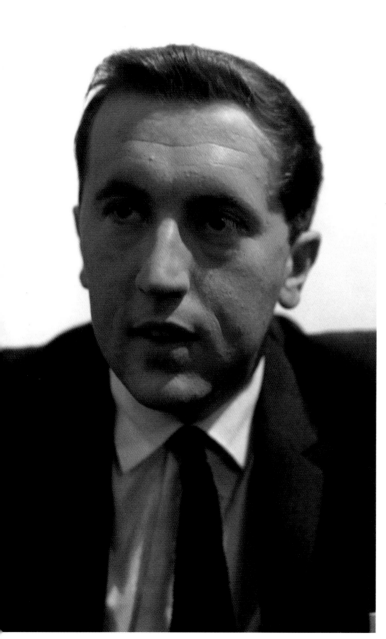

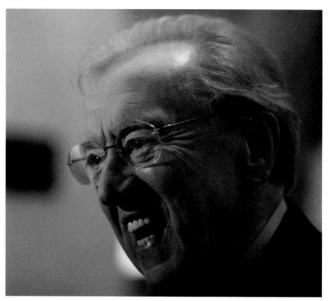

DAVID FROST

Left: David Frost (born 1939) appearing in the innovative 'live' satire show *That Was The Week That Was*. Designed to 'prick the pomposity of public figures', TW3 was unlike anything previously on British television, a chaotic medley of topical comment, satire, audience debate, comedy and song. Thanks to TW3 and the subsequent *The Frost Report*, Frost, who had trained for a while as a Methodist preacher, came to be considered by many as the 'father' of political satire.
14th January, 1963

Above: A laughing Sir David Frost, after being given the Harvey Lee Award for Outstanding Achievement, at the Theatre Royal in London. Frost has conducted countless high-profile interviews, the most notable of which were his post-Watergate meetings with disgraced US President Richard Nixon (1977). The interviews were made into a movie, *Frost/Nixon*, in 2008.
27th March, 2009

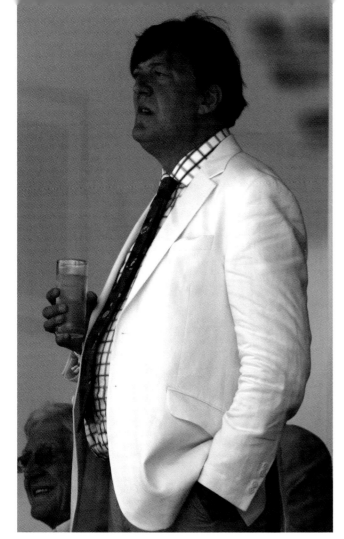

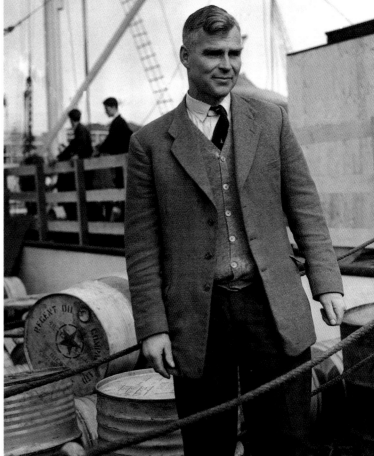

STEPHEN FRY

The talented thespian Stephen Fry avidly watches the action on the cricket pitch as England plays Australia at Lord's. Fry is a multi-faceted actor, comedian, author, director and journalist – to list just some of his accomplishments. Born in 1957, he is considered a 'national treasure' for his quintessential Englishness, intelligent wit, gentle demeanour and perfect diction. He is allergic to champagne and bumblebee stings.

3rd July, 2010

VIVIAN FUCHS

Dr Vivian Fuchs (1908–99), leader of the British Trans-Antarctic Expedition, aboard his ship *Theron*. His team successfully completed the first overland crossing of Antarctica via the South Pole in 1958, and Fuchs received a Knighthood for his achievement. Following his retirement from the British Antarctic Survey in 1973, Fuchs became president of the Royal Geographical Society.

12th November, 1955

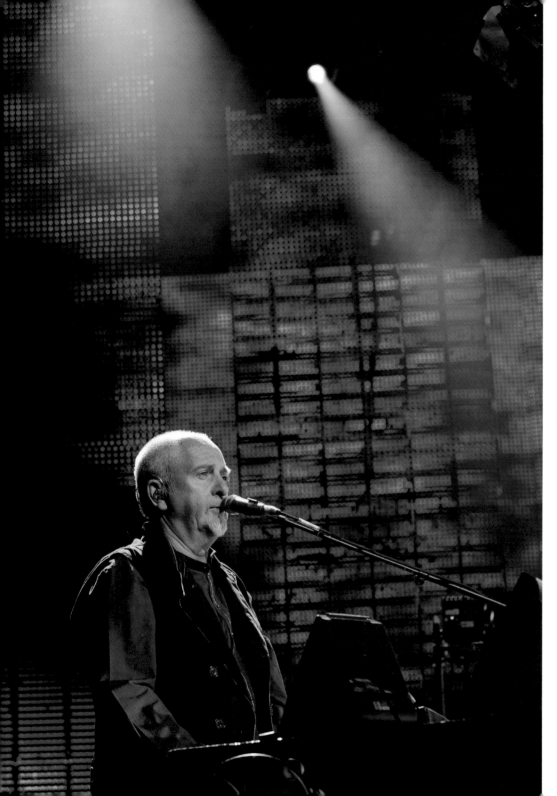

PETER GABRIEL
Singer, songwriter and musician Peter Gabriel performs on the open-air stage during the WOMAD Festival at Charlton Park in Wiltshire. A musical chameleon who fronted the band Genesis in the 1970s, he created the WOMAD – World of Music and Dance – Festival in 1980, along with Thomas Brooman and Bob Hooton. Gabriel (born 1950) has had many solo hits, notably *Sledgehammer* and *Games Without Frontiers*, and has collaborated with musicians as diverse as Kate Bush, Laurie Anderson and Papa Wemba.
25th July, 2009

KING GEORGE VI

"God save the King!" Clad in ermine, velvet and priceless jewels, the newly-crowned and renamed King George VI (1895–1952) with Queen Elizabeth and their daughters, Princess Elizabeth (R) and Princess Margaret Rose, after the Coronation of Albert, Duke of York. The event followed the abdication of the King's older brother, Edward VIII, who created a constitutional crisis by ditching the monarchy for his 'unsuitable' consort, the American divorcee Wallis Simpson.
12th May, 1937

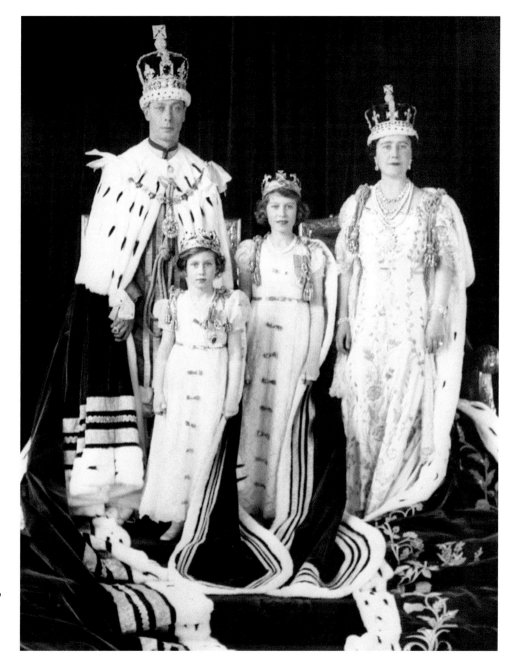

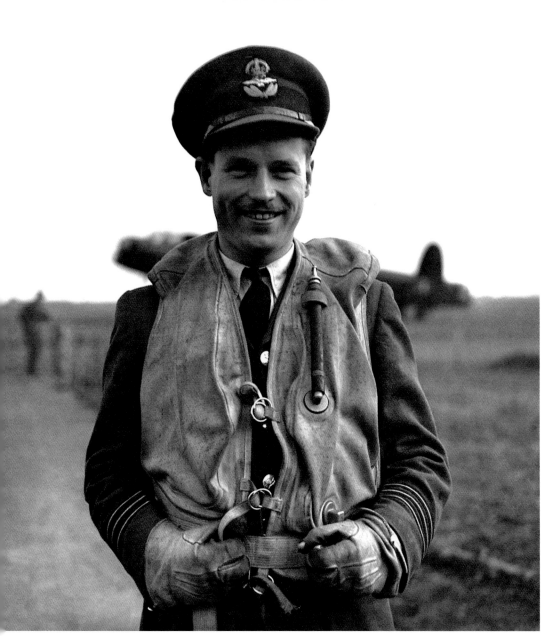

GUY GIBSON

Dashing Wing Commander Guy Gibson (1918–44), DFC and bar, of 106 Squadron RAF. Originally rejected by the RAF for being too short, Gibson went straight into battle the day war was declared. He led a daylight Lancaster bomber raid on Milan, involving a round flight of 1,500 miles over the Alps and, most famously, led the 'Dambusters' raid in 1943, using bouncing bombs to destroy the Möhne and Eder Dams in Germany (for which he received the VC). He was killed in action over Holland, aged 26.

26th October, 1942

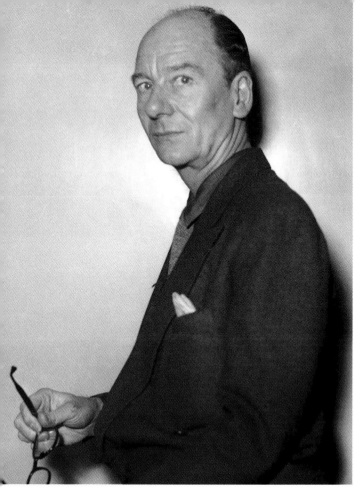

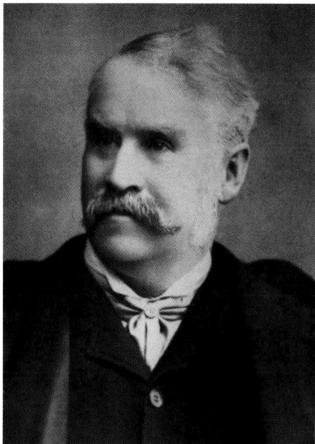

WILLIAM GILBERT

Below: Sir William Schwenck Gilbert (1838–1911), English dramatist, wrote 14 operatic comedies with the composer Sir Arthur S. Sullivan. Initially declared 'shocking', largely due to Gilbert's acerbic lyrics, the operas gradually charmed the Victorian public, and outrage gave way to immense affection and good-humoured indulgence. Gilbert's only successful drama, *The Hooligan*, a short play about a condemned man, was produced four months before his death in 1911. It was reported to be so powerful that women in the audience fainted.
1886

JOHN GIELGUD

Above: The celebrated thespian Sir John Gielgud (1904–2000) looks warily at the camera during rehearsals for the ITV play *A Day by the Sea*. Shaken by his recent arrest for 'importuning for immoral purposes' in a public lavatory, Gielgud would eventually recover from the scandal and go on to become one of the few actors to receive Academy, Emmy, Tony and Grammy Awards for his work in productions such as *Becket*, *Hamlet*, *Brideshead Revisited*, *Ages of Man* and *Arthur*.
24th March, 1953

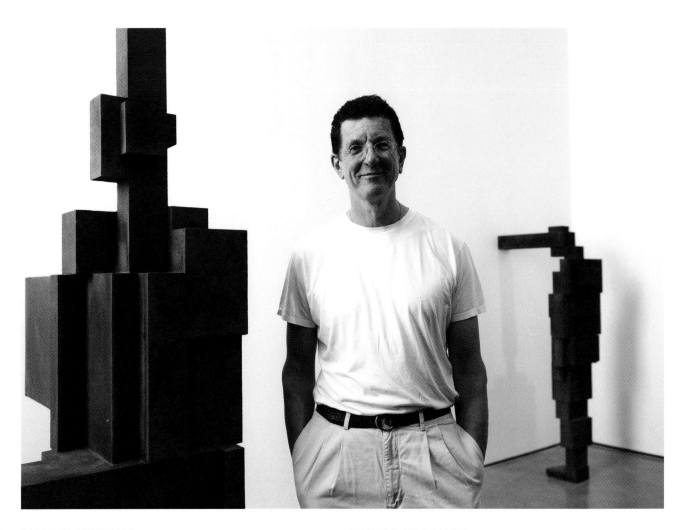

ANTONY GORMLEY
Sculptor Antony Gormley (born 1950) at the White Cube gallery in London, amidst a series of untitled works in cast iron. Gormley's best-known sculptures are the giant, winged *Angel of the North* and *Another Place*, on Crosby Beach, near Liverpool, where 100 of his cast-iron figures stare out to sea. He won the Turner Prize in 1994 for his *Field for the British Isles* – 35,000 miniature terracotta figures that filled the floor of a room, gazing blankly up at the viewer.
3rd June, 2010

DUNCAN GOODHEW
Facing page: The familiar bald pate of Great Britain's Duncan Goodhew emerges from the water as he storms to victory in the Men's 100m Breaststroke at the 1980 Moscow Olympics. Goodhew (born 1957) suffered from alopecia, which gave him a slight hydrodynamic advantage when swimming, as he was completely hairless.
22nd July, 1980

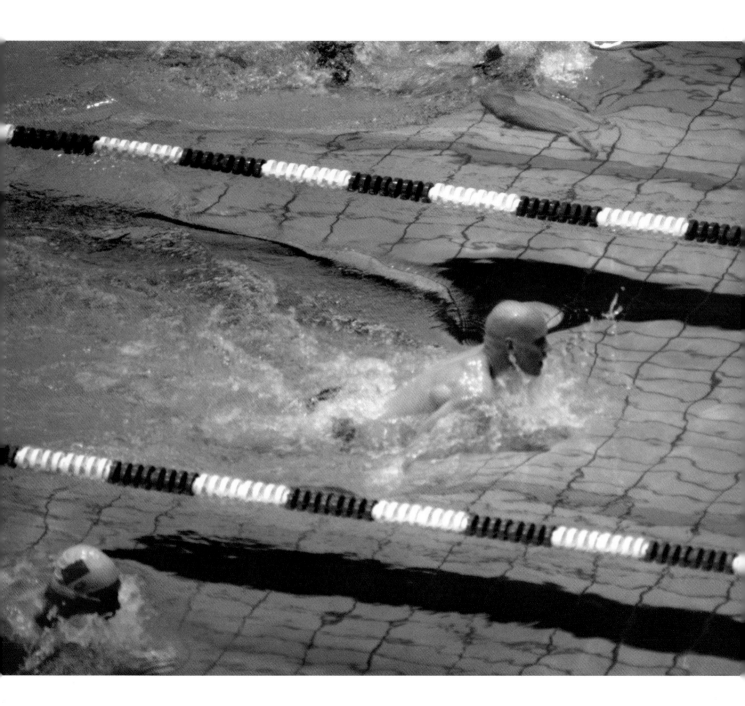

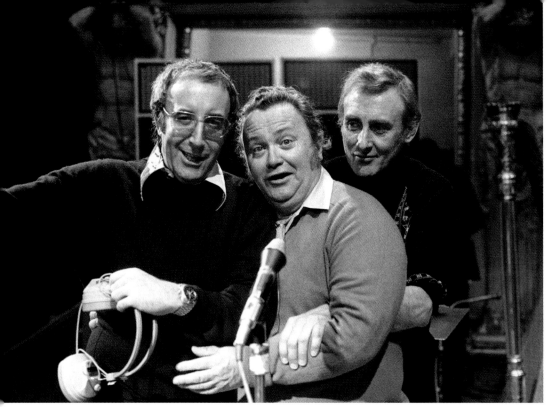

THE GOONS

Left: (L–R) Peter Sellers, Harry Secombe and Spike Milligan, the original 'Goons', reunited for the first time in 12 years for the BBC's 50th anniversary celebrations. *The Goon Show* was broadcast throughout the 1950s, combining Milligan's farcical scripts with catchphrases *("He's fallen in the water!")*, bizarre sound effects and odd characters with names such as 'Neddie Seagoon', 'Minnie Bannister' and 'Hercules Grytpype-Thynne'. HRH Prince Charles is a life-long 'Goons' fan.
30th April, 1972

W.G. GRACE

Right: The celebrated English cricketer William Gilbert Grace (1848–1915). He played in the first Test match in England against Australia in 1880 at the Oval and scored the first Test century by an English batsman. Although a powerful sportsman, W.G. Grace did not possess the traditional svelte figure of an athlete. He was often described as a 'pot-bellied genius' and was reputedly too heavy in middle age for a horse to carry him.
1905

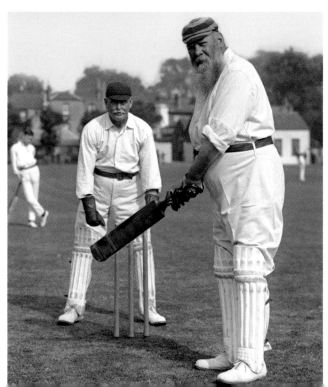

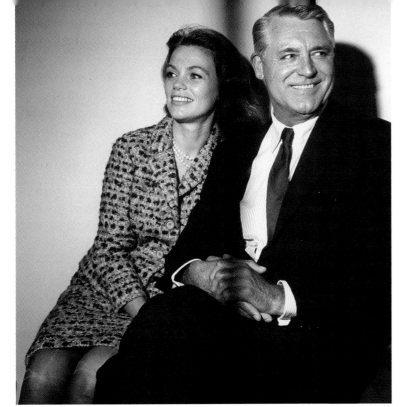

CARY GRANT
Left: Actor Cary Grant (1904–86) and his fourth wife, actress Dyan Cannon, at the Savoy Hotel in London. Grant was in town to promote his latest film, *Walk Don't Run*. Born Archibald Leach in Bristol, Grant came second in the American Film Institute's list of Greatest Male Stars of All Time (after Humphrey Bogart). Mae West is credited with giving Grant his big break when she cast him in the movies *She Done Him Wrong* and *I'm No Angel*.
3rd August, 1966

ROBERT GRAVES
Right: On the south bank of the Thames, poet, translator and novelist Robert Ranke Graves (1895–1985) signs copies of a poem he wrote to commemorate Shakespeare's birthday, which will be read at a concert in Southwark Cathedral. The prolific writer produced more than 140 works; his poems, together with interpretations of the Greek Myths, a memoir of his early life and *Good-bye to All That* are modern classics. His historical novels include *I, Claudius*, *King Jesus* and *The Golden Fleece*.
21st April, 1972

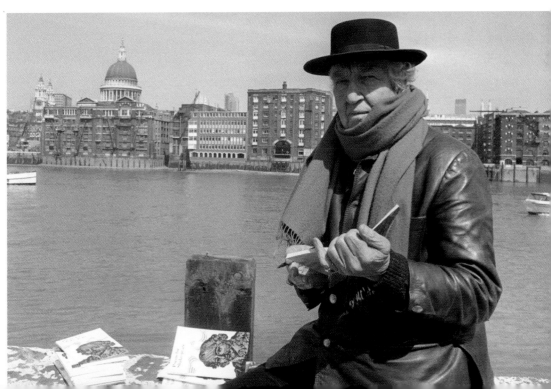

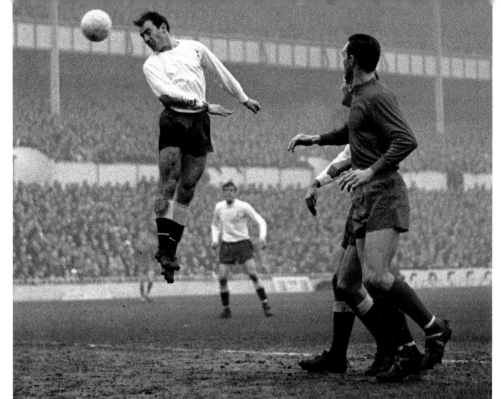

JIMMY GREAVES

Left: Spurs' Jimmy Greaves (L) – the 'goal machine' – leaps for the ball and scores in a match against West Bromwich at White Hart Lane in London. Born in 1940, Greaves is England's third highest scoring footballer and is considered one of the finest players of his generation. After retiring and winning a long-running battle against alcohol addiction, Greaves became a popular TV football pundit, famous for the catchphrase, *"It's a funny old game…"*
27th December, 1966

ANDY GREEN

Right: RAF Squadron Leader Andy Green (born 1962) perches on the body of the supersonic Thrust SSC car, prior to his test run at the Defence Research Agency at Farnborough, Hampshire. On 15th October, 1997, 50 years and one day after the sound barrier was broken in aerial flight by Chuck Yeager, Green reached 763.035mph (1227.99km/h), in the Black Rock Desert, Nevada, USA, the first supersonic ground record (Mach 1.016).
14th October, 1996

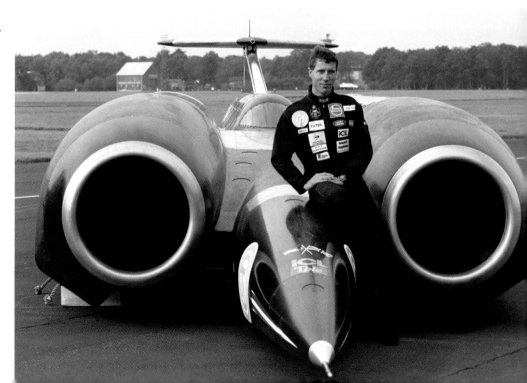

GRAHAM GREENE

Author Graham Greene (1904–91), whose books include *Brighton Rock*, *The Third Man* and *The End of the Affair*. He was recruited to MI6 and worked for the Soviet double agent Kim Philby, who was one of many characters woven into the author's later work. Greene suffered from bipolar disorder, which coloured his daily life and had a profound effect on his novels. He famously wrote, *"In human relationships, kindness and lies are worth a thousand truths."*

22nd February, 1984

TANNI GREY-THOMPSON

Below: Great Britain's Tanni Grey-Thompson celebrates winning the gold medal in the Women's Wheelchair T53 100m race at the Athens Paralympic Games. The remarkable Welsh athlete and TV presenter was born with spina bifida in 1969. She began her Olympic career in Seoul in 1988 and has since amassed 16 Paralympic medals – 11 gold, four silver and a bronze. She was made a Dame of the British Empire in 2005 and a life peer in the House of Lords in 2010.

23rd September, 2004

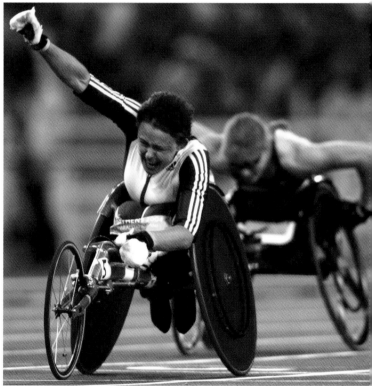

JOYCE GRENFELL

Above: Accomplished actress and writer Joyce Grenfell (1910–79) arrives at Southampton from New York, following a tour of the USA. The niece of Nancy Astor, Grenfell appeared in a string of films, including the St Trinians' series, during the 1950s. She is best remembered for her one-woman shows and her witty, observant, self-penned monologues. She lost an eye to cancer in 1973 and wore an artificial one for the rest of her career, although only those closest to her ever knew.

2nd May, 1960

ALEC GUINNESS

Actor Alec Guinness during a rehearsal for Alan Bennett's play *Habeus Corpus* at the Lyric Theatre, London. The former advertising executive and Royal Navy seaman (1914–2000) began his film career after the Second World War. Known for his versatility, he starred in a string of successful movies, including *The Lavender Hill Mob*, *Lawrence of Arabia* and *Dr Zhivago*, and won many awards, including a Tony and two Academy Awards.

7th August, 2000

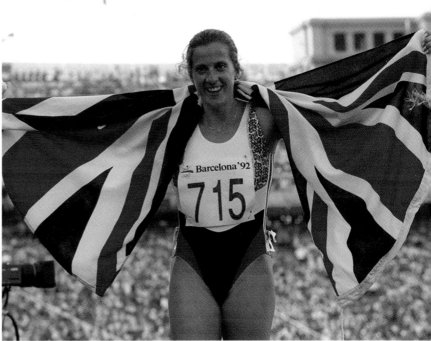

SALLY GUNNELL

A delighted Sally Gunnell of Great Britain (born 1966) celebrates after winning the Women's 400m Olympic hurdles final in Barcelona. She set the world record a year later in the same race at the World Championships. She remains the only woman to have held the 400m title in the Olympic, European, World and Commonwealth competitions.

5th August, 1992

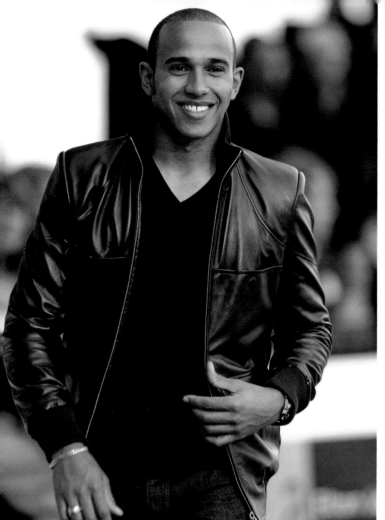

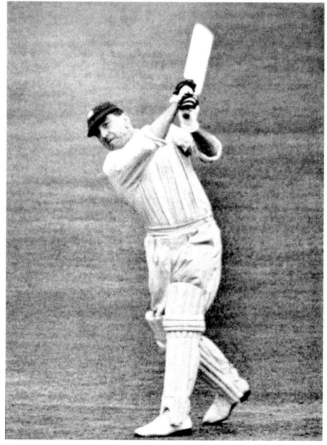

WALLY HAMMOND

Below: Wally Hammond (1903–65), described as one of the four best batsmen in the history of English cricket, playing in the First Test during England v West Indies. He dominated cricket during the 1930s and was made captain in 1938. A notoriously truculent man, possibly as a result of mood-altering mercury, prescribed for a syphilis condition, and a known womanizer, he was not popular with his team-mates and suffered a messy divorce. Hammond was, however, 'a most exciting cricketer'.

26th June, 1933

LEWIS HAMILTON

Above: Unfamiliar out of his racing suit, Formula One World Champion Lewis Hamilton models at a fashion show in Monaco. Known for his confident, aggressive driving style, Lewis (born 1985) was the youngest ever Formula One champion, having taken the title with McLaren in 2008. He left the UK to live in Switzerland in 2007, citing media intrusion and tax concessions as his reasons for moving.

22nd May, 2009

TONY HANCOCK

Comedian Tony Hancock (1924–68) and (R) Sid James (1913–76) on the set of the BBC series *Hancock's Half Hour*. Acknowledged as the first British sitcom, 103 episodes were aired between November 1954 and December 1959, featuring a host of home-grown talent, including Kenneth Williams and Hattie Jacques.

27th November, 1957

Radio and TV star, Tony Hancock, voted Best Comedian of the Year in 1957 and 1959. His TV show, *Hancock's Half Hour*, could clear the streets of Britain, and skits such as 'The Blood Donor' and 'The Radio Ham' are bona fide comedy classics. Hancock was plagued by self-doubt, however, and regularly sacked his writers and co-stars, including Sid James. He committed suicide in Australia in 1968, leaving behind the note: *"Things just seemed to go wrong too many times."*

4th December, 1957

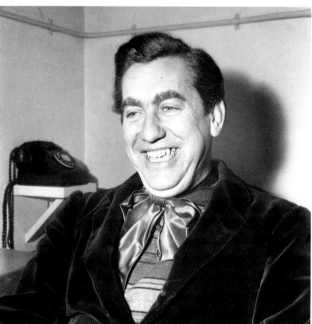

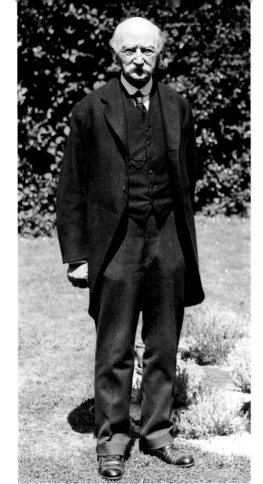

THOMAS HARDY

Novelist and poet Thomas Hardy (1840-1928) in the garden of his home, 'Max Gate', in Dorset, during a lunchtime visit by the Prince of Wales (who admitted that he had not read a single word of Hardy's works). The once radical-thinking author of classics such as *Tess of the d'Urbervilles*, *Far from the Madding Crowd* and *The Mayor of Casterbridge* appeared to have mellowed with age, declaring himself to be *"delighted"* that HM had popped in.
20th July, 1923

ALISON HARGREAVES

A mountain climber from Derbyshire, Alison Hargreaves was the first person to scale all six great north faces of the Alps in one season. The fearless adventurer (1963–95) reached the top of Mount Everest without the aid of oxygen or Sherpas in 1995, but was killed in a violent storm while descending from the summit.
12th February, 1993

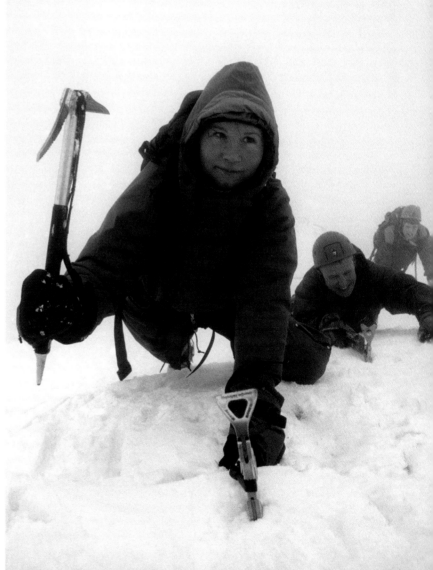

CAROLINE HASLETT

A fresh-faced Dame Caroline Haslett (1895–1957), pioneer in the field of electricity and the first secretary of the Women's Engineering Society, established in 1919 to inspire women as engineers, scientists and industry leaders. Haslett swapped ideas with Albert Einstein and Henry Ford, and was awarded a CBE for her work in electricity in 1931. Subsequently she was made a Dame Commander of the British Empire in 1947 for services to the Ministry of Labour and the Board of Trade.

1920

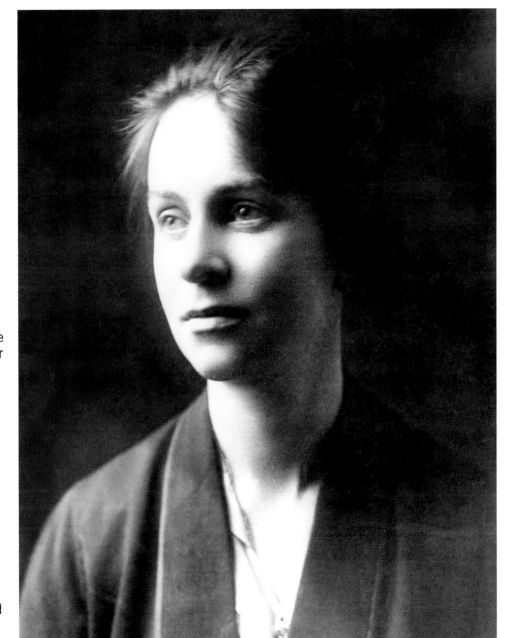

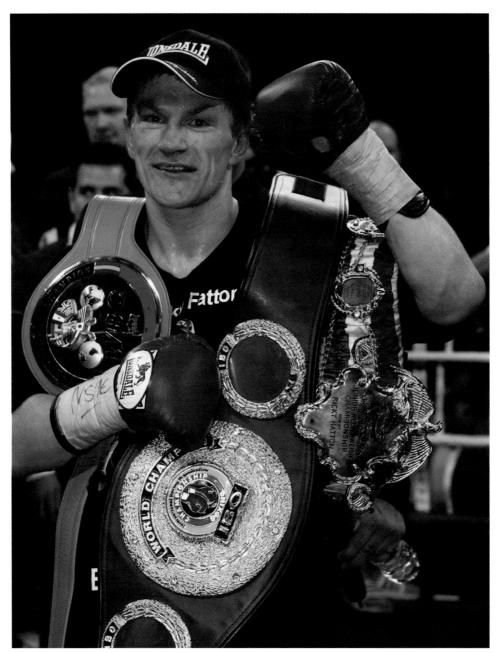

RICKY HATTON
England's Ricky 'the Hitman' Hatton celebrates with his belts after defeating Mexico's José Luis Castillo in a fourth-round stoppage during the Light Welterweight Boxing Championship in Las Vegas, USA. Hatton (born 1978) won 45 of his 47 fights in a boxing career that spanned both Welterweight and Light Welterweight classes. In 2010 a British tabloid printed pictures that allegedly showed Hatton snorting cocaine. The boxer declared himself *"devastated and distraught"* as his career went into hiatus.
23rd June, 2007

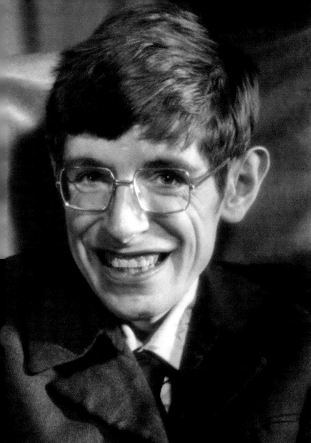

STEPHEN HAWKING

Above: Professor Stephen Hawking, the British theoretical physicist known for his contributions to the fields of cosmology and quantum gravity, especially in the context of black holes. Hawking (born 1942) suffers from neuro-muscular dystrophy and is almost totally paralysed. His genius, public appearances and best-selling books have made him an international celebrity.

1st August, 1985

Below: Professor Stephen Hawking celebrates his 60th birthday with a symposium on fundamental physics and cosmology at the University of Cambridge's Centre for Mathematical Sciences.
11th January, 2002

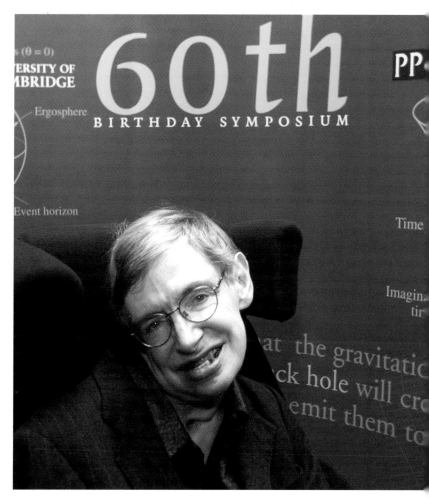

DAVID HAYE

Below: England's David Haye (L) on the attack against Russia's towering Nikolai Valuev during the WBA World Heavyweight title fight at the Nuremberg Arena. Haye won the fight on points and ungallantly described his opponent as *"the ugliest thing I have ever seen."*

7th November, 2009

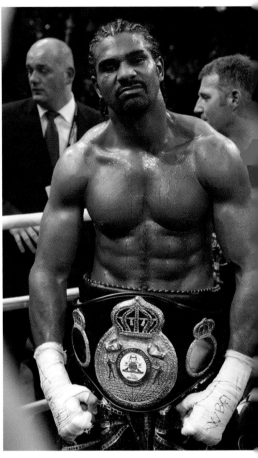

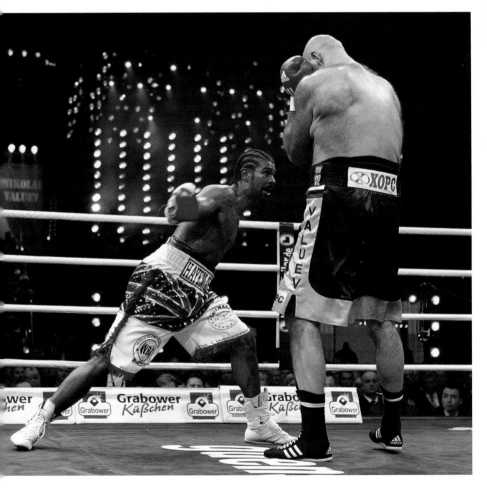

Above: David Haye celebrates becoming the WBA World Heavyweight Boxing Champion, following his title fight against the 7ft-tall Nikolai Valuev. 'The Hayemaker' (born 1980) won and unified all the major world cruiserweight titles in a four-month period before moving up to heavyweight and clinching the title.

7th November, 2009

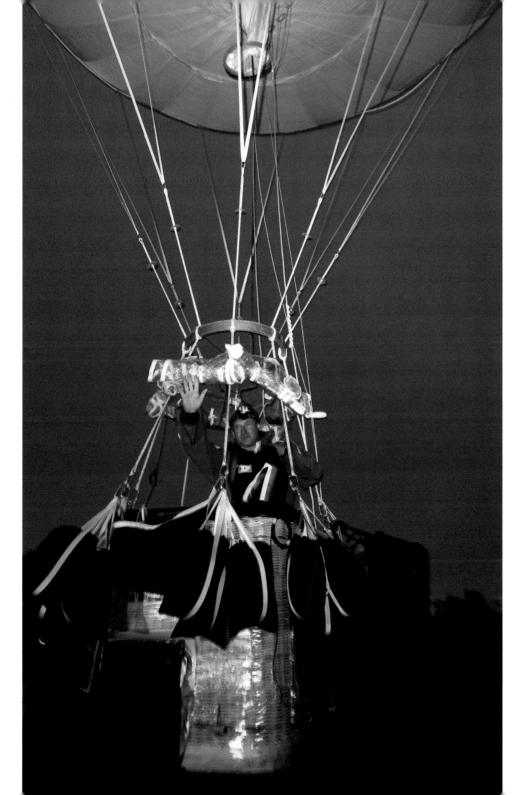

DAVID HEMPLEMAN-ADAMS

Adventurer David Hempleman-Adams takes to the skies in Newfoundland, Canada, at the start of his record-breaking flight across the Atlantic in the world's smallest helium-filled balloon. The Toshiba Transatlantic Challenge was designed to highlight the developments in technology that now allow such basic forms of flight to take place. In 2008, Hempleman-Adams (born 1956) won the Gordon Bennett Cup, having flown 1,000 miles from Albuquerque, New Mexico, to Madison, Wisconsin in a helium balloon.

2nd July, 2007

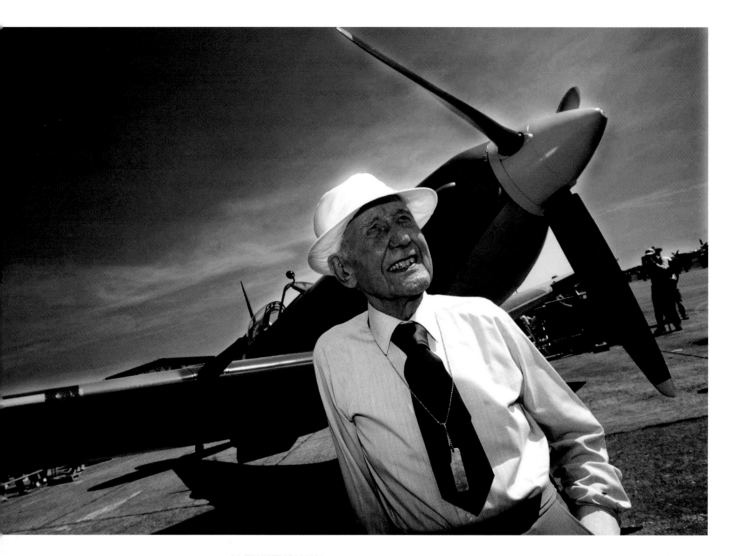

ALEX HENSHAW
Former record breaking pilot and wartime Spitfire test pilot Alex Henshaw (1912–2007)
stands in front of the plane at the Duxford aviation museum in Cambridgeshire. He survived
a near-fatal crash in 1942 and is the only pilot known to have performed a successful – and
highly dangerous – barrel roll in a Lancaster bomber. In 1939, he set the record for a flight
from England to Cape Town and back that stood for 70 years.
14th July, 2002

MYRA HESS
Below: Dame Myra Hess (1890–1965), esteemed British classical pianist, boosted Londoners' morale during the Second World War. She organized and performed a series of celebrated recitals at the National Gallery after the capital's concert halls were boarded up. Stripped of its priceless paintings to protect them from the Blitz, the gallery's empty halls *"rang to the sound of piano music"* in what was seen as an act of bravery and patriotism against the spectre of Hitler's bombing raids.
23rd December, 1931

BARBARA HEPWORTH
Above: English Modernist sculptor Barbara Hepworth (1903–75) with one of her striking works. Along with her friend Henry Moore, her husband Ben Nicholson and others, she redefined sculpture and helped promote what is now considered to be 'modern art'. Her sculpture is characterized by large, elegant, organic shapes, examples of which are found in public places all over the world. Hepworth was made a Dame ten years before she died in a fire at her studio in St Ives, Cornwall.
22nd February, 1951

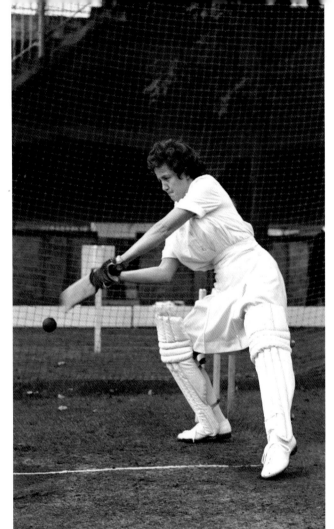

Below: Rachael Heyhoe-Flint became the UK's first female sports commentator when she appeared on the London Weekend Television programme *World of Sport*.
18th January, 1973

RACHAEL HEYHOE-FLINT

England Women's cricket captain Rachael Heyhoe-Flint (born 1939) practises her batting in the nets. Heyhoe-Flint epitomized women's cricket for more than a generation, playing in 22 Test matches. She was the first woman admitted to 'the home of cricket', Marylebone Cricket Club, and also played hockey for England. She became a director of Wolverhampton Wanderers in 1997 and collected her OBE in 2008.
15th August, 1960

DAMON HILL

Right: Former Formula One World Champion Damon Hill (born 1960) succeeded Sir Jackie Stewart as the President of the British Racing Driver's Club at Silverstone in April 2006. Hill is the son of motor racing legend Graham Hill and won the 1996 Formula One World Championship. He racked up 22 Formula One wins in a high-profile career, before retiring in 1999. He runs several successful businesses and occasionally pops up as a guest guitarist with bands such as Def Leppard.

28th April, 2006

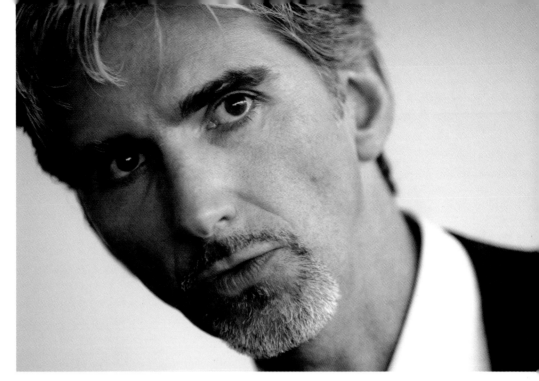

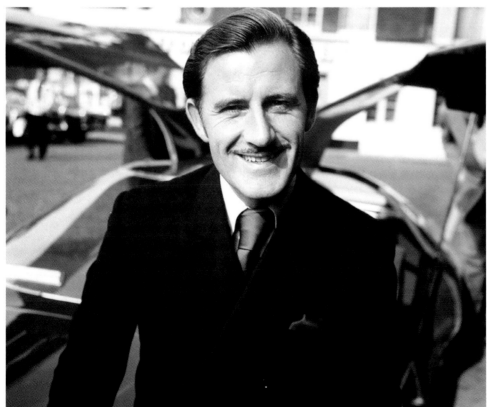

GRAHAM HILL

Left: Looking dapper and sporting his trademark roguish moustache, British Formula One racing driver Graham Hill (1929–75) was a hit with the public thanks to his quick wit, extrovert nature and fierce driving skills. Hill won the Formula One World Championship twice, in 1962 and 1968. He died when the aircraft he was flying crashed in fog on a golf course in north London.

1st October, 1968

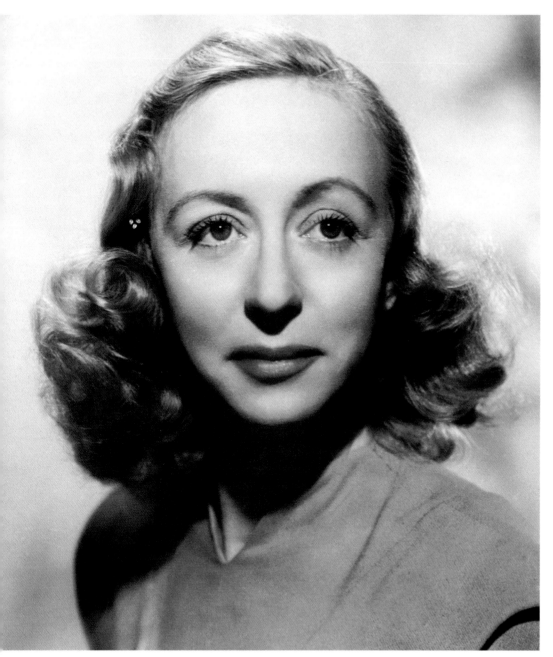

THORA HIRD

A pensive-looking Thora Hird (1911–2003), photographed the year before her 40th birthday. Star of British radio, stage and screen for eight decades, Hird appeared in more than 100 films, collected two BAFTA Awards for her character portrayals in Alan Bennett's *Talking Heads* monologues and appeared in a multitude of classic British TV series, including *Last of the Summer Wine*, *In Loving Memory* and *Meet the Wife*. She became a Dame Commander in 1993 and thus achieved 'national treasure' status.

1st November, 1950

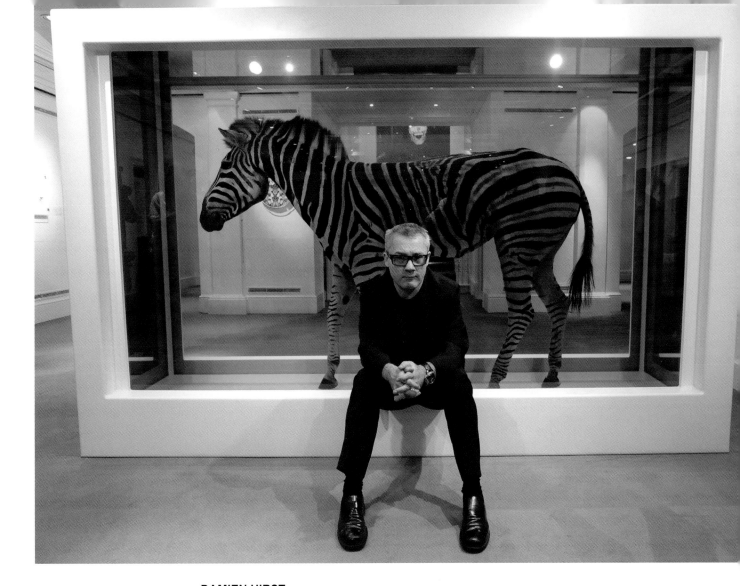

DAMIEN HIRST

The richest living artist, Damien Hirst (born 1965) poses with *The Incredible Journey* (a zebra in formaldehyde), one in a collection of his works auctioned for £115.5m at Sotheby's, London. Hirst's 'dead animals' and the backing of art collector Charles Saatchi brought him fame, notoriety and wealth. His works, including a diamond encrusted platinum skull and a metal cabinet filled with pills, sell for enormous amounts of money and his personal fortune is estimated at £215m. But is it Art?

8th September, 2008

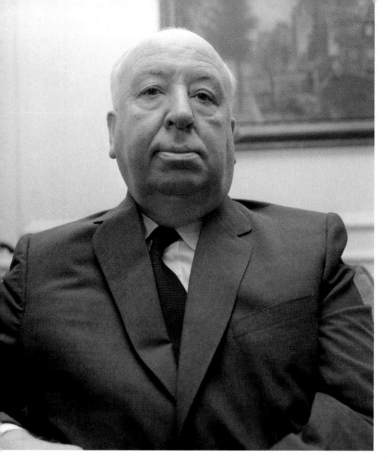

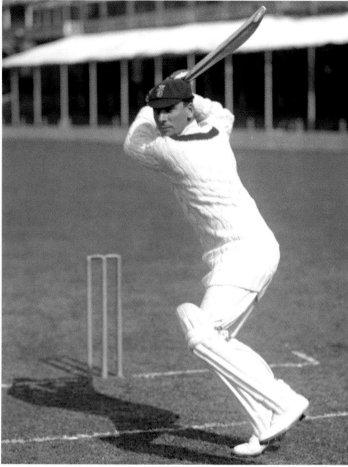

ALFRED HITCHCOCK

Film director Alfred Hitchcock (1899–1980) at Claridges Hotel in London, before the premiere of his latest thriller, *Torn Curtain*. The son of an East End greengrocer, Hitchcock was known as 'the master of suspense'. He popped up in cameo roles in almost every movie he made, including in *The Lady Vanishes*, *The 39 Steps*, and *Dial M for Murder*. He had a penchant for cool, blonde actresses and made stars of many, including Grace Kelly, Janet Leigh and Kim Novak.

25th April, 1966

JACK HOBBS

Surrey and England batsman Jack Hobbs (1882–1963) strikes an athletic pose at The Oval after being named Cricketer of the Year. During his career as a master cricketer, Hobbs scored more than 61,237 runs with an average of 50.65 and scored 197 centuries. He played in every Test match for his country between 1907 and 1930 and, in 1953, became the first professional cricketer to receive a Knighthood from the Queen.

1925

DAVID HOCKNEY

Versatile British artist David Hockney (born 1937) in front of paintings from his new series, set in Andalucia. The self-styled 'playboy of the art world' has enjoyed phenomenal success as one of the leaders of the 'pop art' movement, and as a set designer, print maker, draughtsman and photographer. Difficult to define, Hockney famously quipped, *"Art has to move you and design does not, unless it's a good design for a bus."*
3rd June, 2004

David Hockney stands in front of his painting *Mr and Mrs Clark and Percy*, painted in 1970, at the National Portrait Gallery in London. The painting represents fashion designer Ossie Clark and his fiancée, Celia Birtwell, prior to their wedding, at which Hockney was best man. The cat in the painting was actually called Blanche, but Hockney preferred to use the name of the couple's other cat, Percy.
11th October, 2006

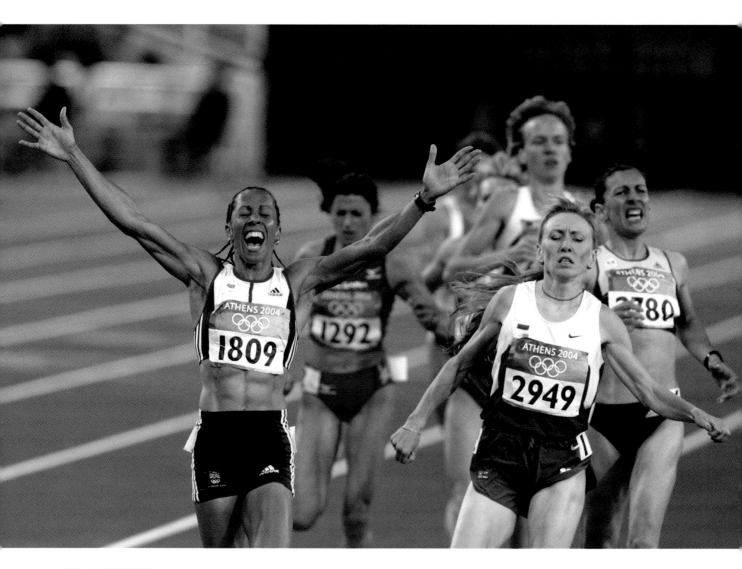

KELLY HOLMES

Great Britain's Kelly Holmes (L) celebrates winning the Women's 1500m final at the Olympic Stadium in Athens. The former British Army soldier also took gold in the 800m race. An outstanding competitor, Holmes (born 1970) holds records for the 600m, 800m, 1000m and 1500m distances even in retirement. She was BBC Sports Personality of the Year in 2004 and was made a Dame of the British Empire a year later.

28th August, 2004

GUSTAV HOLST

Seated at his piano, Gustav Theodore Holst (1874–1934), composer of *The Planets*, discusses his latest comic opera, *The Perfect Fool*, with the British National Opera Company conductor Eugene Goossens (L). The satirical work, inspired by Wagner, begins with a ballet that is enthusiastically performed by the Spirits of Earth, Water and Fire. It is one of almost 200 compositions written by Cheltenham's most famous son. Holst, who studied at the Royal College of Music in London, was influenced by Hindu spiritualism and English folk tunes to forge a unique style with haunting melodies and unconventional use of metre.

20th April, 1923

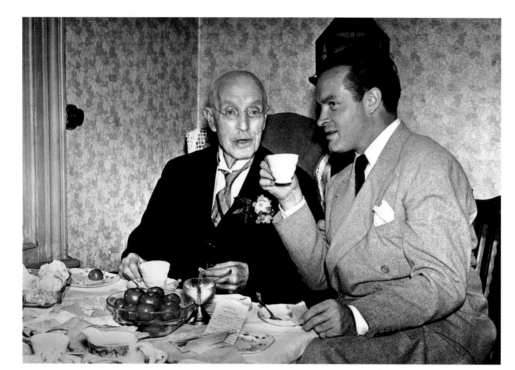

BOB HOPE

Left: Entertainer Bob Hope (1903–2003) enjoys a cup of tea during a visit to his grandfather in south London. Hope was born Leslie Townes Hope in Eltham, but emigrated to the United States at an early age. Famous for his wisecracks and screen partnership with Bing Crosby, Hope became the world's biggest comedy star through the medium of stage, television and movies. Asked on his deathbed where he wanted to be buried, the 100-year-old comedian quipped, *"Surprise me."*
1943

Right: Bob Hope on stage at the London Palladium, where he appeared in the Royal Variety Command Performance. Hope was popular on both sides of the Atlantic; in the USA he was well known for entertaining the troops during the Second World War, and the conflicts in Korea and Vietnam. In 1996, in recognition of this work, the US Congress made him the *"first and only honorary veteran of the U.S. armed forces."*
13th November, 1967

CHRIS HOY

Scotsman Chris Hoy celebrates winning gold for Great Britain in the Men's Sprint during the UCI Track Cycling World Championships at Manchester Velodrome. Hoy (born 1976) went on to win three gold medals at the 2008 Beijing Olympics, making him Scotland's greatest Olympian, the most successful male Olympic cyclist, and the first Briton to win three gold medals since 1908. He received a Knighthood in 2008 and won his tenth world title, the Track Cycling World Championships, in 2010.

28th March, 2008

TED HUGHES

Below: British Poet Laureate Ted Hughes attending a memorial service for the poet Philip Larkin at Westminster Abbey. Hughes (1930–98) was the Poet Laureate until his death and was ranked fourth in *The Times'* 50 Greatest British Writers since 1945 in 2008. He had been second choice as Poet Laureate after Larkin (1922–85), who declined due to ill health. Hughes was married to the American poet Sylvia Plath until her suicide in 1963.

14th February, 1986

JAMES HUNT

Above: Formula One pin-up James Hunt, the handsome racing driver credited with greatly increasing interest in the sport in the UK. Hunt (1947–93) won the World Championship in 1976, narrowly beating his arch-rival and close friend Niki Lauda by one point. Hunt's antics off the track were as newsworthy as his racing; he enjoyed the high life and was rarely seen without a pretty girl on his arm. After retiring from racing *"for reasons of self-preservation"* in 1979, he became a popular television pundit.

15th June, 1975

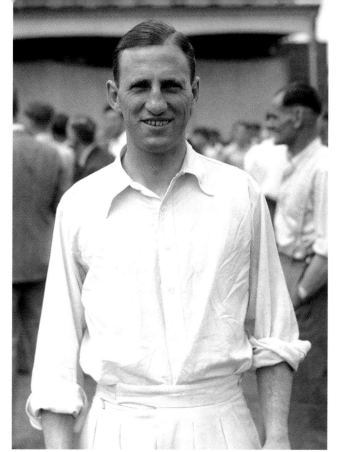

LEN HUTTON

Above: Yorkshire cricketer Len Hutton (1916–90) is widely regarded as one of the most accomplished batsmen to have played for his country. He scored 364 innings against Australia in a Test Match in 1938, setting a record that stood for almost 20 years. Hutton served as captain of the England squad during his career and was knighted for services to the sport in 1955. He retired the following year, became a successful journalist and wrote several books on cricket.

16th July, 1946

TONY JACKLIN

Below: Tony Jacklin, the first British winner of the US Open Golf Championship for half a century, enjoys a victory parade as he rides in the back of a vintage white Cadillac, driven past cheering crowds in his home town of Scunthorpe, Lincolnshire. Jacklin (born 1944) was the most successful British golfer of his generation.

24th June, 1970

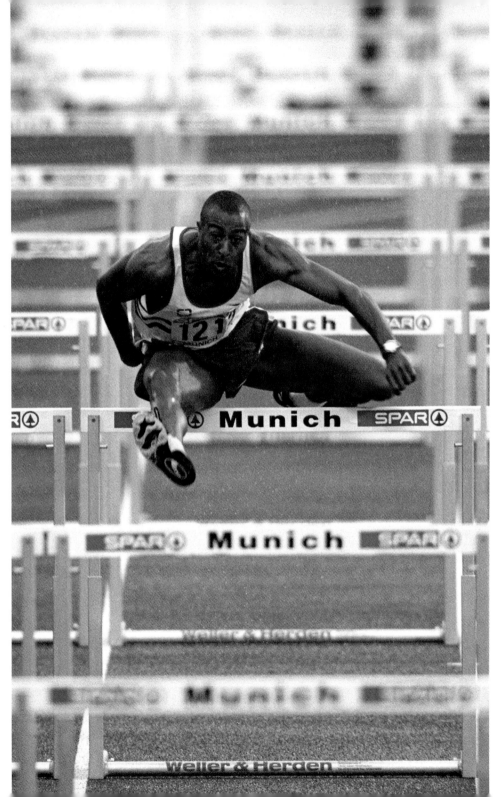

COLIN JACKSON
British hurdler Colin Jackson on his way to a disappointing second place during the European Cup 110m competition in Munich. He was beaten by Germany's Florian Schwarthoff. Jackson (born 1967), an Olympic silver medallist, was three times 110m World Champion and was unbeaten in the European Championships for 12 years. He set the indoor record of 12.91 seconds in 1993.
22nd June, 1997

DEREK JACOBI

Actor and film director Sir Derek Jacobi with the *Evening Standard* Film Award for Best Actor for his performance in *Love is the Devil: Study for a Portrait of Francis Bacon*, a biography of the Irish painter (played by Jacobi). Born in London in 1938, Jacobi is a stalwart of the stage, appearing in productions such as *Hamlet*, *Uncle Vanya* and *Oedipus the King*; he received a Tony Award for his performance in *Much Ado About Nothing*. A founder member of the Royal National Theatre, he has also appeared in films and on TV. Like Laurence Olivier, he has the distinction of holding two Knighthoods, one Danish and one British.
7th February, 1999

Renowned for his stage roles playing notable historical figures such as Edward II, Octavius Caesar and Richard III, Sir Derek Jacobi performs in the role of the fictional character, 'Phileas Fogg' (*Around the World in Eighty Days*), during the naming ceremony of the Cunard liner *Queen Victoria*, in Southampton.
10th December, 2007

DAVID JASON

Sir David John White, OBE (stage name David Jason) is an English television actor born in 1940. He is best known for his sitcom roles as Derek 'Del Boy' Trotter in the long running BBC TV sitcom *Only Fools and Horses* from 1981, and Granville in *Open All Hours.* He was also loved as Pop Larkin in the comedy drama *The Darling Buds of May* and later enjoyed considerable success as detective Jack Frost on the ITV crime drama *A Touch of Frost* from 1992. In 1997, he won a BAFTA award for Best Comedy Performance, (*Only Fools and Horses – Christmas Special*) at the Royal Albert Hall, London (right). His last appearance as Del Boy was in 2003, while Jason retired his role as Frost in 2010.

29th April, 1997

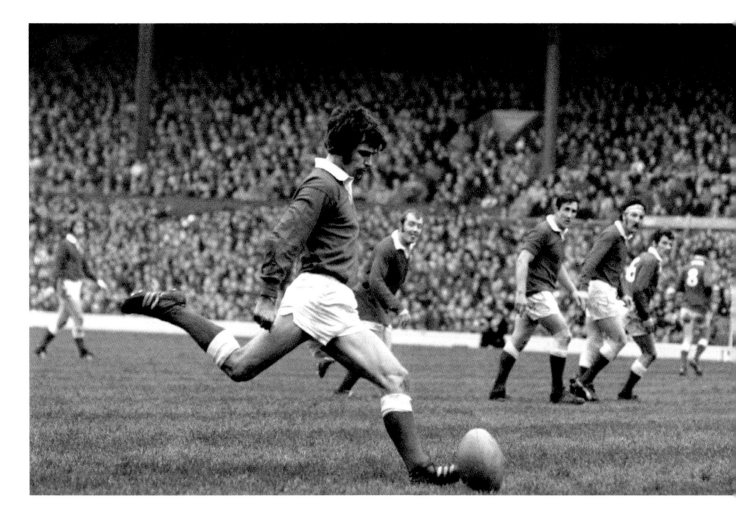

BARRY JOHN
Barry John of Wales in the Five Nations Championship, England v Wales, at Twickenham.
Considered by many to be the best fly-half in the history of rugby union, John (born 1945)
had a unique talent for weaving his way through the opposition's defence and scoring almost
unbelievable tries. He was known simply as 'the King', but sensationally quit rugby aged 27,
at the peak of his career, citing his distaste for *"living in a goldfish bowl."*
15th January, 1972

Above: Even more over-the-top than usual, pop 'royalty' Elton John in towering Louis XIV wig (L) leaves his London home with his civil partner, David Furnish, to attend his 50th birthday party. The five-times Grammy Award winner (born Reginald Kenneth Dwight in 1947) has had more than 50 Top 40 hits and has sold more than 250 million records, making him one of the most successful recording artists of all time.
6th April, 1997

ELTON JOHN

Below: Singer Elton John performing a rewritten version of his song *Candle in the Wind* as a tribute to Diana, Princess of Wales, at her funeral in Westminster Abbey. More than one million mourners lined the route of the funeral procession through London, and the country was struck by an outpouring of grief, the likes of which had not been seen before in the UK. The Princess was 36 years old when she was killed in a car crash in Paris.
6th September, 1997

AMY JOHNSON

British aviatrix Amy Johnson (1903–41), with her Gypsy Moth *Jason*, at the London Aeroplane Club. Johnson was the first woman to fly solo from Britain to Australia, a distinction achieved at the age of 26, which brought her global celebrity. She perished after baling out over the Thames Estuary while flying an Airspeed Oxford aircraft for the Air Transport Auxiliary. Johnson's body was never found, but her tan leather flying bag was recovered and is now exhibited at Sewerby Hall in Yorkshire.

10th January, 1930

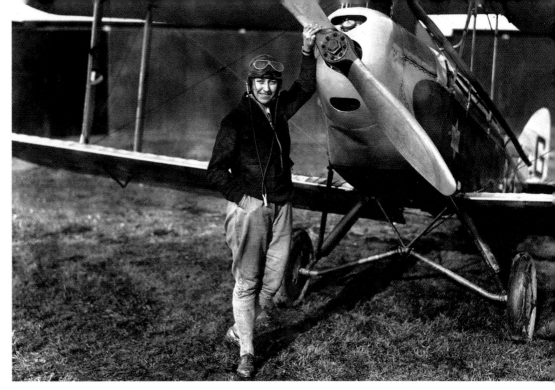

JAMES EDGAR JOHNSON

RAF fighter pilot Group Captain James Edgar 'Johnnie' Johnson, DSO, DFC, at the RAF station in Biggin Hill in Kent, after flying one of three Spitfires home for their 'retirement' from service. Johnson (1915–2001) completed more than 1,000 missions and shot down 38 German planes, making him the highest-scoring British ace to survive the Second World War.

11th July, 1957

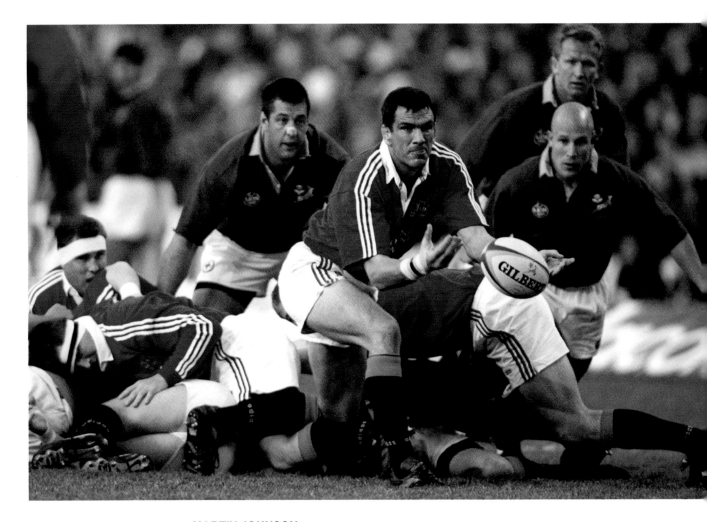

MARTIN JOHNSON
England captain Martin Johnson takes over at scrum half to
pass the ball out during the Third Test of the British Lions'
tour of South Africa. The Lions won the first two Tests, taking
the series 2–1. In 2003, Johnson (born 1970) became the
first England rugby union captain to hoist the World Cup,
following a dramatic 20–17 win over the hosts, Australia, in
Sydney. He was made England manager in 2008.
5th July, 1997

ANN HAYDON-JONES
Britain's triumphant Ann Haydon-Jones during play against Australia's Margaret Court in the women's singles semi-final on the Centre Court at Wimbledon. Haydon-Jones (born 1938) trounced Court to take on the title-holder, Billie Jean King, in the final. The British player beat King, preventing the American from winning her fourth Wimbledon singles title.
2nd July, 1969

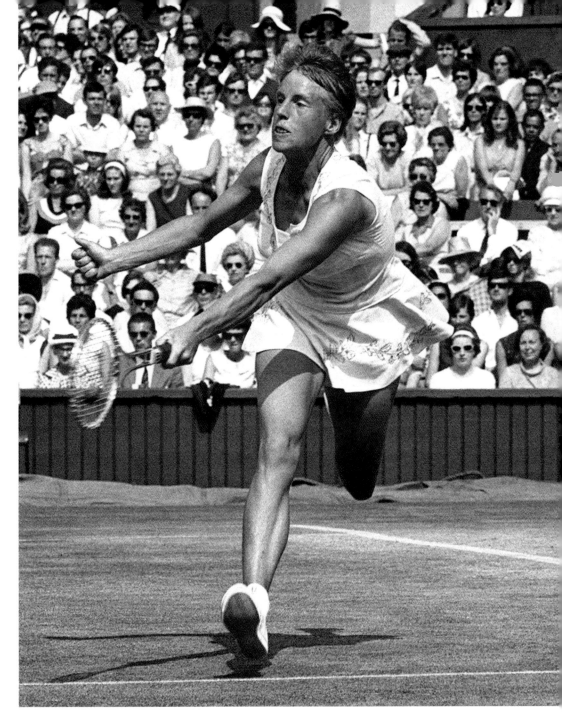

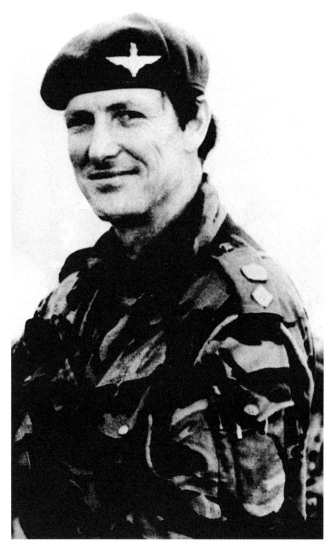

TOM JONES

Below: Welsh pop singer Tom Jones (born 1940) works the camera in 1965. His instantly recognizable voice and raunchy stage act catapulted Jones to stardom in the 1960s. He has sold more than 100 million records and dabbled in every style of music, from pop, rock and show tunes to techno, R&B and gospel. Still in demand thanks to collaborations with Robbie Williams, The Art of Noise and Stereophonics, Jones continues to perform and record.

25th February, 1965

HERBERT JONES

Above: Lieutenant Colonel Herbert Jones, who was posthumously awarded the Victoria Cross for his gallantry in action during the Falklands Conflict. 'H' Jones (1940–82) was killed while serving as the commanding officer of 2 Para during the Battle of Goose Green.

8th October, 1982

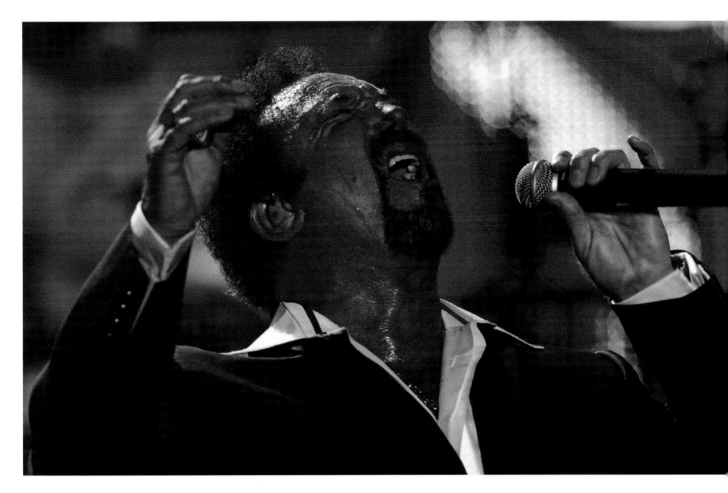

Still shaking the rafters with his unique baritone to tenor range, Tom Jones is pictured on stage during the Brit Awards in 2003 at Earls Court, London. One of the most enduring British singers, Jones collected the award for Outstanding Contribution to Music. He had the audience on their feet, singing along to a medley of his greatest hits, including *What's New Pussycat?*, *Green Green Grass of Home* and *Delilah*.

20th February, 2003

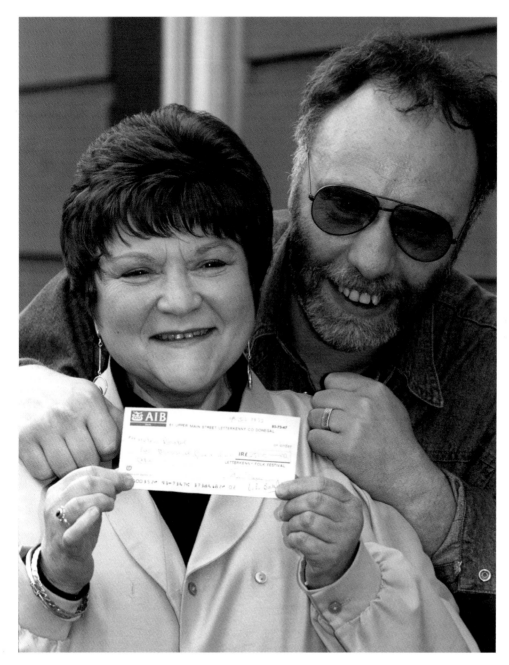

BRIAN KEENAN

Former Beirut hostage Brian Keenan (born in Belfast, Northern Ireland in 1951) presents Helen Bamber, Director of the Medical Foundation, which cares for victims of torture, with a cheque for £2,500. Keenan, a teacher, was kidnapped by Islamic Jihadists and spent more than four years locked up in Beirut between 1986 and 1990. He was kept blindfolded and chained for most of his imprisonment and described the ordeal in his book, *An Evil Cradling*, in 1991.

13th March, 1992

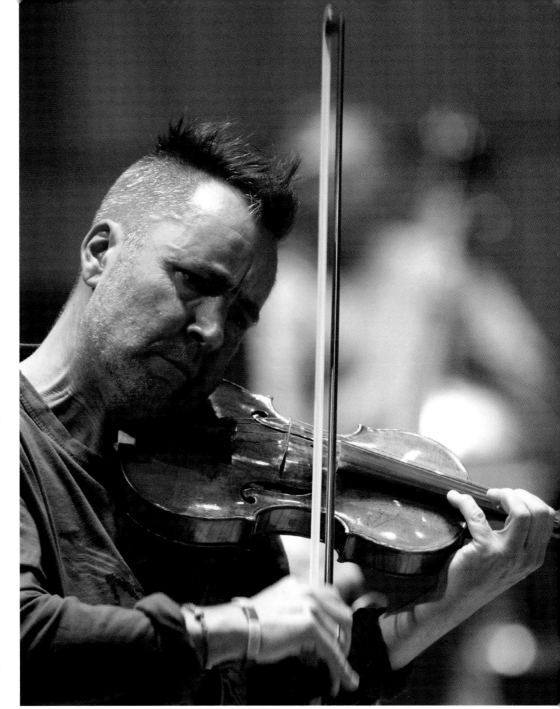

NIGEL KENNEDY
Violin soloist Nigel Kennedy, performing with the Royal Philharmonic Orchestra during rehearsals of Elgar's Violin Concerto, ahead of a concert at London's Royal Festival Hall. Often mocked in classical circles for his defiantly punk appearance and apparently cultivated 'mockney' accent, Kennedy (born 1956) has been one of the world's leading virtuosos for more than 20 years, and is credited with bringing a freshness and energy to both classical and contemporary violin music.
12th March, 2008

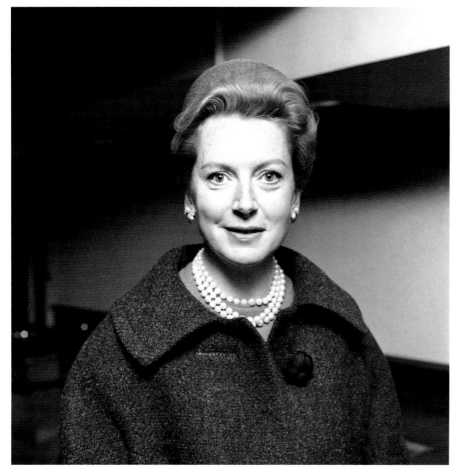

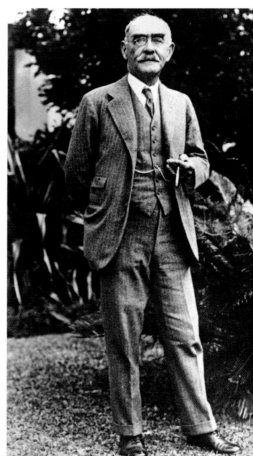

RUDYARD KIPLING

Below: British author and poet, Rudyard Kipling (1865–1936), photographed during a trip to Bermuda. Born in Bombay, then part of the British Empire, and sent to England at the age of five, Kipling penned his most famous work, *The Jungle Book*, before he was 30. He was master of the short story, publishing such classics as *Gunga Din* and *The Man Who Would Be King*, and was the first English-language author awarded the Nobel Prize in Literature (1907).
1926

DEBORAH KERR

Above: The gifted Scottish film actress Deborah Kerr (1921–2007), following her Academy Award nomination for the role of 'Ida Carmody' in *The Sundowners*. Famed for her cool gracefulness, Kerr enjoyed success in Britain and Hollywood from the 1940s until her retirement in 1986. She appeared in almost 50 movies, including *Black Narcissus*, *The Prisoner of Zenda* and *Separate Tables*. Her landmark role was as 'Mrs Anna' in the hugely successful 1956 musical *The King and I*, with Yul Brynner.
26 April, 1962

HERBERT KITCHENER

In an overt display of British imperialism, soldiers present arms as King George V, in regal sash and pristine white shoes, is escorted by Lord Horatio Herbert Kitchener (C), the British Consul General in Egypt, during an official royal visit to Port Sudan. First Earl Kitchener (1850–1916) was Secretary of State for War at the start of the First World War in 1914. He organized the large volunteer army that fought Germany on the Western Front and his commanding image, appearing on recruiting posters demanding 'Your country needs you!', remains recognized and parodied in popular culture to this day.

17th January, 1912

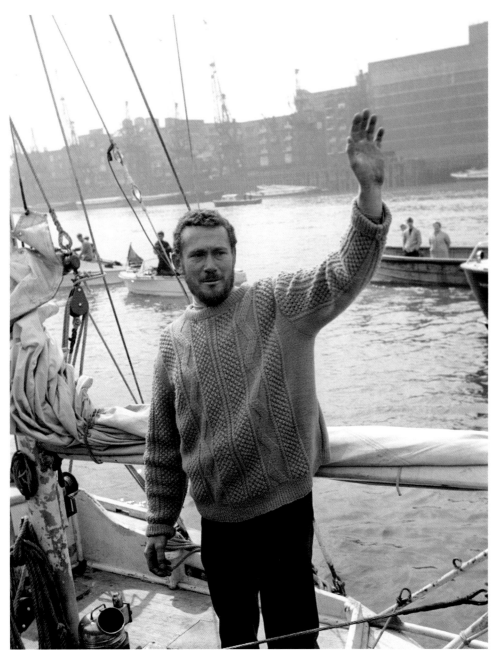

ROBIN KNOX-JOHNSTON

Round-the-world yachtsman Robin Knox-Johnston aboard his ketch, the *Suhaili*, on arrival in London after winning the Golden Globe race. Despite losing his self-steering equipment off the coast of Australia, Knox-Johnston (born 1939) became the first man to single-handedly sail non-stop around the globe and was the only competitor to finish the race. He also became the oldest man to circumnavigate the globe solo in 2006 at the ripe old age of 67, in the VELUX 5 Oceans Race.

1st May, 1969

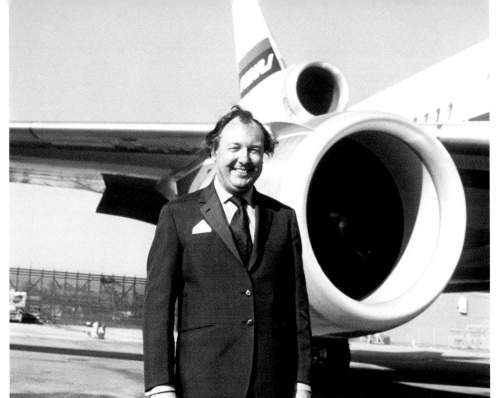

FREDDIE LAKER

Left: The chairman and managing director of Laker Airways. Sir Freddie Laker (1922–2006) founded the first 'no-frills' airline, offering cheap flights and using secondhand planes. Laker scored another first when he launched the Skytrain, the UK's first budget flight from London to New York for the princely sum of £32.50 one way. The company, however, went bankrupt in 1982.
16th October, 1974

JIM LAKER

Right: Surrey cricketer Jim Laker (1922–86) will always be remembered for his outstanding performance in the Test Match against Australia at Old Trafford in 1956. No other spin bowler, before or since, has matched his record of taking 19 wickets in one match. The Yorkshireman's ashes were scattered at the Oval Cricket Ground following his death.
4th July, 1954

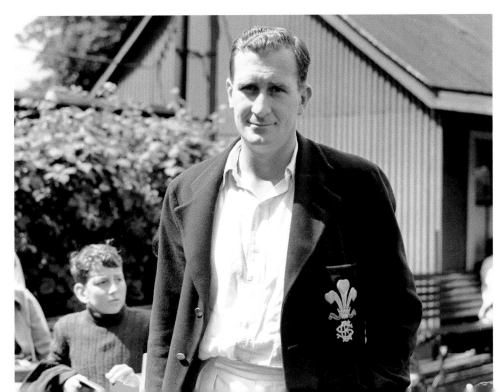

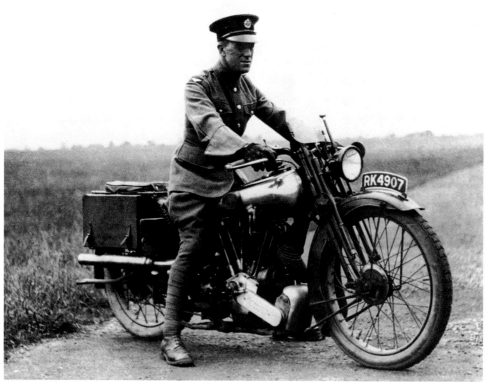

T.E. LAWRENCE

Sitting astride his Brough Superior SS100 motorcycle, aircraftsman 'Ned' Lawrence (1888–1935) – better known as Lt Col T.E. Lawrence or 'Lawrence of Arabia' – revs his engine. A noted military strategist, he became famous for posing as an Arab to lead a rebellion against the Turks in Hejaz in 1916. The author of *The Seven Pillars of Wisdom*, which recounted his military adventures, the enigmatic Lawrence died after a motorcycle accident in Dorset, England.

26th March, 1927

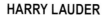

HARRY LAUDER

Left: Scottish entertainer Sir Harry Lauder (1870–1950) has his sporran weighed in 1932. Lauder honed his act in the tough Glasgow music halls and found international fame thanks to his clownish tartan ensemble, over-the-top parody and self-penned ditties such as *Roamin' in the Gloamin'*, *I Love a Lassie* and *Keep Right On to the End of the Road*. He was less revered in Scotland, where he is perceived to have encouraged the largely unsubstantiated view of Scots as 'overtly thrifty'.

18th April, 1932

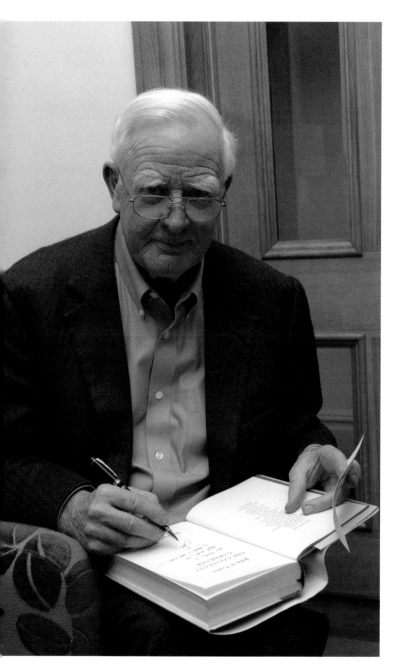

JOHN LE CARRÉ

Left: Eminent author John Le Carré attends an auction in aid of The Constant Gardeners' Trust in London. The Trust was set up to help the people of Kenya, where the film *The Constant Gardener*, based on Le Carré's novel of the same name, was set. Le Carré (born David Cornwell in 1931), an ex-MI5 and MI6 officer, is the best-selling author of *A Perfect Spy*, *The Spy Who Came in from the Cold* and *Tinker, Tailor, Soldier, Spy.*
12th March, 2006

DAVID LEAN

Above: British film director David Lean arriving at Heathrow Airport. Lean (1908–91) directed some of the great epic films of the 20th century, including *Lawrence of Arabia*, *Bridge Over the River Kwai*, *Dr Zhivago* and *A Passage to India*. Four of his films appear in the Top 11 of the British Film Institute's Top 100 British Films.
31st October, 1987

LED ZEPPELIN

Facing page: Members of Led Zeppelin (L–R), John Bonham, Robert Plant and Jimmy Page, with the singer Sandy Denny, after receiving their awards in the Melody Maker Pop Poll in London. The band split up in 1980, having sold more than 200 million albums worldwide. They were arguably one of the most influential and successful hard rock groups of the 1970s.

16th September, 1970

JENNIE LEE

Baroness Jennie Lee (1904–88), Labour MP for Cannock, typing in her London office. A fierce socialist and fine orator, Lee challenged Winston Churchill on his Budget proposals in her first House of Commons speech. He was so impressed that he congratulated her. She married Nye Bevan MP in 1934 and fought to stop the spread of fascism in Europe throughout the 1930s. As Arts Minister under Harold Wilson in the 1960s, her finest achievement was establishing the Open University.

22nd January, 1948

JOHN LENNON

Beatle John Lennon attends a rehearsal of the Rolling Stones Rock and Roll Circus at Intertel Studios, Wembley, London, where he was to be one of the guest stars. Singer-songwriter Lennon, (1940–80) rose to worldwide fame as one of the founding members of The Beatles and, with Paul McCartney, formed one of the most successful songwriting partnerships of the 20th century. Born and raised in Liverpool, he became involved as a teenager in skiffle, and his first band, The Quarrymen, evolved into The Beatles in 1960. After the break up of The Beatles in the 1970s, Lennon forged a solo career and recorded a number of critically acclaimed albums, and iconic songs such as *Give Peace a Chance* and *Imagine*. Lennon's immense talent was lost when, in New York in 1980, he was murdered by gunman Mark David Chapman.

10th December, 1968

DORIS LESSING

Doris Lessing, prolific short story writer and novelist, who was awarded the Nobel Prize for Literature 11 days before her 88th birthday. She was praised by the judges for her *"skepticism, fire and visionary power"*. Lessing (born 1919) is the oldest person to have been awarded the coveted prize, for works that include *The Golden Notebook*, *The Grass is Singing* and *The Fifth Child*. Her response, when told of the award by journalists, was: *"Oh Christ... I couldn't care less."*

11th October, 2007

DENISE LEWIS

Olympic heptathlon hopeful Denise Lewis, who was forced to withdraw from the 2004 Athens Olympics after sustaining several injuries. Lewis, from West Bromwich, won the gold for Great Britain in the heptathlon at the Sydney Olympics four years earlier. The athlete (born 1972) competed in the BBC's *Strictly Come Dancing* TV series later in 2004, but was beaten in the final dance-off by actress Jill Halfpenny.

10th August, 2004

JOAN LITTLEWOOD
Surrounded by redevelopment and rubble, theatre director Joan Littlewood (1914–2002) surveys a building site outside her base, the Theatre Royal in London. A founder member of the Theatre Workshop, Littlewood's productions of *Fings Ain't Wot They Used T'Be*, *A Taste of Honey* and *Oh, What a Lovely War* were huge hits during the 1950s–60s.
27th January, 1974

GARY LINEKER

Below: Former England footballer, turned BBC presenter, Gary Lineker, with his wife Danielle, during a Prince's Trust reception at the Prince of Wales' Highgrove home in Gloucestershire. Prince Charles hosted the celebrity reception to thank pop stars, actors and sports personalities for their support of his Prince's Trust charity, which he founded in 1976 to help improve the lives of disadvantaged young people in the UK.
8th September, 2009

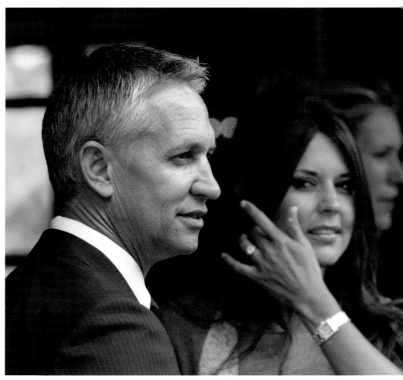

Above: Everton striker Gary Lineker at Goodison Park. Lineker made the England squad in 1984 and by the end of his international career was the team's second highest goal scorer (after Bobby Charlton). He was the top scorer at the 1986 World Cup in Mexico and still holds the record for the most goals scored in the FIFA World Cup finals (10). Capped 80 times for England, upon retirement Lineker (born 1960) carved out a successful career as a broadcaster.
23rd October, 1985

KEN LIVINGSTONE
Ken Livingstone on a balcony at City Hall in front of the capital's landmark Tower Bridge. The controversial and outspoken politician held the key position of Leader of the Greater London Council (1981–86) and was Mayor of London (2000–08) until defeated by the Conservative Boris Johnson. Famously dubbed 'Red Ken' for his left-wing leanings, Livingstone (born 1945) was expelled from the Labour Party in 2000, but re-endorsed in 2004. In his spare time he breeds newts.
12th August, 2003

MARIE LLOYD

Posing beside a giant floral tribute from an admirer, popular stage comedienne Marie Lloyd (1870–1922) is pictured at her home in Hendon, north London. Lloyd was mistress of the *double entendre* and could make even the most innocent phrase sound saucy, a talent that won her a legion of music hall fans. Her act also regularly riled Vigilance Committees – the moral guardians of the day – but she invariably retorted, *"Any immorality is in the minds of the complainants."*
1915

DAVID LLOYD-GEORGE

The Liberal politician David Lloyd-George (1863–1945) addresses a large crowd during a meeting at Sutton-in-Ashfield, Nottinghamshire. Lloyd-George toured working-class areas of the country drumming up support for his People's Budget, which increased tax levied on those who earned £3,000 to 1s. 2d. in the pound, and introduced a 'supertax' of 6d. in the pound for those earning over £5,000. He finally forced his budget through Parliament after a long, bitter struggle with the House of Lords.

1913

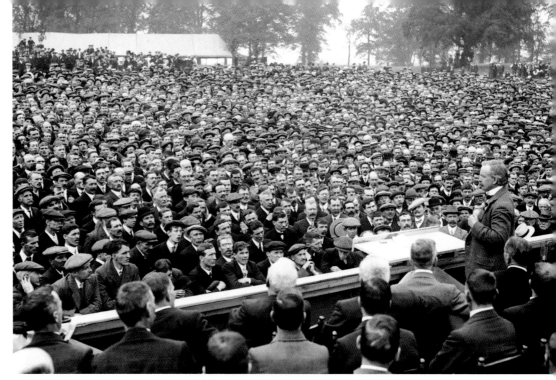

Right: Cigar in hand, the Chancellor of the Exchequer, David Lloyd-George, introduces new pub licensing laws following a series of fatal accidents at munitions factories. The government feared that inebriated workers were hampering production during the First World War. Lloyd-George claimed that Britain was fighting *"Germans, Austrians and Drink and, as far as I can see, the greatest of those foes is Drink."* He urged high-profile figures to set an example by not drinking until the war ended.

20th October, 1914

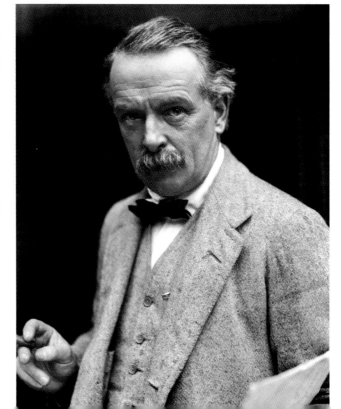

ANDREW LLOYD WEBBER

Sir Andrew Lloyd Webber attends the final of BBC TV's *Eurovision: Your Country Needs You*. The composer had been recruited to write the UK's entry in the 2009 Eurovision Song Contest and to audition performers, after the country finished last in the 2008 contest. Singer Jade Ewen, who sang the Webber composition *It's My Time,* came fifth in the Eurovision contest, and later joined British girl group Sugababes. Lloyd Webber (born 1948) has a distinguished career in musical theatre with shows that have run for more than a decade in the West End and on Broadway. In partnership with lyricist Tim Rice, he was responsible for such hits as *Joseph and his Amazing Technicolour Dreamcoat* (1968), *Jesus Christ Superstar* (1970), *Evita* (1976), and, without Rice, *Cats* (1981), *The Phantom of the Opera* (1986) and its sequel *Love Never Dies* (2010).

10th January, 2009

NAT LOFTHOUSE

Above: Former Bolton Wanderers and England player Nat Lofthouse visits his old football ground, Bolton's Burnden Park. Lofthouse (born 1925) played 503 games for Bolton, scoring 285 times. Described as a 'battering ram', he was responsible for one of the most controversial goals in football, when he scored against the favourites, Manchester United, by shouldering the goalkeeper, Harry Gregg, into the net along with the ball, giving Bolton a 2-0 win in the FA Cup Final in 1958.

16th April, 1970

ANITA LONSBROUGH

Below: BBC Sports Personality of the Year Anita Lonsbrough climbs out of the swimming pool. The 20-year-old, who took Olympic gold in the 200m breaststroke in Rome in 1960, was the last British female swimmer to win an Olympic gold until 2008. The Yorkshire lass (born 1941) also scooped three gold medals for Britain at the 1962 Commonwealth Games in Perth, Australia. She has the distinction of having held the Olympic, Commonwealth and European titles at the same time.

11th August, 1962

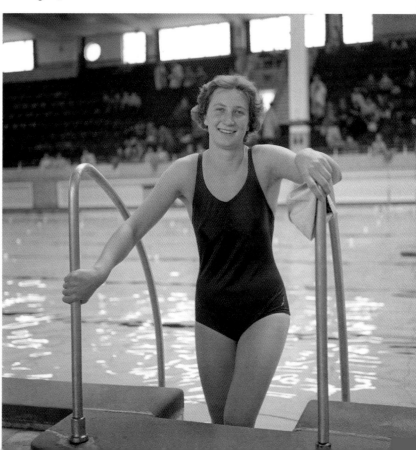

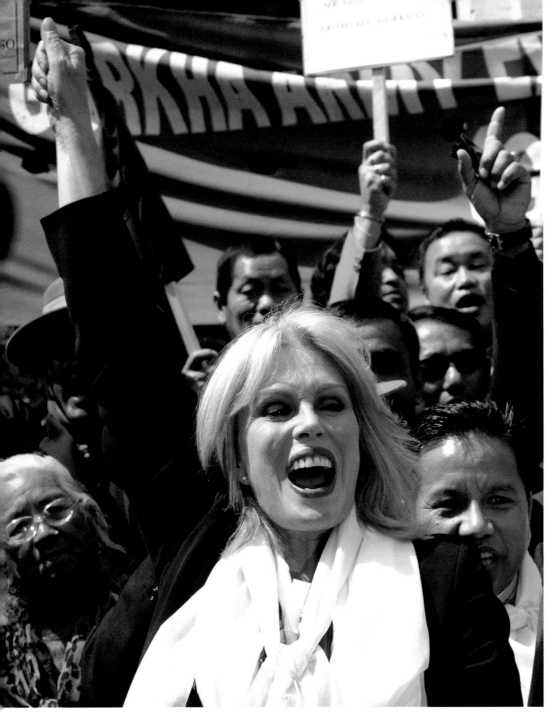

JOANNA LUMLEY

Gurkha rights campaigner and perennially popular actress Joanna Lumley cheers after hearing the Labour government's decision to allow all Gurkha veterans to settle in Britain. Lumley's father, Major James Rutherford Lumley, served in the 6th Gurkha Rifles. A former model and 'Bond girl', the actress with the cut-glass English accent (born 1946) is best-known for her roles in the TV comedy series *Absolutely Fabulous*, the science fiction fantasy *Sapphire and Steel* and the British agent adventure *The New Avengers*. She is considered a 'national treasure' in both Nepal and Britain.

21st May, 2009

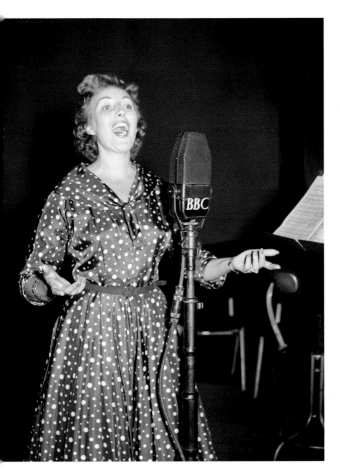

HUMPHREY LYTTLETON
Below: Jazz musician Humphrey Lyttleton performing on stage in Oxford with the rock group Radiohead on their song *Life in a Glasshouse*. 'Humph' (born 1921) was one of the great British all-rounders, excelling as a trumpet player, cartoonist, composer, writer and broadcaster. He presented *The Best of Jazz* on BBC Radio 2 for 40 years, as well as chairing the quirky comedy panel game *I'm Sorry I Haven't a Clue* on BBC Radio 4 from 1972 until his death in 2008.
7th July, 2001

VERA LYNN
Above: 'Forces sweetheart' Vera Lynn belting out a song during a BBC recording session. Lynn (born 1917) achieved superstardom during the Second World War, when hits such as *We'll Meet Again* and *The White Cliffs of Dover* held poignant meaning for British soldiers overseas and their loved ones back home. She entertained the troops in Burma and elsewhere, and was made a Dame of the British Empire in 1975. Dame Vera continues to support charities for former servicemen and women.

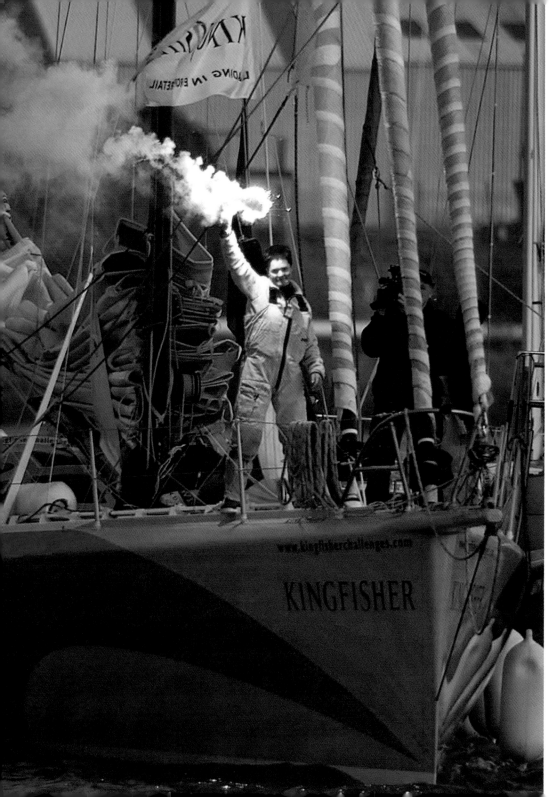

ELLEN MACARTHUR

Yachtswoman Ellen MacArthur arrives in England after coming second in the solo round-the-world Vendée Globe race. The 24 year-old from Derbyshire was the youngest person and the fastest woman to circumnavigate the world single-handedly in her yacht *Kingfisher*. Four years later, MacArthur broke the world record for the fastest solo circumnavigation of the globe, covering 27,354 nautical miles in 71 days, 14 hours, 18 minutes and 33 seconds.

15th February, 2001

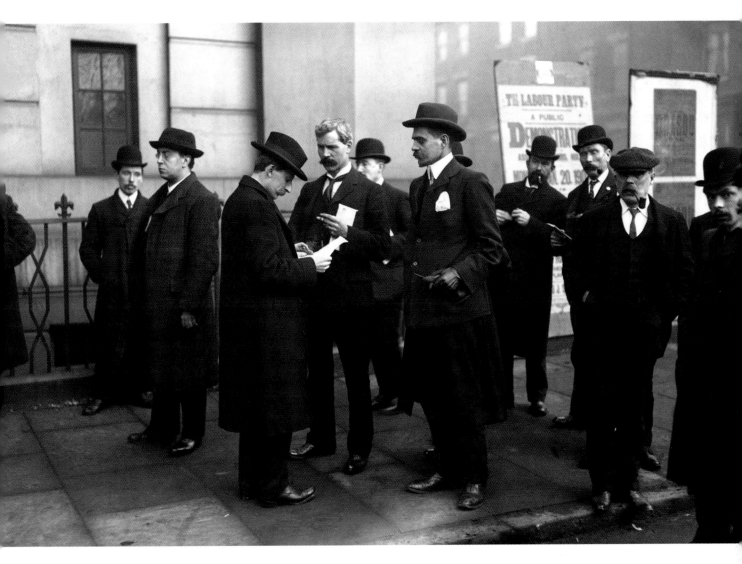

JAMES RAMSAY MACDONALD

In bowler hats, flat caps and smoking pipes, a disgruntled gaggle of Labour Party demonstrators takes to the streets alongside the recently elected MP for Leicester, James Ramsay MacDonald (C, bare-headed). MacDonald (1866–1937) went on to become Labour's first Prime Minister and served two terms in office, in 1924 and again from 1929 to 1935. His second term was overshadowed by the 1929 Wall Street Crash, which caused a global economic crisis and brought the Roaring Twenties to an abrupt end.

20th January, 1907

JOHN MCCARTHY
Freed after spending more than five years as a hostage in Lebanon, John McCarthy steps out of a VC10 at RAF Lyneham. McCarthy (born 1956), a British journalist, was kidnapped by Islamic terrorists in 1986 and was Britain's longest-held captive in Beirut. He shared a cell with the Irish hostage Brian Keenan for a time. McCarthy's fiancée, Jill Morrell, campaigned tirelessly for his release, but the couple separated in 1994.
8th August, 1991

PAUL MCCARTNEY
Wearing a duplicate of the type of suit he wore in the 1960s, Sir Paul McCartney performs in concert at the 02 Arena in London. Former Beatle and Wings frontman, McCartney (born 1942) is the most successful musician and composer in pop music history, according to *Guinness World Records*. He has sold more than 100 million records, had 33 number-one hits and his ballad *Yesterday* is the most covered track in the history of recorded music. He continues to perform around the world.
22nd December, 2009

ALEXANDER MCQUEEN

Fashion designer Lee Alexander McQueen arrives for the funeral of style icon Isabella Blow at Gloucester Cathedral. Four times winner of the British Designer of the Year award, McQueen (born 1969), had apprenticed in Savile Row, home of bespoke British tailoring, but while his clothes were impeccably cut, they bore his rebellious trademarks – the skull motif, the buttock-baring 'bumsters', the extreme shoes – and his catwalk shows were theatrical and thought provoking. The fashion world was stunned when he was found hanged in 2010, nine days after the death of his mother.

15th May, 2007

IAN MCKELLEN

Sir Ian McKellen (born 1939) on stage at the Criterion Theatre, London. The award-winning English actor is popularly known for his film roles as 'Gandalf' in *The Lord of the Rings* trilogy and 'Magneto' in *X-Men*, but he has also triumphed on the stage in Royal Shakespeare Company productions such as *Othello* and *King Lear*.

15th January, 2003

NIGEL MANSELL

Racing driver Nigel Mansell punches the air after winning the British Grand Prix at Brands Hatch. Mansell's Formula One career spanned 15 seasons and he is the most successful British F1 driver of all time, clocking up 31 victories and winning the World Championship in 1992. Mansell (born 1953) was ranked ninth in *The Times'* list of the 50 Greatest F1 Drivers of All Time and was BBC Sports Personality of the Year twice, in 1986 and 1992.

13th July, 1986

GREIG MASSON

Six year-old Greig Masson, who was hailed a hero after alerting the police and comforting his pregnant mother when her foot was trapped and crushed under a car wheel in Kincardineshire. The kilted mini-hero received an award for his bravery from Scotland's First Minister, Jack McConnell, during a ceremony held at the Great Hall in Edinburgh Castle. His mother, Catriona, said afterwards: *"Greig is a wee darling and I couldn't be more proud of him."*
6th October, 2003

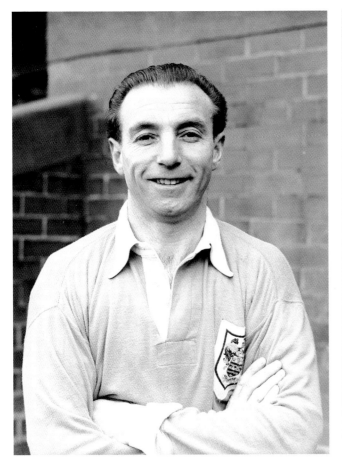

STANLEY MATTHEWS
The first celebrity footballer, Stanley Matthews (1915–2000), was a Stoke City, Blackpool and England winger. He is hailed as one of the game's finest ever players. Compared to the astronomical sums paid to star players today, Matthews took home £20 per week at the height of his fame. He was named Footballer of the Year in 1948 and 1963, European Footballer of the Year in 1956, and is the only player to have been Knighted while still a footballer.

20th February, 1951

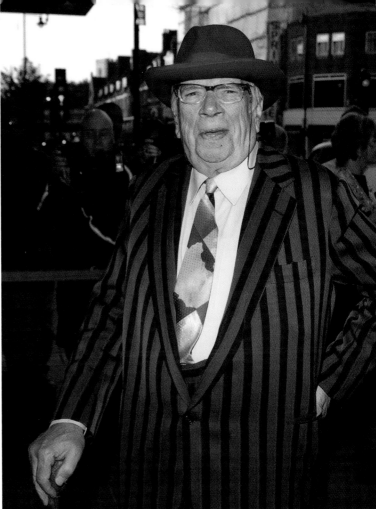

GEORGE MELLY
Jazz singer, writer and bon viveur George Melly arrives for The Best of the Empire charity gala performance and celebrity auction at the Hackney Empire in east London. Known for his flamboyant suits and fedoras, 'Good Time George' (1926–2007) joined the Royal Navy *"because the uniforms were so much nicer"*. He drifted into jazz when he left the Navy and was a surprise hit, working with several major jazz bands. He was *The Observer*'s film critic for six years.

14th September, 2004

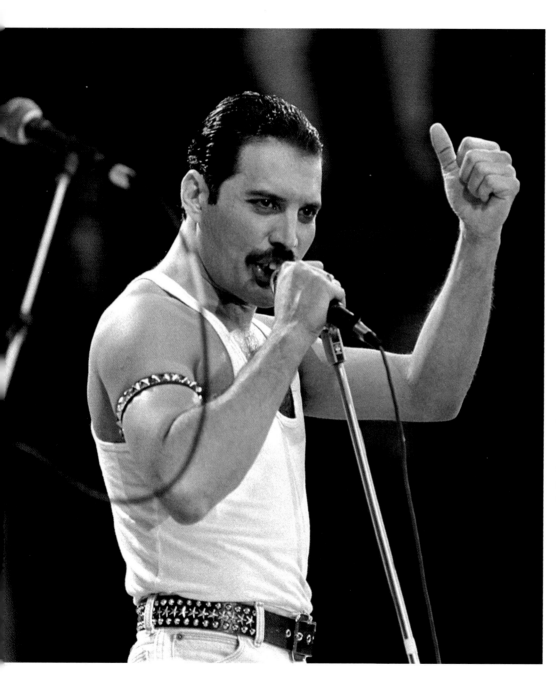

FREDDIE MERCURY

Singer-songwriter Freddie Mercury of Queen performs onstage during Live Aid. Queen opened the concert at Wembley Stadium with their classic *Bohemian Rhapsody*, before launching into *Radio Ga Ga*, *We Will Rock You* and *We Are the Champions*. The band's stunning performance was voted Greatest Live Gig Ever in a 2005 poll. Mercury, a parsi, born Farrokh Bulsara in the British protectorate of Zanzibar, East Africa, moved to Britain in his mid-teens. On stage the otherwise shy man adopted a flamboyant persona and his powerful vocals over a four-octave range helped to give Queen its unique identity. Mercury died of bronchopneumonia brought on by AIDS in 1991, a day after publicly acknowledging he had the disease.

13th July, 1985

GEORGE MICHAEL

Singer George Michael performing to an estimated two billion people in 60 countries during Live Aid, the most ambitious international satellite link-up ever attempted. Born Georgios Kyriacos Panayiotou in East Finchley, north London, in 1963 he rose to fame in the 1980s in the pop duo Wham! with school friend Andrew Ridgeley. He went solo in 1987, desiring to reach a more sophisticated audience than the duo's teenage fan base. On his first solo album, *Faith* (which sold over 20 million copies worldwide) Michael showcased his virtuosity by playing a large number of instruments, and wrote and produced every track, except for one, which he co-wrote. He subsequently became one of the world's most successful music artists, selling more than 100 million records worldwide.

13th July, 1985

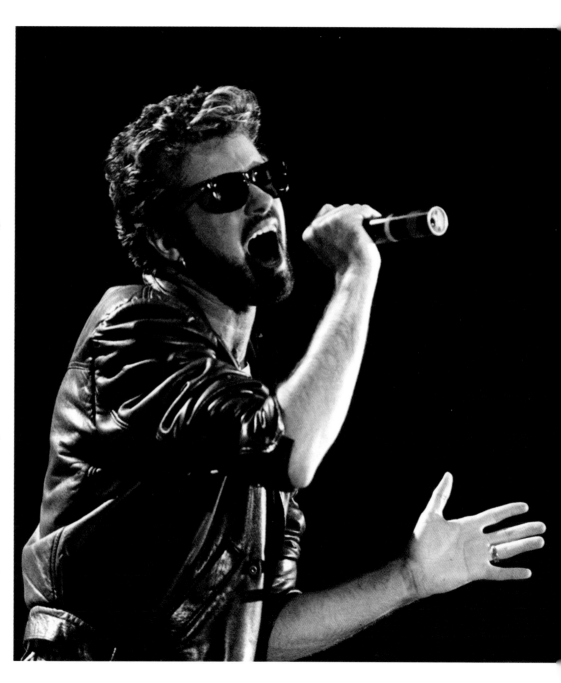

JOHN MILLS

The veteran British actor Sir John Mills in the garden of his Queen Anne cottage in the Buckinghamshire village of Denham. One of Britain's leading thespians and the father of actresses Juliet and Hayley, Mills (1908–2005) appeared in more than 120 films in his 70-year career. His first lead role was in *Great Expectations* (1946), and he went on to star in many other notable movies, including *Goodbye, Mr Chips*, *Ice-Cold in Alex* and *Ryan's Daughter*.

22nd February, 1988

BERNARD MONTGOMERY
Field Marshall Viscount Bernard Montgomery of Alamein ('Monty' to his men) being chauffeured in an Army vehicle through London's Regent's Park. Montgomery (1887–1976) was one of the most inspirational military commanders of the Second World War, fighting in north Africa, Italy and leading the D-Day invasion of Normandy on 6th June, 1944. Uncompromisingly single-minded, his unshakeable confidence appeared to spread rapidly through the ranks of those he commanded and among the wider public who observed him.
8th June, 1946

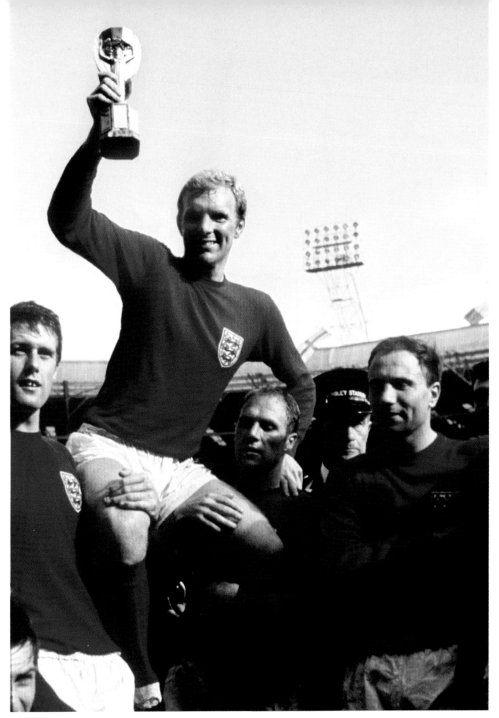

BOBBY MOORE

England football captain
Bobby Moore (1941–93)
holds aloft the World Cup
while being carried on the
shoulders of his England
colleagues, following their
4-2 win against West
Germany. Moore became a
national hero following the
historic win, named BBC
Sports Personality of the
Year and receiving an OBE.
He continued playing for
England and won a total of
108 caps, a record at the
time of his retirement in
1973. England's 1966 victory
has yet to be repeated.
30th July, 1966

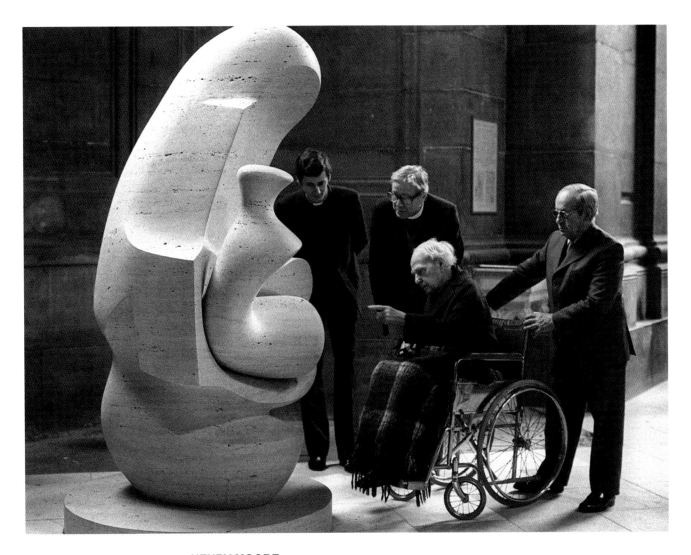

HENRY MOORE
The English sculptor Henry Moore (in wheelchair) explains his abstract marble carving, *Mother and Child*, to the Reverend Philip Buckler (L) and Dr Alan Webster, Dean of St Paul's, at the Cathedral in London. Moore (1898–1986) was the most celebrated Modernist sculptor of his generation and his distinctive avant-garde statues can be seen in public venues all over the world.
27th March, 1984

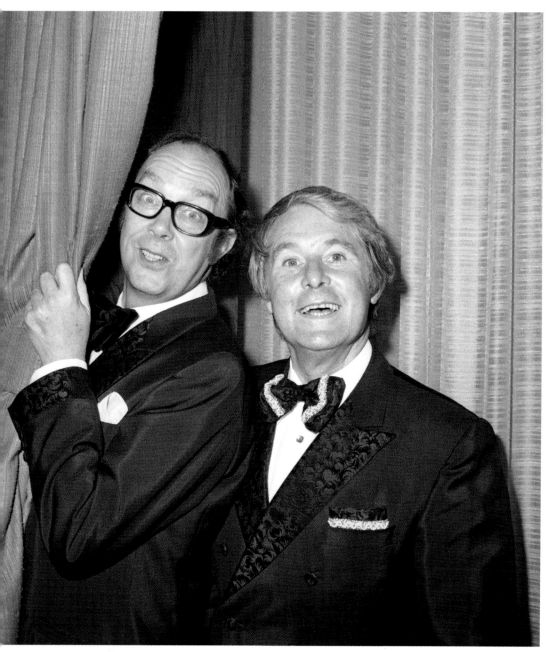

ERIC MORECAMBE & ERNIE WISE

L–R: Comedy duo Eric Morecambe (1926–84) and Ernie Wise (1925–99) during one of their classic shows. One of the best-loved comedy duos on British television, their partnership lasted more than 40 years until Morcambe's death. Their shows attracted big name guests such as Glenda Jackson, Laurence Olivier and Angela Rippon, all of whom were coerced to take part in farcical sketches.
17th May, 1974

STIRLING MOSS

Facing page: Race winner Stirling Moss (born 1929) is the centre of attention as he cradles the trophy and a cigarette after his victory in the 200-mile Silver City race at Brands Hatch, during which he lapped all but the next two finishers. Despite winning 212 of the 529 races he took part in between 1948 and his retirement in 1962, Moss holds the dubious title of *"the greatest driver never to win the World Championship"*. He received a Knighthood in 2000.
3rd June, 1961

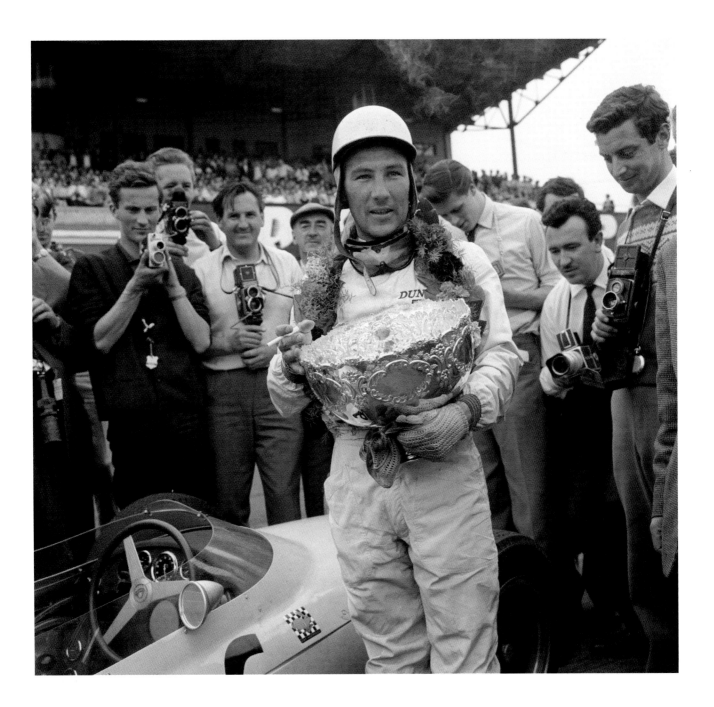

FLORENCE NIGHTINGALE

Famous for her efforts to improve conditions for wounded soldiers during the Crimean War, Florence Nightingale (1820–1910) was based at the barrack hospital in Scutari on the northern coast of the Black Sea and tended thousands of men under extreme conditions. A stickler for cleanliness and professionalism, she established nursing as a respectable profession for women and set up a training school for nurses at St Thomas's in London after the War.
26 May, 1976 ?

LAURENCE OLIVIER

Facing page: Glamorous stars of film and stage, Sir Laurence Olivier (1907–89) and his second wife, Vivien Leigh (1913–67), attend the first night performance of Gian Carlo Menotti's opera, *The Consul*, at the Cambridge Theatre, London. The couple were together for more than 20 years, but had an emotional and physically turbulent relationship, and Olivier subsequently married actress Joan Plowright, with whom he remained until his death. Olivier, who played roles on stage and screen from Greek tragedy, Shakespeare and Restoration comedy to modern American and British drama, is widely regarded to be the greatest actor of the 20th century. He was the first artistic director of the National Theatre and its main stage is named in his honour.
7th February, 1951

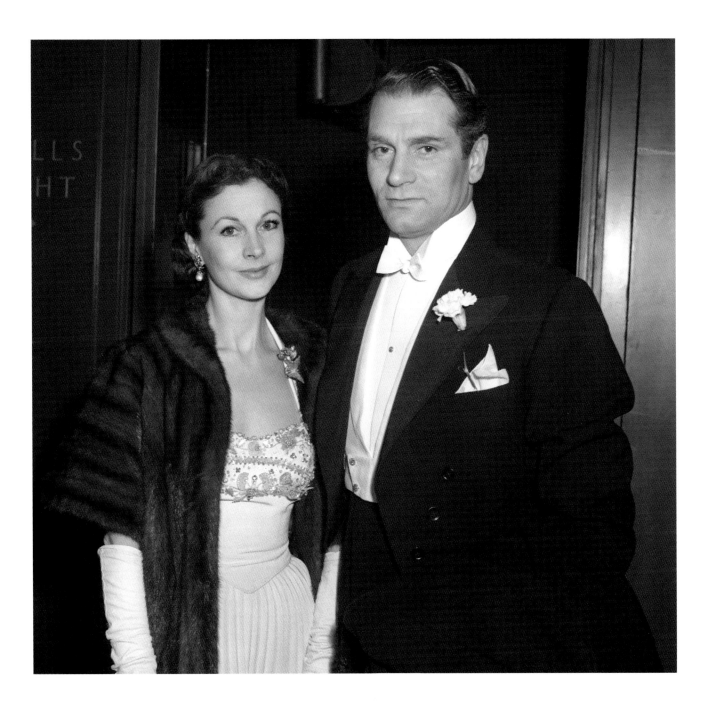

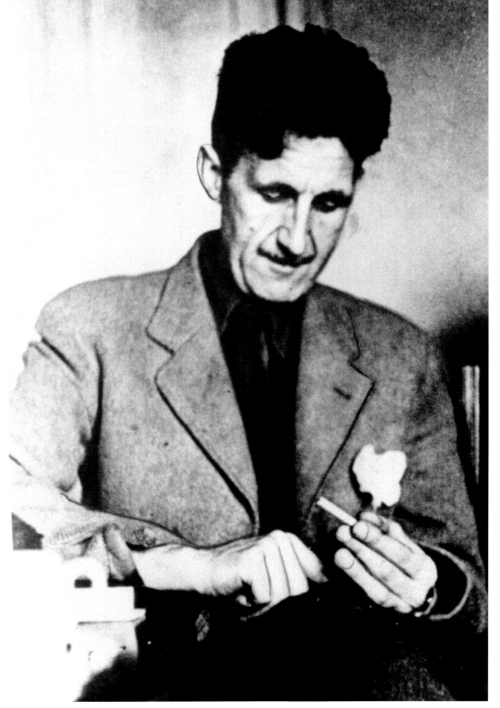

GEORGE ORWELL

Journalist and author Eric Arthur Blair (1903–50), better known by his pen name, 'George Orwell', rolls a cigarette. Widely acknowledged as the foremost chronicler of 20th-century English culture, his democratic socialism spills over into his most famous novels, *Nineteen Eighty-Four, Animal Farm, Keep the Aspidistra Flying*, as well as the autobiographical *Homage to Catalonia*. His command of English was unsurpassed and many Orwellian terms – notably *"Big Brother", "Room 101", "thought police", "newspeak"* – have passed into the common language.
1946

PHIL PACKER

Major Phil Packer, who suffered a spinal cord injury while serving in the Iraq War, completes the 2010 London Marathon. A registered paraplegic, Packer (born 1972) has raised more than £1m through his fundraising efforts. He was forced to leave the Army after the armoured vehicle he was driving was flipped over by a rocket blast and he was crushed beneath it. After treatment for spinal injuries, he confounded doctors who told him he would never walk again.

26th April, 2010

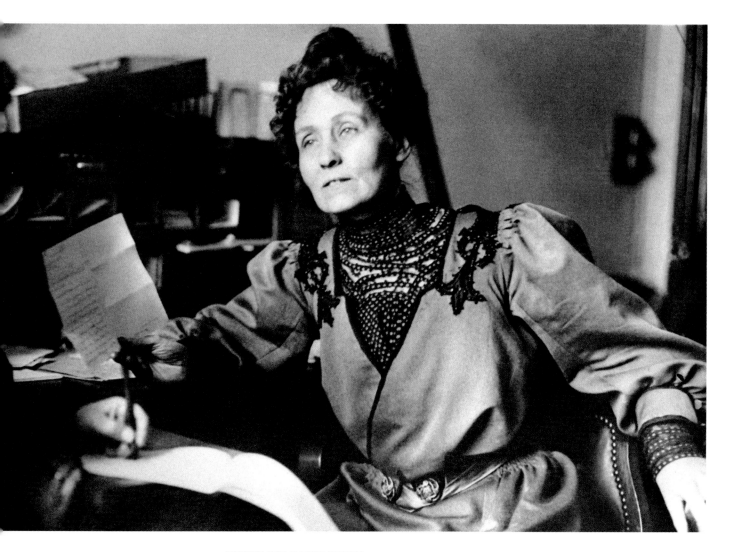

EMMELINE PANKHURST
Founder of the Women's Social and Political Union and a leading light in the suffragette struggle to gain women the vote during the first decade of the 20th century, Emmeline Pankhurst was imprisoned several times after violent clashes with British police. Pankhurst (1858–1928) regularly went on hunger strike, describing it as *"a dreadful ordeal, but it is a mild experience compared with the thirst strike, which is from beginning to end simple and unmitigated torture"*.
1st March, 1903

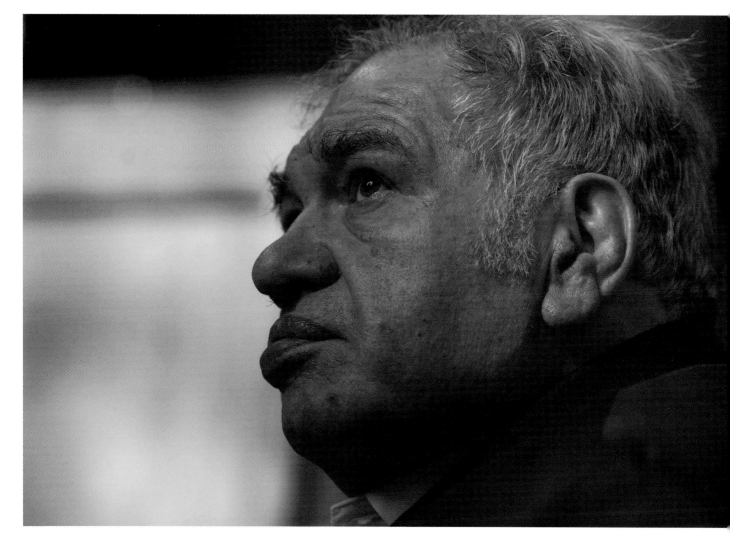

EDUARDO PAOLOZZI

Light streaming through coloured glass behind him, Sir Eduardo Paolozzi, who designed The Millennium Window at St Mary's Cathedral, Edinburgh. Paolozzi (1924–2005) was a visionary Scottish sculptor and artist, famous in the 1960s for his screenprints and collages. He designed the stylised bronze statue of Newton that sits in the courtyard of the British Library and the giant Head of Invention in front of the Design Museum on London's South Bank.

4th October, 2002

NICK PARK

Animation director Nick Park (born 1958), accompanied by his much-loved characters Wallace (L) and Gromit, pictured at Buckingham Palace after receiving a CBE. The characters rose to fame as the animated plasticine stars of the Oscar-winning short films *The Wrong Trousers* and *A Close Shave*, and the full-length feature film *The Curse of the Were-Rabbit*. Nick Park is also responsible for the popular *Creature Comforts* animated series, which won an Oscar in 1990.

25th November, 1997

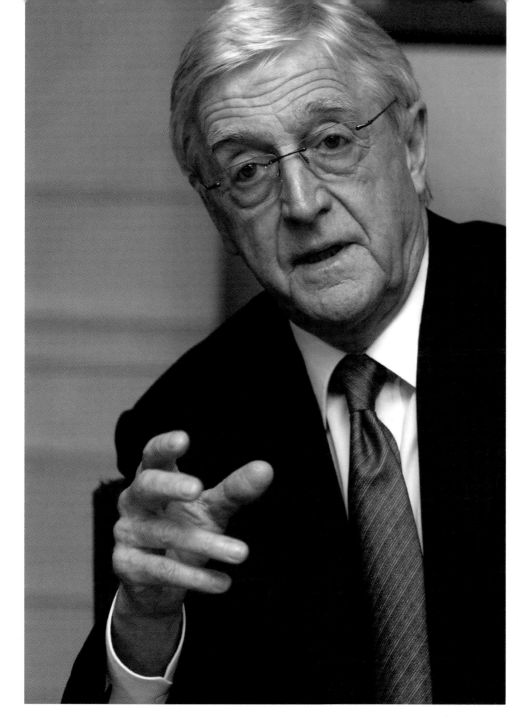

MICHAEL PARKINSON

TV chat show host Sir Michael Parkinson announcing that he has quit the BBC and defected to ITV. His sensational resignation occurred after BBC bosses tried to shunt the veteran presenter's show into a different time slot, to make way for the return of *Match of the Day*. Parkinson (born 1935) was a hit on the BBC for 17 years. He stayed with ITV for three years before retiring in 2007 to write his autobiography. Parkinson once calculated that he had interviewed more than 2,000 of the world's most famous people, and that the most remarkable had been Muhammad Ali.

26th April, 2004

MARGUERITE PATTEN

Below: The doyenne of TV cooks and the original BBC 'celebrity chef', Marguerite Patten (born 1915) was a regular on the radio programme *Woman's Hour* before launching her TV career on *Designed for Women*, at a time when only a quarter of the homes in Britain had a fridge. She wrote more than 170 cookery books, including *The Spam Cookbook*, and her cookery cards sold in excess of 500 million.

30th December, 1953

JOHN PEEL

Above: Disc Jockey John Peel (born 1939) was the longest-serving member of the original Radio 1 DJ squad, broadcasting from 1967 until his death from a heart attack in 2004. His 'Peel Sessions' provided an invaluable showcase for countless bands that might otherwise have gone unnoticed, including The Boomtown Rats, Billy Bragg and Joe Cocker.

25th July, 1968

FRED PERRY

The world's no. 1 tennis player Fred Perry (1909–95) lunges to play a backhand during the Men's Singles Final at Wimbledon against Australia's Adrian Quist. Three times Wimbledon Champion and the last Englishman to take the title since 1936, Perry is one of only seven men ever to have won all four Grand Slam tournaments (US, Australian, Wimbledon and French). No less dynamic off-court, Perry married four times, dated Marlene Dietrich and launched an iconic clothing brand.

30th June, 1934

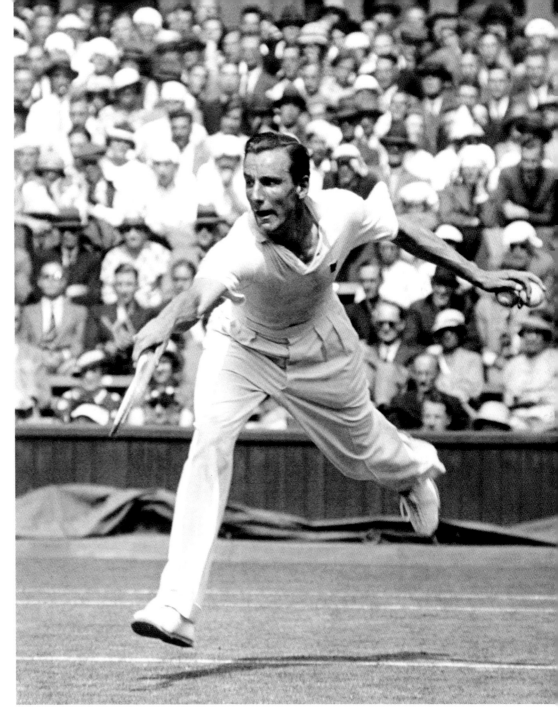

In a kimono-inspired 'hoodie' but minus his drag make-up, artist Grayson Perry attends the UK premiere of the film *Memoirs Of A Geisha*, at the Washington Mayfair Hotel in London. Perry lives in London and Sussex with his wife, the author and psychotherapist, Philippa Perry and their daughter Flo, born in 1992
11th January, 2006

GRAYSON PERRY

Winner of the Turner Prize, transvestite potter Grayson Perry, dressed as his alter ego, 'Claire', pictured with his vases at Tate Britain in London. Some of the unsettling vessels include images of Perry dressed as 'Claire' while others depict images of sexual perversion or hint at child abuse, subjects that vie with their attractive appearance. In addition to ceramics, Perry (born 1960) works in print, embroidery and textiles and he has written a novel, *Cycle of Violence*. He once shared a squat with pop star Boy George.
7th December, 2003

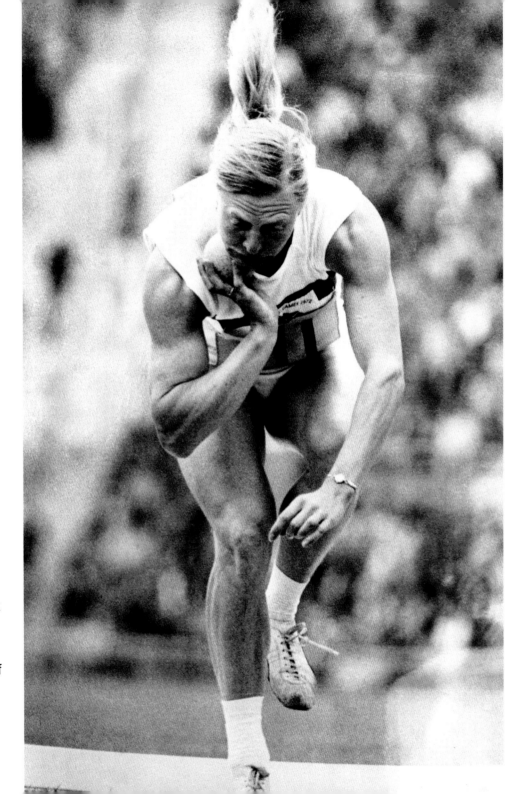

MARY PETERS
Great Britain's Mary Peters
putting the shot during the
Pentathlon at the 1972
Munich Olympics. She took
the gold medal, beating
the local favourite, Heide
Rosendahl. Peters (born
1939) was made a Dame of
the British Empire in 2000.
7th September, 1972

PICKLES THE DOG

Canine hero Pickles and his owners, David and Jeanne Corbett, happily clutching their £500 reward for the recovery of the Jules Rimet World Cup soccer trophy. The trophy had been stolen during a public exhibition in London just four months before the 1966 FIFA World Cup. The black and white mongrel unearthed the trophy in the garden of the couple's home in Upper Norwood, where it had been buried in newspapers. The thief was never caught.

31st March, 1966

COURTNEY PINE
Jazz saxophonist Courtney Pine (born 1964) playing at the Jam in the Park, in London's Finsbury Park. Pine's earliest jazz album, *Journey to the Urge Within*, earned him a Silver Disc and was the first of its genre to make a significant dent in the UK charts. He has since made 14 albums and has enjoyed success in the US charts, proving an inspiration to many fledgling British jazz artists.
17th June, 2001

MATTHEW PINSENT

Left: Rower Matthew Pinsent (born 1970) is winner of 10 world championship gold medals and four consecutive Olympic gold medals, three with Steve Redgrave (R). The rowers were members of the coxless four who took gold at the 2000 Games in Sydney. It was Pinsent's third Olympic gold and Redgrave's record-breaking fifth (*see page 232*). Pinsent was knighted for his achievements in 2004; since his retirement from rowing, he has worked for the BBC.
11th April, 2000

The Great Britain coxless four rowing team – (L–R) Matthew Pinsent, Tim Foster, Steve Redgrave and James Cracknell – takes to the water during a training session at Henley-on-Thames. The famous four beat Italy to the gold at the 2000 Summer Olympics.
24th August, 2000

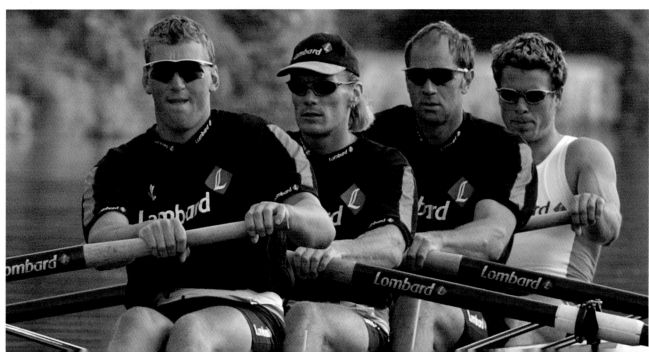

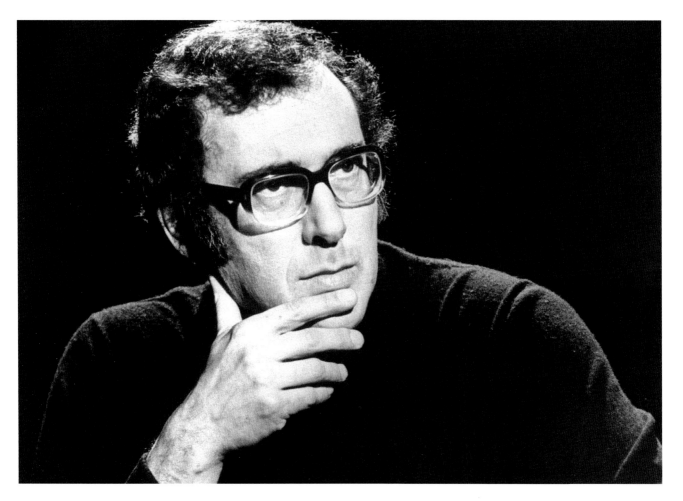

HAROLD PINTER

Playwright Harold Pinter, considered one of the most influential writers of modern times. The former actor, screenwriter, director and political activist (1930–2008) was awarded the Nobel Prize for Literature in 2005. His most famous works are *The Birthday Party, The Caretaker* and *Betrayal*, but he also adapted other writers' work for film, including *The Servant* and *The French Lieutenant's Woman*. Pinter's real life was often as turbulent and complicated as his dramatic works of fiction.

1st March, 1978

LISA POTTS

Wolverhampton nursery teacher Lisa Potts returns to work at St Luke's Primary School in Blakenhall. It was her first day back since fighting off a machete-wielding paranoid schizophrenic in the school grounds in July 1996. Potts, who was 21 at the time, almost had her arm severed while defending the children in her care. Subsequently, she was presented with the George Medal for bravery by Queen Elizabeth.

7th January, 1997

ENOCH POWELL

Right: Enoch Powell MP debates immigration problems with the Rector of the Church of St Mary Le Bow during a public meeting. Powell (1912–98) became infamous for his controversial 'Rivers of Blood' speech, warning of the dangers of mass immigration. He was removed from his post as Shadow Defence Secretary by Conservative leader Edward Heath, following a public outcry after the speech.

21st January, 1969

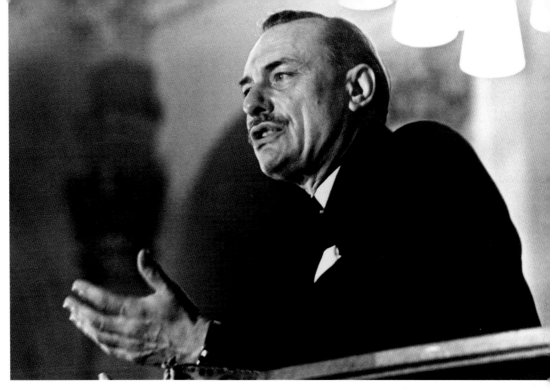

J.B. PRIESTLEY

Left: Yorkshire-born novelist J.B. Priestley, who died at his home in Alveston, near Stratford-upon-Avon, at the age of 89. John Boynton Priestley (1894–1984) published 27 books, among them *The Good Companions* and *Angel Pavement*. He was also a successful dramatist, his most famous plays being *An Inspector Calls*, which still thrills modern theatre audiences, and *Time and the Conways*.

15th August, 1984

DEBBIE PURDY

Multiple sclerosis sufferer and political activist Debbie Purdy outside the House of Lords with her husband, Omar Puente, after winning her appeal. Purdy (born 1963) helped force the government to clarify the Suicide Act and agree to publish guidelines on assisted suicide. The Director of Public Prosecutions ruled that a decision to prosecute those who helped loved ones commit suicide would be focused on their motivation.

30th July, 2009

MARY QUANT

Facing page: Fashion designer Mary Quant (bottom R), with models in hotpants, displays her new shoe collection in London. One of three designers who took credit for inventing the mini skirt, Quant (born 1934) certainly cashed in on it during the 1960s and her fashions were synonymous with 'Swinging London'. She began designing household goods, make-up and dolls and, giving a talk at London's V&A in 2007, claimed to have invented the duvet cover. She sold Mary Quant Limited in 2000.

1st August, 1967

PAULA RADCLIFFE
Great Britain's Paula Radcliffe competes in the London Marathon. Radcliffe produced one of her greatest performances to win, finishing in a European record time of 2:18:56 in her debut marathon. Radcliffe (born 1973) was voted BBC Sports Personality of the Year in 2002 and currently holds the world record for the women's marathon, with a time of 2:15:25, which has been unbroken since 2003.
14th April, 2002

MARY RAND

Olympic gold medallist Mary Rand (born 1940) wins the long jump at an athletics meet in White City, London. Rand set the world long jump record in 1964, beating Russia and Poland in the Olympic final with a leap of 6.76m. She was the first British female to win gold in Olympic track and field. She followed up with another gold medal for the long jump at the 1966 Commonwealth Games, but retired due to injury later that year.

3rd July, 1965

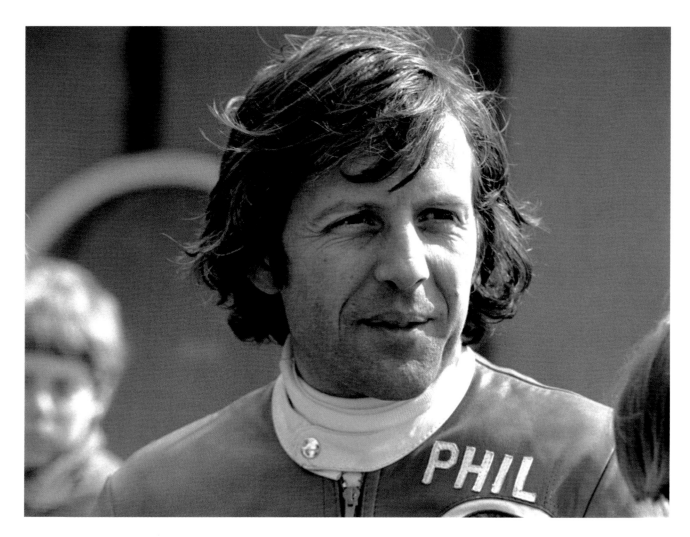

PHIL READ
Motorcyclist Phil Read, who was the first man to win the
World Championships in the 125cc, 250cc and 500cc
classes. Read (born 1939) was motorcycling champion eight
times in a career that earned him the nickname 'The Prince
of Speed'.
8th April, 1977

MICHAEL REDGRAVE

English actor Sir Michael Redgrave (1908–85), who directed *A Month in the Country*, starring Ingrid Bergman, at Guildford's Yvonne Arnaud Theatre. The son of silent film actors Roy Redgrave (1873–1922) and Margaret Scudamore (1884–1958), Redgrave was the husband of actress Rachel Kempson (1910–2003). Together they spawned an acting dynasty, as parents of noted thespians Vanessa, Corin (1939–2010) and Lynn Redgrave (1943–2010) and grandparents of actresses Jemma Redgrave and Natasha (1963–2009) and Joely Richardson.

13th September, 1965

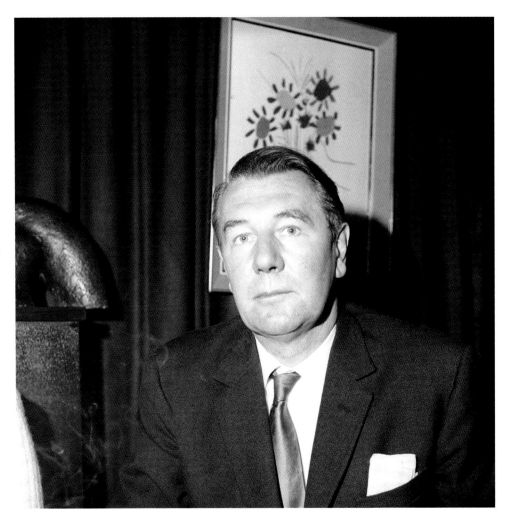

STEVE REDGRAVE
Britain's greatest Olympian, Sir Steve Redgrave (born 1962) attending a reunion with the rowing crew that secured the gold medal at the 2000 Sydney Olympics. The four-man team took to the water again for The National Lottery Legends Sprint, an event to raise money for children affected by the Asian tsunami disaster. The rower won gold medals at five consecutive Olympic Games from 1984 to 2000, and he has also won three Commonwealth Games gold medals and nine World Rowing Championships gold medals, making him Britain's greatest Olympian.
28th May, 2005

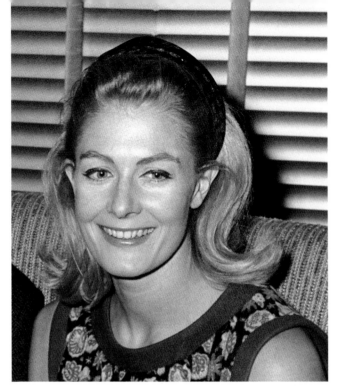

VANESSA REDGRAVE

Actress and controversial political activist Vanessa Redgrave (born 1937) at a press conference promoting the BBC series *A Farewell to Arms*. Proclaimed by playwrights Tennessee Williams and Arthur Miller to be 'the greatest living actress of our times', she remains the only British actress to win the Oscar, BAFTA, Golden Globe, Tony, Screen Actors Guild, Emmy and Cannes Awards. She famously remarked, *"I do not know of a single government that actually abides by international human rights law…including my own."*
10th January, 1966

Right: Vanessa Redgrave takes part in a march through London's West End, in a demonstration staged by the Workers' Revolutionary Party, in support of its demands for a trade union inquiry into a police raid on the party's education centre in Derbyshire.
16th November, 1972

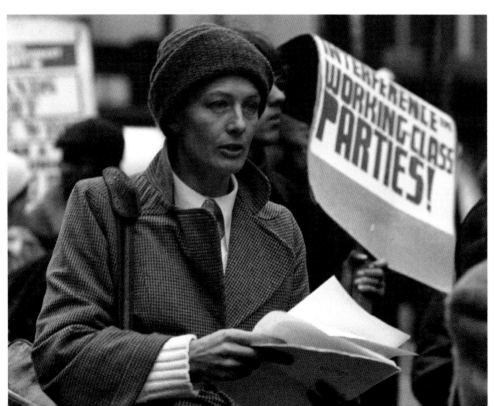

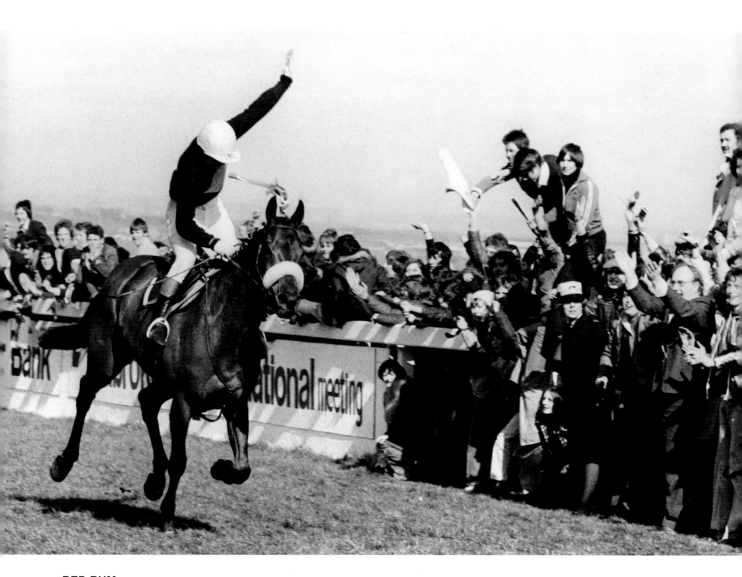

RED RUM
Ridden by Tommy Stack, Red Rum wins his record-breaking third Grand National at Aintree Racecourse in front of ecstatic fans. Afterwards, the bay gelding (1965–1995) became a household name, opening supermarkets and appearing on countless mugs and tea towels. When he died, the legendary horse was buried by the winning post at Aintree.
2nd April, 1977

ZANDRA RHODES

Fashion designer Zandra Rhodes at the launch of the Woman's Journal Fashion and Beauty Shows in London. Born in 1940, Rhodes led a new wave of British designers in the 1970s and 1980s with her bold but feminine designs, dressing celebrities, royalty and theatre productions. She continues to design and to sport her trademark garish hair colours, 'punk' make-up and chunky jewellery.

23rd September, 1996

CLIFF RICHARD

Facing page: Pop singer Cliff Richard (born 1940) and his backing group, The Shadows, at London Airport, as they prepare to fly off on a tour of Scandinavia. Together, they dominated the British pop charts of the late 1950s and early 1960s with a string of hits, including *Living Doll* and *Travellin' Light*, and appeared in the teen movies *Summer Holiday* and *The Young Ones*. The aging rockers celebrated their 50th anniversary together in 2009 with a sell-out UK arena tour.

15th August, 1961

Right: Sir Cliff Richard at the launch of his 'Time Machine Tour DVD' at Quo Vadis in Soho, central London. In a career that spans over 50 years, he is the biggest selling singles artist of all time in the UK, with sales of over 27 million and UK album sales of over 18 million.

5th December, 2008

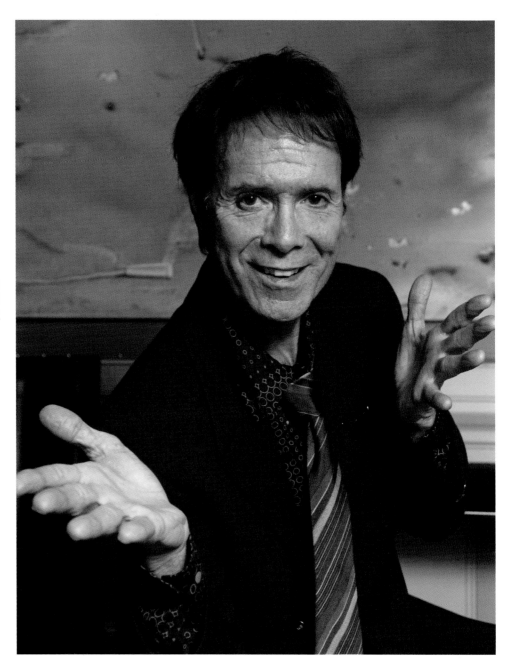

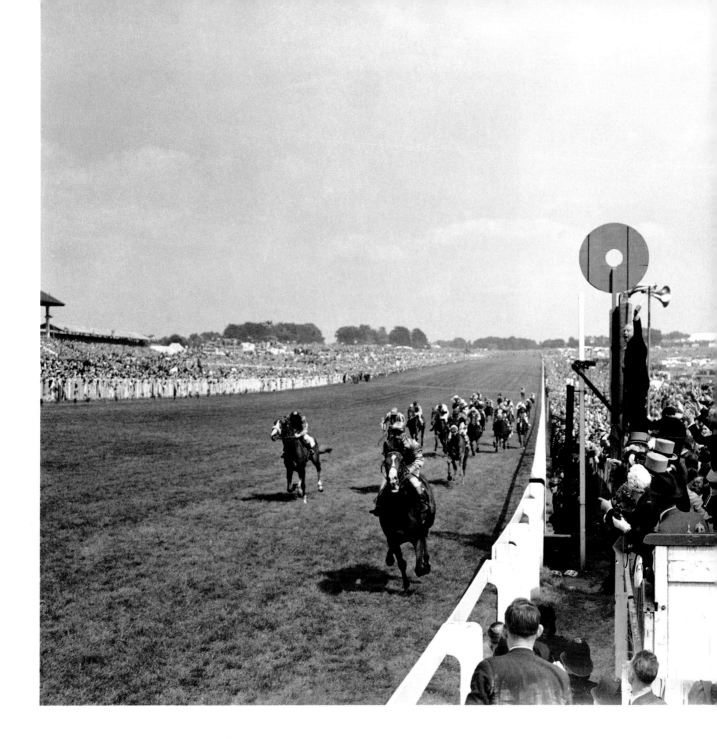

GORDON RICHARDS

Facing page: Pinza, with jockey Sir Gordon Richards in the saddle, passes the post to win the Epsom Derby from Aureole and Pink Horse by a convincing four lengths. It was Richards' final Derby and he was knighted shortly afterwards. Upon retirement, he became racing manager for Lady Beaverbrook.
6th June, 1953

Sir Gordon Richards (1904–86), often considered the world's greatest ever jockey. Champion jockey 26 times and winner of 14 Classics, he was affectionately known as 'Moppy' or 'The Champ'.
18th June, 1953

BRIDGET RILEY

Contemporary British artist Bridget Riley in front of *Movement in Squares* at the Serpentine Gallery in London, part of a major exhibition bringing together 30 of the artist's works from the 1960s and 1970s. Riley's signature stark black and white optical art played tricks on the eye and was said to induce the sensation of seasickness in some viewers. Riley (born 1931) switched from monochrome to colour in the late 1960s, after becoming disillusioned that her 'op art' was being commercially exploited.
16th June, 1999

STELLA RIMMINGTON

Former MI5 Director-General Dame Stella Rimington looks through files at the Public Records Office in Kew, which, along with other government buildings across the country, held an open day to the public. Rimington (born 1935) was the first female MI5 chief and the first Director-General whose name was made public, following a sustained media hunt. After leaving MI5 in 1996, Rimington controversially published her memoirs and has since written several thriller novels.

20th September, 2003

THE ROLLING STONES

Facing page: Looking suitably dishevelled, The Rolling Stones are captured during a rehearsal at London Weekend Television's Wembley studios in preparation for the band's appearance on David Frost's *Frost on Saturday* programme. L–R: Brian Jones, Mick Jagger, Charlie Watts, Keith Richards and Bill Wyman. The band performed the song *Sympathy for the Devil*.

29th November, 1968

Life etched across each face, The Rolling Stones, (L–R) Mick Jagger, Ronnie Wood, Charlie Watts and Keith Richards, arrive in London's Leicester Square for the film premiere of Martin Scorsese's documentary *Shine a Light*. The film records the group's 2006 tour and includes rare vintage footage. The Stones formed in 1962 and there have been ten members since they began recording. They are among the most successful, influential musicians of all time and continue to tour.

2nd April, 2008

J.K. ROWLING
Author of the phenomenally successful Harry Potter stories, J.K. Rowling stands beside a new painting of herself at the National Portrait Gallery in London. Joanne 'Jo' Rowling (born 1965) created a fantasy series that has sold more than 400 million books worldwide and which became an exceptional film and merchandising franchise. From living on welfare payments in 1990, when she began writing her first Harry Potter book, she was, by 2010, the 12th richest woman in Britain, worth an estimated £560m.
6th September, 2005

CONRAD RUSSELL
Facing page: Conrad Sebastian Robert Russell, the 5th Earl Russell (1937–2004), reads in the study of his North Wales home. A 17th century historian, Liberal Democrat peer and son of the philosopher Bertrand Russell, he sent telegrams to Soviet leader Nikita Krushchev and US President John F. Kennedy during the Cuban Missile Crisis and is credited with bringing a hint of conciliation between them at a time when the world appeared to be poised on the brink of a nuclear war.
25th October, 1962

JIMMY SAVILE

Facing page: Reunited with his 'magic' *Jim'll Fix It* chair, on display at Savile Hall, Leeds. Former DJ Sir Jimmy Savile hosted the popular children's show for 18 years, 'making dreams comes true'. He was the first and last presenter of the long-running BBC chart show *Top of the Pops*, introducing it in 1964 and ending it in 2006. Born in 1926, Savile, a keen marathon runner, is forever associated with the catchphrase: *"Now then, now then, now then, guys and gals".*
18th May, 2009

ERNEST SHACKLETON

Dreaming of what might have been? Sir Ernest Henry Shackleton (1874–1922) stares out from the bridge of the three-masted sailing ship *Nimrod*, moored on the Thames in London. The previous year, his British Antarctic Expedition team had stalled 96 miles from the South Pole after dwindling supplies forced them to turn back and make the gut wrenching journey home. He told his wife, Emily: *"I thought you'd rather have a live donkey than a dead lion."*
1910

LLOYD SCOTT

The fastest woman in the London Marathon, Paula Radcliffe, greets the slowest man, Lloyd Scott, who finished the race in six days, wearing a heavy antique diving suit. The pair met in The Mall as Scott crossed the finishing line. Scott, born in 1961 in Rainham, Essex, walked the marathon in full diving gear for the CLIC (Cancer and Leukaemia in Childhood) charity, based in Bristol. A survivor of leukaemia himself, Scott has raised more than £4m for cancer charities.

19th April, 2002

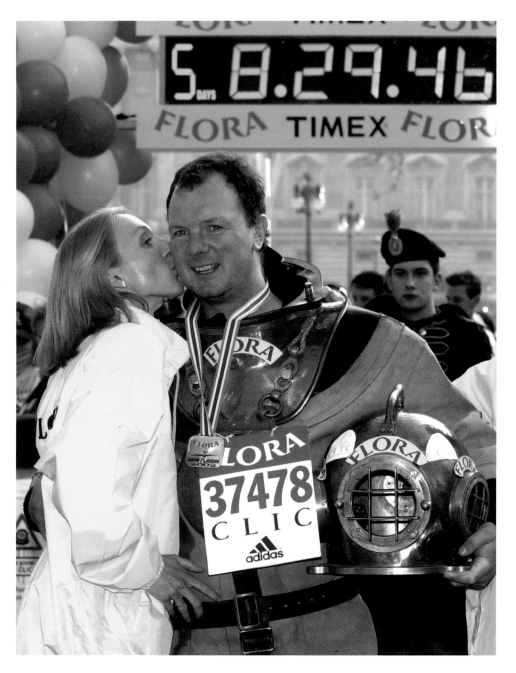

PETER SCOTT

Sir Peter Scott (1909–89), British ornithologist and son of the explorer Captain Robert Falcon Scott, pictured by his father's old ship, *Discovery*. Scott was preparing to make his first visit to the Antarctic on a special BBC expedition to find his father's final resting place. Scott famously gave the scientific name *Nessiteras rhombopteryx* to the Loch Ness monster, registering it as an endangered species; it was later revealed to be an anagram of Monster hoax by Sir Peter S.

16th December, 1965

Ornithologist, artist and broadcaster Sir Peter Scott, photographed in the year of his death. Scott was the only son of the doomed Antarctic explorer Robert Falcon Scott and the artist Kathleen Bruce.

30th August, 1989

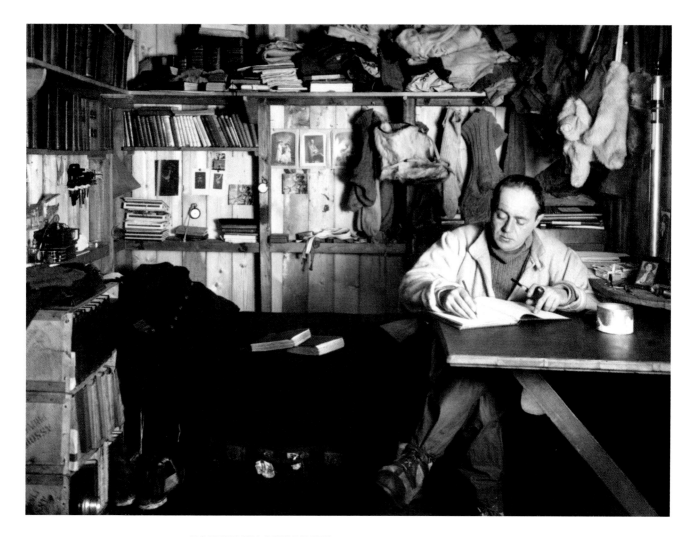

ROBERT FALCON SCOTT
Surrounded by books, photographs and exploration essentials, and enjoying the calm of his pipe, Captain Robert Falcon Scott (1868–1912) updates his diary in his cosy 'den' at the British base camp in Antarctica. His last diary entry at base camp read: *"The future lies in the lap of the gods. I can think of nothing left undone to deserve success."* On 1st November, 1911, he and his South Pole expedition team would begin its final, fateful journey.
1911

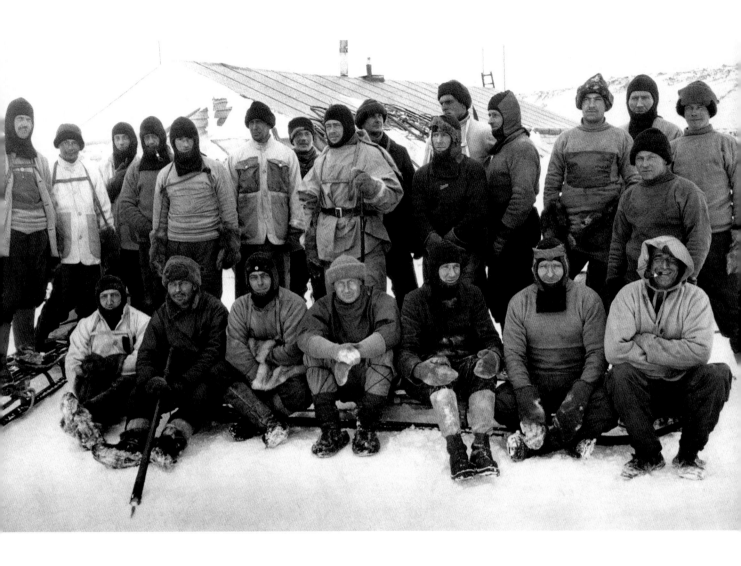

Captain Robert Falcon Scott (standing C, wearing balaclava) and members of the ill-fated British expedition to Antarctica. Scott and four companions, 'Titus' Oates, Edward Wilson, 'Birdie' Bowers and 'Teddy' Evans, succeeded in reaching the South Pole but were beaten to it by a team of Norwegian explorers led by Roald Amundsen. The defeated British explorers perished on the return journey, just 70 miles from the safety of base. Scott's final diary entry read: *"For God's sake look after our people."*
1912

SHEILA SCOTT

Sitting in front of a daunting array of controls, lone airwoman Sheila Scott (1922–88) finds room for her lucky mascots in her new Piper Aztec aircraft, as she makes final preparations at Oxford Airport, Kidlington, for a flight that will take her around the world one and a half times. The former actress became the first person to fly over the North Pole in a light aircraft during the 34,000 mile trip.

28th May, 1971

HARRY SECOMBE

Singer, comedian and former 'Goon' Harry Secombe inhales the perfume of his namesake – a new rose called 'Harry Secombe' – at a preview of the Chelsea Flower Show in London. Welshman Sir Harry Donald Secombe CBE (1921–2001) not only was a madcap comedian, but also possessed a fine tenor singing voice. Although best known for playing Neddie Seagoon, a central character in the BBC radio comedy series *The Goon Show* (1951–60), by contrast he was also a prominent presenter of television shows incorporating hymns and other devotional songs.

22nd May, 1999

PETER SELLERS

Comedian and former 'Goon' Peter Sellers (C) does his impression of a boxer turned painter during a recording of the TV sketch show *Not Only…But Also…*, starring Dudley Moore (L) and Peter Cook (R). The Enigmatic Sellers (1925–1980) was renowned for his role in *Dr. Strangelove*, hilarious as 'Chief Inspector Clouseau' in *The Pink Panther* film series and as the man-child 'Chance' the gardener, in his penultimate film, *Being There*. His talent in speaking in foreign and British regional accents, and his finely observed character studies, contributed to his success as a radio personality and screen actor, earning him national and international nominations and awards.

13th March, 1965

HELEN SHARMAN
Britain's first astronaut, Helen Sharman, unveils her waxwork at The London Planetarium. The figure, modelled by sculptor Sue Kale, is dressed in an exact replica of the Russian spacesuit Helen wore during her eight-day flight to space station *Mir*. In 1989, chemist Helen (born 1963) answered a radio advert: 'Astronaut wanted – no experience necessary'. She was selected from 13,000 applicants to take part in Project Juno, the historic Soviet Space Mission, to become the first Briton in space.
17th October, 1996

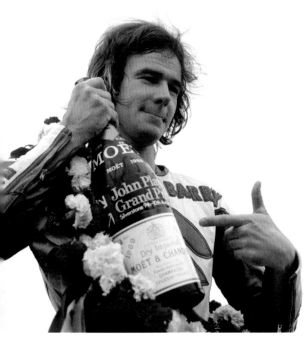

BARRY SHEENE

Left: Barry Sheene celebrates victory in the 500cc John Player British Grand Prix at Silverstone with the obligatory magnum of champagne. Sheene (1950–2003) was to motorcycling what James Hunt was to Formula One, a glamour boy who won 23 grand prix races in 14 years. His battle against Kenny Roberts in the 1979 British Grand Prix is legendary. A talented self-promoter, Sheene was one of the first sportsmen to make a fortune from advertising endorsements, notably Brut 33 aftershave.

10th August, 1975

British motorcyclist Barry Sheene in action in the 500cc John Player British Grand Prix at Silverstone. Sheene lost a fiercely competitive battle with his closest rival, the American Kenny Roberts.

12th August, 1979

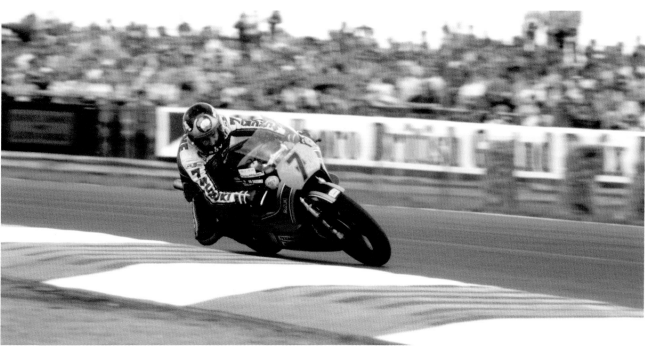

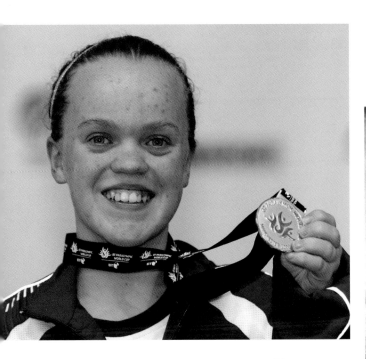

ELEANOR SIMMONDS
Above: The darling of Team GB, a beaming 'Ellie' Simmonds with her gold medal from the 100m Freestyle during the Paralympic World Cup in Manchester. Simmonds, who hails from the West Midlands, was born in 1994 with achondroplasia. She is likely to be a medal contender for Great Britain in the 2012 London Paralympics.

25th May, 2009

Great Britain's Eleanor Simmonds competes in the 50m Paralympic Butterfly during the international open swimming heats at the Aquatic Centre in Manchester. At 13, Simmonds was the youngest British athlete to compete at the 2008 Beijing Olympics, winning gold in the 100m and 400m Freestyle events. She won the BBC Young Sports Personality of the Year Award and at 14 is the youngest person ever to have been awarded an MBE.

25th May, 2009

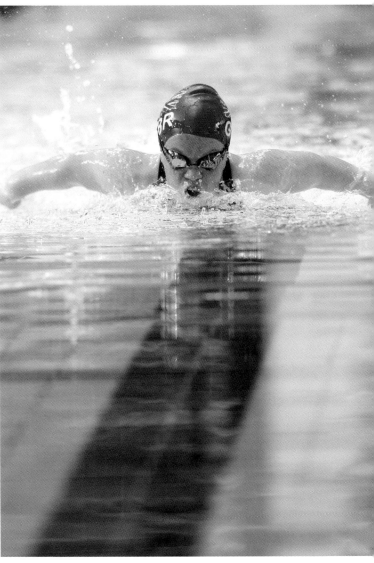

CLIVE SINCLAIR

Sir Clive Sinclair demonstrating his C5 electric vehicle, the battery-cum-pedal powered 'trike', at Alexandra Palace. Sinclair (born 1940) was a prolific inventor, launching a slimline pocket calculator in 1972 and a series of ZX home computers a few years later. In 1986, he sold the Sinclair trademark to Amstrad for £5m and by 1990 his company employed just three people. In 2010, his main occupation is cited as *"playing poker"*.

10th January, 1985

EDITH SITWELL

Swathed in floor-length brocade, statuesque poet and critic Dame Edith Sitwell (1887–1964) and her equally avant-garde brother, Osbert, take refreshment at a 'jazz' coffee stall. Most famous for her poem *Still Falls the Rain*, written in response to the London Blitz, Sitwell's eccentric appearance raised as many eyebrows as her work. She famously fell out with the flamboyant playwright Noël Coward after he poked fun at the lady and her brothers in his musical revue *London Calling!*.

7th March, 1924

WILLIAM SLIM

The burly figure of Field Marshal Sir William Slim – also known as 'Uncle Bill' – at London Airport following a flight from New York. Slim (1891–1970) was commander of the 14th 'Forgotten' Army during the reconquest of Burma from the Japanese (1943–45). Between 1953 and 1960, this authentic war hero was the 13th Governor General of Australia, welcoming Queen Elizabeth II to the country on the first visit by a reigning monarch.

3rd November, 1950

DELIA SMITH
The nation's favourite celebrity cook, Delia Smith, attends a football match played by the club she saved from bankruptcy, Norwich City. Smith (born 1941), who has sold more than 21 million cookery books, first appeared on British television in the 1970s and owes her success to teaching basic cooking techniques. The 'Delia Effect' is often used to describe the sudden upturn in sales of specific items featured in her cookbooks or shows, such as eggs or omelette pans.
5th March, 2005

Dame Maggie Smith appearing in her new play, *The Lady From Dubuque*, at the Theatre Royal in London's Haymarket. The doyenne of stage and screen, who began her theatre career at the age of 16, admitted that she was now *"frightened to work in theatre"* after recovering from chemotherapy and radiotherapy for breast cancer, which had knocked her confidence. Nonetheless, in her seventies, she continues to be much in demand in film and theatre.
12th March, 2007

MAGGIE SMITH

Above: In puckish fettle, British actress Maggie Smith flirts playfully with the camera in 1957. One of Britain's finest actors, Dame Maggie (born 1934) has commanded stage and screen for more than half a century, lighting up productions as diverse as *The Prime of Miss Jean Brodie*, *Private Lives*, *Tea With Mussolini*, *Richard III* and the Harry Potter series. She is the recipient of countless awards, including five BAFTAs, two Oscars, two Emmy Awards, two Golden Globes and a Tony Award.
3rd October, 1957

SOOTY

"Izzy wizzy, let's get busy!" – The enigmatic Sooty, pictured with his creator, the genial children's entertainer Harry Corbett (1918–89), and his sons David (9) and Peter (6). Corbett's partial deafness proved no barrier to making glove puppet Sooty and his cohorts, Sweep and Soo, the natural successors to Muffin the Mule. Featuring gentle slapstick and magic tricks, *The Sooty Show* was a TV favourite for more than two generations before Corbett passed the baton to his youngest son Matthew, following a heart attack in 1975.

8th February, 1955

THOMAS SOPWITH

"Ay, ay, captain!" – Thomas Sopwith (R) with his wife, Phyllis, at the helm of his yacht *Endeavour*, a 130ft J Class sloop, in the Americas Cup. He did not clinch the trophy, but became a legend for trying. A proper 'action man', Sopwith (1888–1989) was also an aviation pioneer, piloting the longest flight made by a British plane in 1910, and an ice hockey champion, playing in Britain's national squad and winning gold at the first European Championships.

7th July, 1934

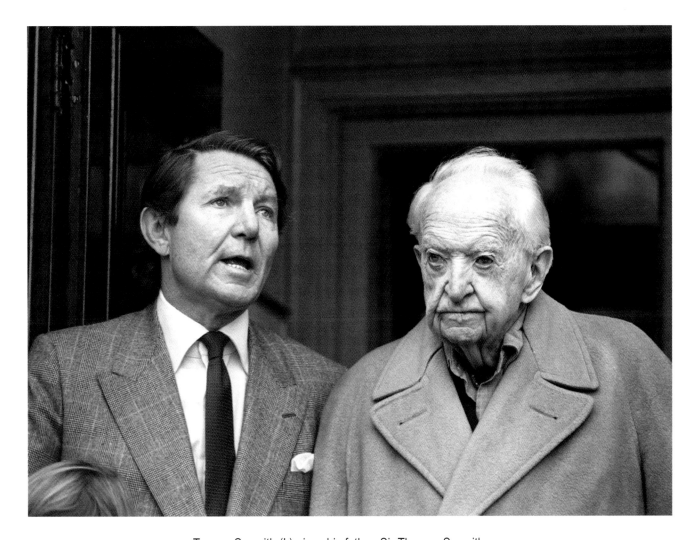

Tommy Sopwith (L) gives his father, Sir Thomas Sopwith, an account of the military fly-past in honour of the pioneer aviator's 100th birthday, from the steps of his 19th-century manor house near Winchester. The former aviation pioneer and aircraft manufacturer lost his sight to glaucoma and died aged 101.

18th January, 1988

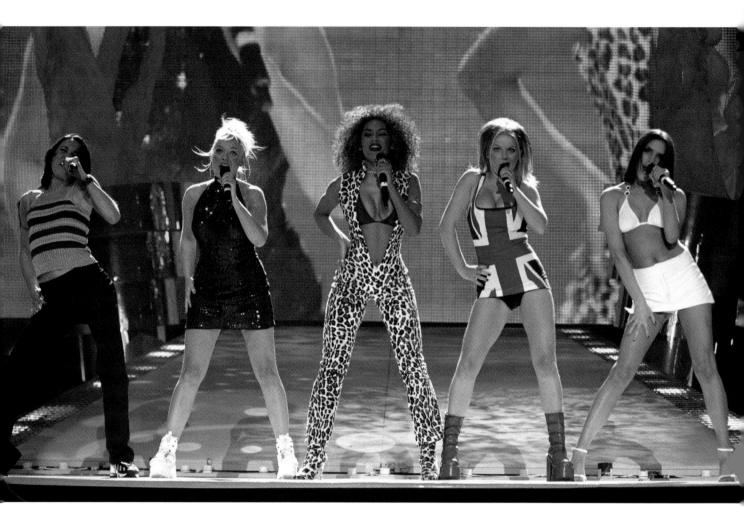

THE SPICE GIRLS
At the peak of their career, the Spice Girls perform onstage at the 1997 Brit Awards in London, where they scooped awards for Best British Video and Best Single during the era of 'Britpop'. L–R, Melanie Chisholm 'Sporty', Emma Bunton 'Baby', Melanie Brown 'Scary', Geri Haliwell 'Ginger', and Victoria Beckham 'Posh'. The girls' first single, *Wannabe*, went to number one in 31 countries and their international album sales made them the biggest-selling girl group of all time. They were named the 'biggest cultural icons of the 1990s' thanks to their motto: 'Girl Power', which defined a decade.
24th February, 1997

STATUS QUO

Still rockin': Rick Parfitt (L) and Francis Rossi (born 1948 and 1949 respectively) of Status Quo perform during the 2009 Glastonbury Festival in Somerset. The members of the five-piece 'boogie rock' band, which formed in 1970, have enjoyed more than 60 chart entries in the UK – more than any other group in history – and have sold 118 million records. They had their biggest successes in the 1970s and 1980s, with hits such as *Caroline*, *Down Down* and *Rockin' All Over the World*.

28th June, 2009

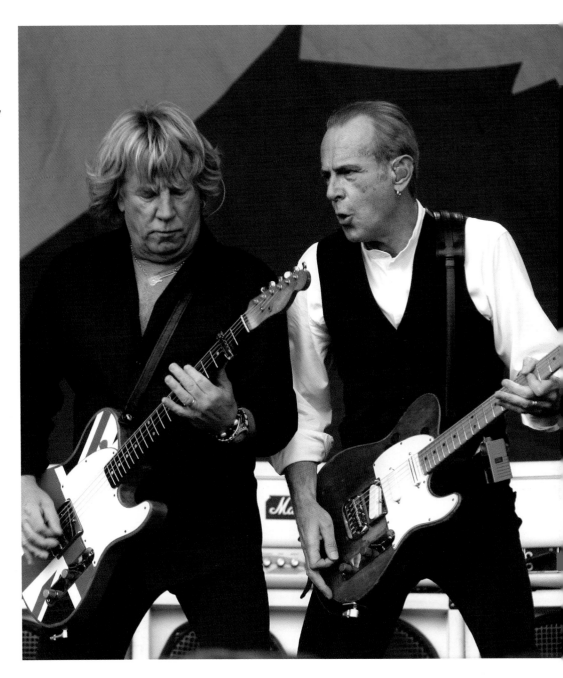

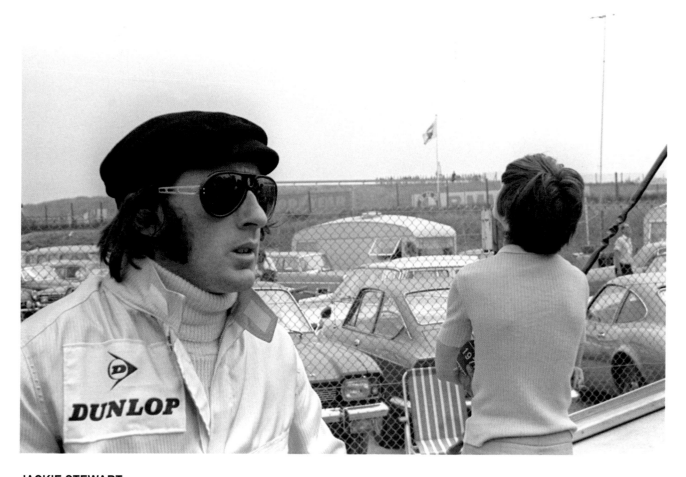

JACKIE STEWART

Jackie Stewart at Zandvoort for the Formula One Dutch Grand Prix. 'The Flying Scot' (born 1939) was an outstanding driver, winning three World Championships and 27 Grand Prix races. He is lauded for his motor racing safety campaigns, following the deaths of several of his close friends on the circuit. He championed full-face helmets and seatbelts for drivers and is credited with saving thousands of lives in competitive motor racing.

21st June, 1970

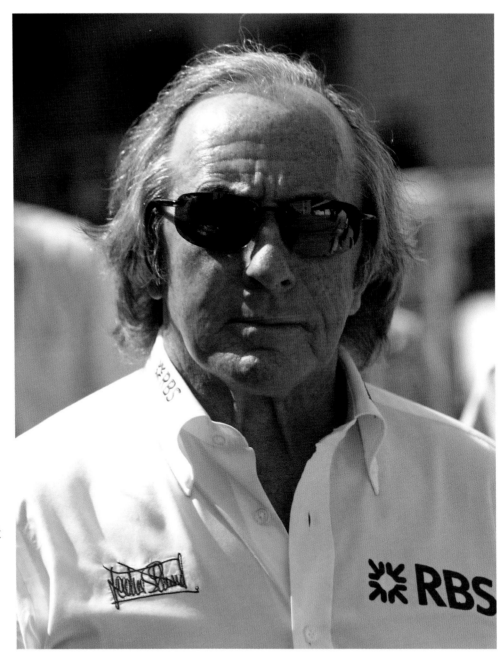

Former Formula One Champion Sir Jackie Stewart attends the Abu Dhabi Grand Prix. Britain's Lewis Hamilton took pole position in the race for the 17th time in his career, matching Stewart's own tally.
1st November, 2009

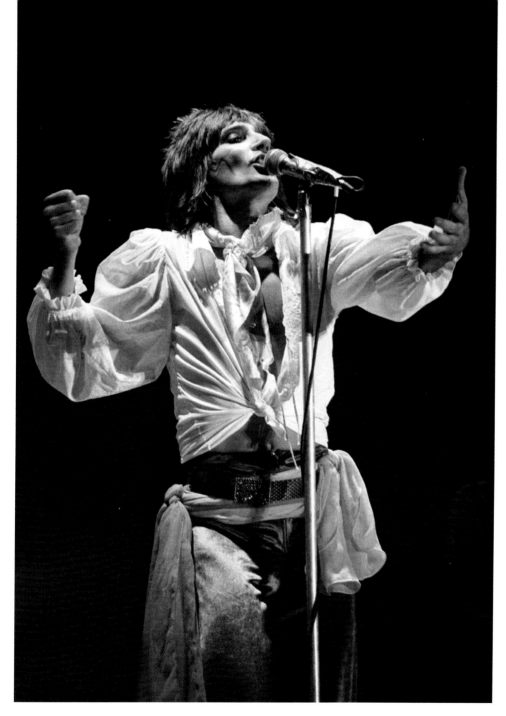

ROD STEWART

In typically glitzy 'seventies garb, spiky-haired pop superstar Rod Stewart was in fine rasping form for the 8,000 fervent fans who packed Olympia to attend the former gravedigger's first London concert since his split with The Faces. Stewart (born 1945) is one of the UK's most successful performers, having sold more than 250 million copies of hits such as *Hot Legs*, *Sailing* and *Handbags and Gladrags*.

22nd December, 1976

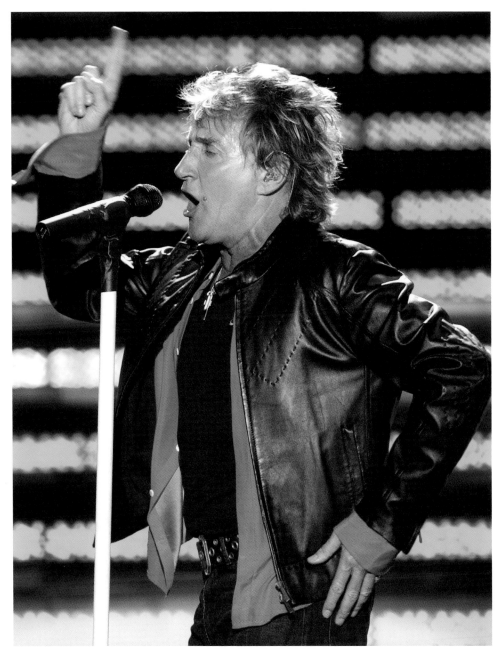

Aging rocker Rod Stewart performs live onstage during his One Night with Rod Stewart gig, at the Royal Albert Hall in central London, in aid of The Prince's Trust youth charity.
13th October, 2004

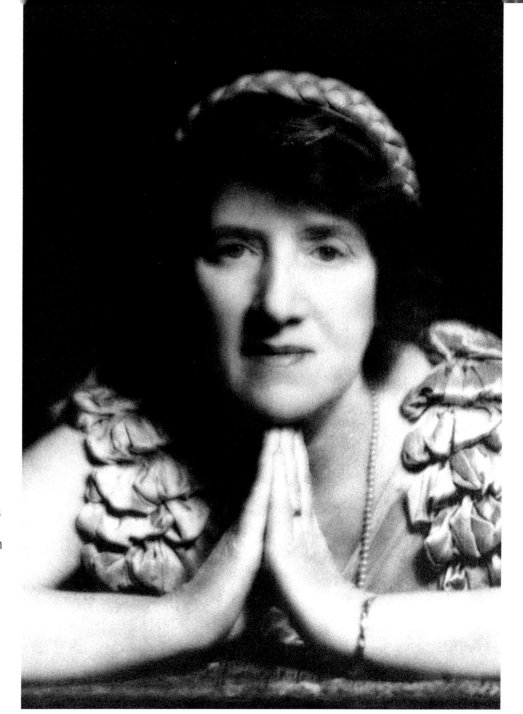

MARIE STOPES

Pioneer of birth control, Dr Marie Stopes (1880–1958), who founded the world's first birth control clinic in Holloway, London, in 1921. Edinburgh-born Stopes was harshly criticized for her work by the Catholic Church and ended up in court after suing a Catholic doctor for libel. She lost the case but the publicity generated a massive awareness of her cause and Marie Stopes Clinics continue to flourish. She ended her days quietly, writing poetry.

1st February, 1940

ARTHUR SULLIVAN

London-born composer Sir Arthur Seymour Sullivan (1842–1900) best-known for penning provocative comic operas with the librettist Sir William S. Gilbert, among them *HMS Pinafore*, *The Pirates of Penzance* and *The Mikado*. The duo became wealthy as a result of their 15-year collaboration, but the relationship soured in 1890 during a quarrel about money, when Gilbert sued Sullivan and the theatre impressario Richard D'Oyly Carte over a bill for a new lobby carpet at the Savoy Theatre.

1870

EDITH SUMMERSKILL

Sporting a fetching hat, Dr Edith Summerskill MP (R), Parliamentary Secretary to the Ministry of Food, at a Woman's Fair and Exhibition in London. A left-wing feminist, Summerskill (1901–80) was Secretary during the post-war period of rationing and austerity, and among her campaigns was one to ensure that milk was free from tuberculosis. She was made a life peeress in 1961 and campaigned vigorously through the House of Lords for the reform of laws relating to homosexuality and abortion.

23rd September, 1947

JOHN SURTEES

John Surtees (born 1934) on one of his Norton racing motorcycles at the Crystal Palace circuit. Surtees remains the only person to have clinched world championships in both grand prix motorcycling and Formula One motor racing, an achievement he brushed off in retirement with the quip: *"I was a bit nuts, really."*

14th August, 1957

DAVID SUTCH

In typical sober attire, perpetual political loser 'Screaming Lord Sutch' (real name plain David Sutch) of the Official Monster Raving Loony Party, faced the threat of bankruptcy in 1995 after being served with a writ for £194,000. One of Britain's eccentrics, the former musician (born 1940) had contested more than 40 elections in the constituencies of Bermondsey and Finchley, although he never came close to winning. Suffering from depression, the tireless campaigner committed suicide in 1999, but his legacy – the political party he founded – still continues. The OMRLP boast a deliberately bizarre manifesto that contains things that seem to be too impossible or too absurd to implement, usually to highlight what they see as real-life absurdities..

1st June, 1995

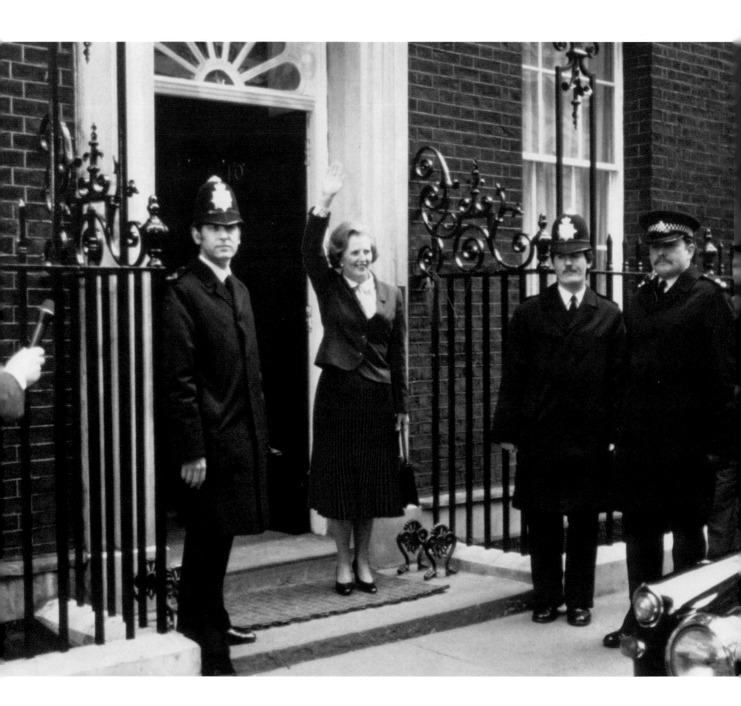

MARGARET THATCHER

Facing page: The newly-appointed Conservative Prime Minister of Great Britain, Margaret Thatcher, arriving at No. 10 Downing Street, after defeating James Callaghan's Labour Party to win the General Election. The 'Iron Lady' (born 1925) was the first female Tory leader and the first female Prime Minister, and is still the only woman to have held either post. She was PM for 11 years, but dramatically resigned when a leadership challenge by Michael Heseltine went to a second ballot. Thatcher was replaced by John Major.
4th May, 1979

Immaculately coiffured and pearls in place, Prime Minister Margaret Thatcher focuses on the questions posed by journalists at a Conservative Party press conference in London.
26th May, 1983

J.R.R. TOLKIEN

Before writing the classic fantasy tales *The Hobbit* and *The Lord of the Rings*, John Ronald Reuel Tolkien (1892–1973) was a university professor with a consuming passion for rare historical languages. Originally published in three volumes, *The Lord of the Rings* became one of the most widely read books in history. It was turned into a blockbuster action movie trilogy by Newline Cinema in 2001–03.

9th December, 2001

JAYNE TORVILL & CHRISTOPHER DEAN
Sending chills down the spines of the watching millions, Jayne Torvill (born 1957) and Christopher Dean (born 1958) dance the Bolero at the end of the 1994 Winter Olympics at Lillehammer, where they took bronze for their interpretation of *Let's Face the Music and Dance*. The British pair had received perfect marks for the Bolero routine at the 1984 Winter Olympics in Sarajevo, taking gold and becoming the highest-scoring figure skaters of all time. They now tour and appear on TV's *Dancing on Ice*.
26th February, 1994

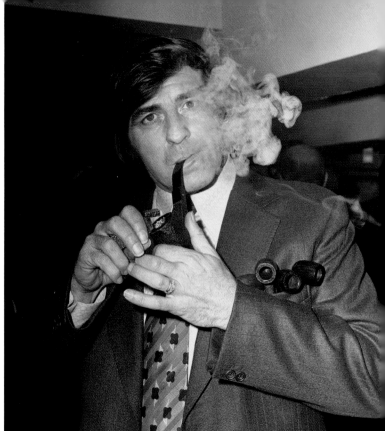

FRED TRUEMAN

Left: Yorkshire's Fred Trueman (L) bowling in a Marylebone Cricket Club versus Yorkshire match at Lord's. One of the fastest bowlers of all time, 'Fiery Fred' (1931–2006) was the first bowler to take 300 wickets in Test cricket. Such was his appeal that Prime Minister Harold Wilson declared him to be *"the greatest living Yorkshireman"*.

6th June, 1968

Top: With a pocket full of pipes, former England bowler Fred Trueman revels in his fame as Pipe Smoker of the Year in 1974. He was diagnosed with lung cancer in 2006.

17th January, 1974

TWIGGY

False eyelashes and elfin cut in place, British model Twiggy is snapped at London Heathrow Airport, en route to a photo shoot in Tunisia. Born Lesley Hornby in 1949, the waif-like Twiggy was named 'The Face of 1966', and her fame soon rivalled that of the reigning English supermodel Jean Shrimpton. Twiggy appeared on the covers of *Vogue* and *Harper's Bazaar* before becoming an award-winning actress and singer. In her sixties, she continued to work as a model and appear on television.

28th September, 1966

THE TWO RONNIES
Looking shifty in a couple of frocks, The Two Ronnies, comedians Ronnie Corbett, (born 1930, L) and Ronnie Barker (1929–2005), filming on location at Berkeley Castle in Gloucestershire for their latest serial *The Worm That Turned*, which also starred Diana Dors. Their TV sketch show was one of the most popular and long-running on British television, regularly attracting 22 million viewers, thanks to their particular brand of humour, clever wordplay and the comedians' strong onscreen chemistry.
4th September, 1980

Comedians Ronnie Corbett
(L) and Ronnie Barker, the
BBC's indefatigable comic
team, The Two Ronnies.
27th April, 1988

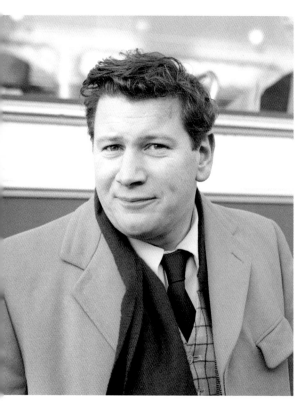

Below: Peter Ustinov on stage at the Lyceum Theatre in London during the Prince's Trust Comedy Gala. In addition to being an actor, Ustinov was also a renowned wit and raconteur, a film maker, theatre director, writer, and radio and television broadcaster. He served as a Goodwill Ambassador for UNICEF and as President of the World Federalist Movement.
28th October, 1998

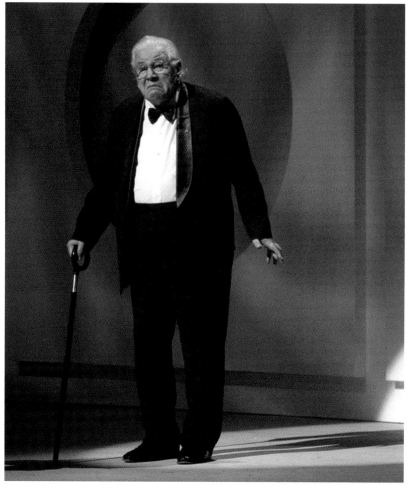

PETER USTINOV

Above: Actor Peter Ustinov (1921–2004) at London Airport, en route to Paris, in the year he made *We're No Angels* with Humphrey Bogart. The former Army batman of fellow actor David Niven, Ustinov was an almost permanent fixture on TV, film and chat shows for nearly 40 years, and his career highlights included *Quo Vadis*, *Spartacus*, *Topkapi* and *Lorenzo's Oil*. He starred as Agatha Christie's Belgian detective 'Poirot' in a string of popular movies during the 1970s and 1980s.

12th February, 1955

RALPH VAUGHAN WILLIAMS

Arguably Britain's greatest contemporary composer, Dr Ralph (pronounced 'Raif') Vaughan Williams (1872–1958) is photographed arriving for a Royal Philarmonic Society concert at the Royal Festival Hall in London. A prolific writer and great champion of English heritage, Vaughan Williams composed in every musical genre except chamber music. His compositions included nine symphonies, choral work, operas, folk music and numerous film soundtracks, including the *49th Parallel*. He was the great-nephew of English naturalist Charles Darwin.

9th October, 1957

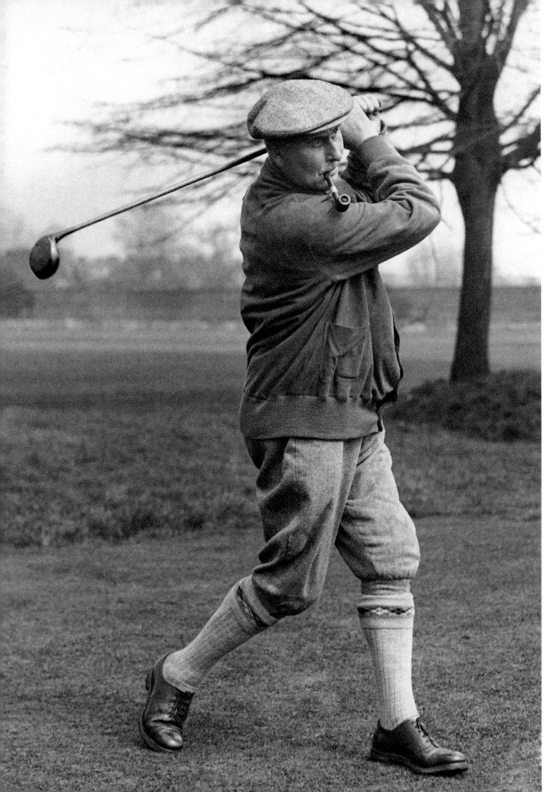

HARRY VARDON

Sporting his trademark plus fours and smoking a pipe, British golfer Harry Vardon (1870–1937) is one of the sport's true originals and is a legend on both sides of the Atlantic. Dubbed 'a shot-making machine', his record of six Open Championship wins (in 1896, 1898, 1899, 1903, 1911, 1914) has yet to be broken and he is acknowledged as having had a major influence on modern golfing. Vardon was inducted into the World Golf Hall of Fame in 1974.

1st May, 1920

QUEEN VICTORIA

A characteristically joyless portrait of Queen Victoria (1819–1901) in widow's weeds, lace and full regalia, taken to commemorate her Diamond Jubilee. As Britain's longest reigning monarch, Victoria gave her name to an astonishing golden age and witnessed immense social, technological and industrial changes during the 64 years she was figurehead of the largest Empire in history.

20th June, 1897

VIRGINIA WADE

Former Wimbledon champion Virginia Wade shares a laugh with photographers from a window at Wimbledon after rain stopped play at the 113th Tennis Championships. Wade (born 1945) won the Women's Singles title in 1977, which is the last time a Briton won a singles trophy at Wimbledon. She amassed three Grand Slam singles titles and four Grand Slam doubles titles during her career, and was consistently ranked in the world's Top 10 players between 1967 and 1979.

29th June, 1999

TERRY WAITE

The Archbishop of Canterbury Ronald Runcie's special envoy, Terry Waite, came to prominence when he was kidnapped during hostage negotiations in the Lebanon. After successfully securing the release of hostages in Iran in 1980, Waite (born 1939) had intervened on behalf of four hostages in 1987, including John McCarthy, but was instead seized by an Islamic Jihad group and held captive until 1991.

16th November, 2008

BARNES WALLIS

Facing page: Sir Barnes Wallis (1887–1979), inventor of the bouncing bomb that was used to devastating effect in the 'Dambuster' raids on the dams of the Mohne and Eder Valleys in Germany during the Second World War. His many achievements include the first use of geodesic design in engineering, and in the gasbag wiring and use of light alloy and production engineering techniques in the structural design of Vickers' R100 airship in 1930. After the war, Wallis worked on the concept of the swing-wing aircraft design, although he had not invented it. During the 1960s and into his retirement, he developed ideas for an aircraft that would be capable of efficient flight at speed ranges from subsonic to hypersonic.

1968

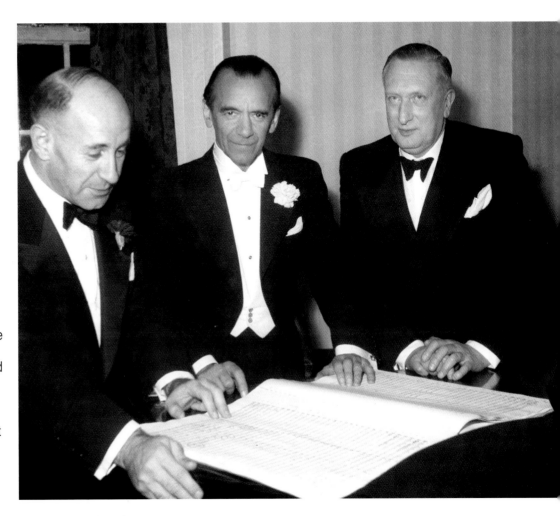

WILLIAM WALTON

English composer Sir William Walton (R), examines the score of his opera *Troilus and Cressida*, based on a poem by Chaucer, with American conductor Erich Leinsdorf (L) and English conductor Sir Malcolm Sargent (C). The three-act tragedy, which took Walton seven years to complete, debuted at Covent Garden in 1954 under Sargent's conductorship, and transferred to the San Francisco Opera under Leinsdorf's direction in 1955. During a 60-year career, Lancashire born Walton (1902–83), who was largely self-taught, wrote music in several genres and styles, from film scores to opera.

5th May, 1955

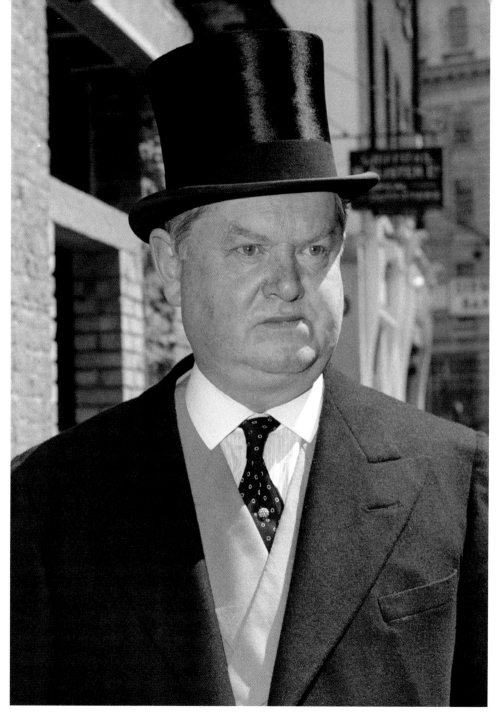

EVELYN WAUGH
Novelist Evelyn Waugh (1903–66) leaves church in London after the marriage of his eldest son, Auberon, to Lady Teresa Onslow. Waugh, whose best-known work is the classic *Brideshead Revisited*, wrote 16 novels, including *Vile Bodies* and *A Handful of Dust*, as well as biographies and travel books. In 1925, Waugh had attempted suicide by wading out into freezing water; but in the nick of time he thought better of it and instead began writing his first book, *Rossetti*.
1st July, 1961

BERT WEEDON
Guitarist Bert Weedon OBE with his medal after an honours ceremony at Buckingham Palace. Born in East Ham, London, in 1920, Weedon bought his first battered secondhand guitar for 75p and went on to become one of the most accomplished British players of the 1950s and 1960s, influencing future stars such as Eric Clapton, Brian May and The Shadows. His acclaimed guitar tutorial book, *Play in a Day*, helped generations of young hopefuls to master their chords.

12th December, 2001

VIVIENNE WESTWOOD

Below: In recognition of her contribution to British fashion, designer Vivienne Westwood collected an OBE from the Queen at Buckingham Palace. Born in 1941, the three-times winner of the British Fashion Designer Award (1990, 1991 and 2006) brought punk style and new wave fashions into the mainstream. In the 1970s, working with lover Malcolm McLaren, she famously dressed punk band the Sex Pistols in clothes based on biker, bondage and fetish gear, combined with Scottish tartans and adorned with safety pins, razor blades and chains, offset with flamboyant make-up and hair. Her work typically re-interprets classical 17th- and 18th-century cloth cutting principles, often adorned with outrageous slogans and accessories.
14th June, 2007

SIMON WESTON

Above: Falklands hero Simon Weston revisits Stanley, in the Falkland Islands, where locals flew the Union Jack on the 25th anniversary of Liberation Day, the end of the Falklands Conflict. Weston (born 1961), a former Welsh Guard, survived the Argentinean bombing of the ship RFA *Sir Galahad*, in which 48 servicemen died, but he suffered horrific burns to his face. His courage during years of recovery led to him being in great demand as a commentator on the conflict.
14th June, 2007

ALAN WHICKER

Broadcaster and journalist Alan Whicker, who became a household name as a result of his long-running documentary series *Whicker's World*. Born in 1925, Whicker presented the series for 30 years, collecting several awards for his satirical but informative take on other cultures.

1st April, 1968

Sir Alan Whicker, at the opening of The Museum of Brands, Packaging and Advertising in Notting Hill, west London. The museum holds over 10,000 original British consumer household items dating from the Victorian era through to the present day.

28th November, 2005

FRANK WHITTLE

RAF engineer Sir Frank Whittle (1907–96), who shared credit with Germany's Dr Hans von Ohain for independently inventing the jet engine. Whittle's innovation was initially dismissed by the Air Ministry expert Alan Arnold Griffith as *"quite impractical"*. However, Whittle persevered and is now considered to be the father of the jet age. Dr von Ohain stated publicly that had the government taken Whittle's idea seriously when first submitted in 1929, there would have been no Second World War.

1st November, 1958

JONNY WILKINSON

England stand-off Jonny Wilkinson captured in contemplation ahead of England's Six Nations match against Ireland in Dublin. England won the game by 42–6 and Wilkinson (born 1979) was declared Man of the Match. England went on to win the Rugby World Cup in a nail-biting finale, with Wilkinson scoring the winning drop goal against Australia in the last minute of extra time to take the match 20–17. He became a British hero and was declared the world's best rugby player.

26th March, 2003

The moment England's Jonny Wilkinson kicked the winning drop goal to clinch the Rugby World Cup for the nation in the final seconds of the thrilling match against Australia at Telstra Stadium in Sydney, Australia.

22nd November, 2003

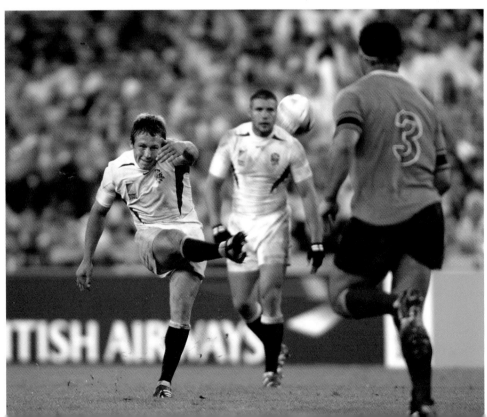

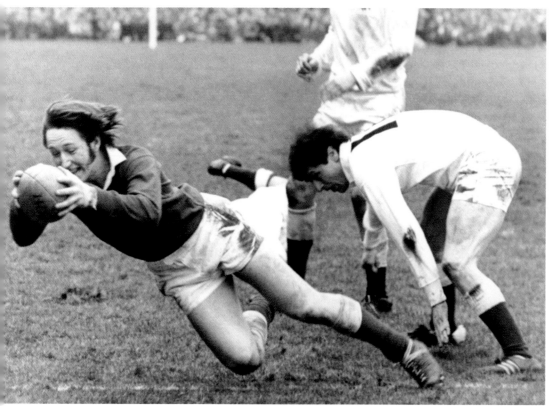

J.P.R. WILLIAMS

Wales' J.P.R. Williams dives to score a try. John Peter Rhys Williams (born 1949) played rugby union for his country between 1969 and 1981, sporting his trademark sideburns. His immense presence gave the team great confidence. Famed for his injuries, he was once described as *"charging around the park like a wounded bison."*
28th February, 1970

Exhaustion etched on his face, Welsh rugby union captain J.P.R. Williams in the Wales v Scotland match at Cardiff Arms Park during the 1978 Five Nations Championship. Wales won the Grand Slam and the Triple Crown that year.
18th February, 1978

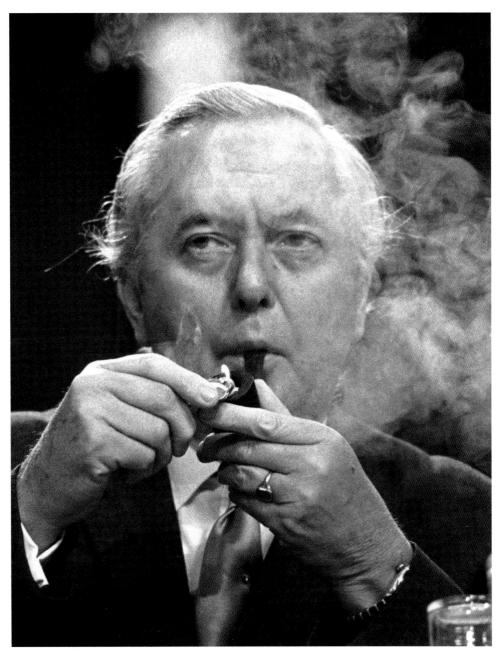

HAROLD WILSON

Almost lost in a cloud of pipe smoke, Harold Wilson listens to a speech by Party Chairman Anthony Wedgewood Benn at the start of the Labour Party Conference in Blackpool. Wilson (1916–95) served twice as Prime Minister of Great Britain and holds the distinction of contesting more general elections than any other 20th century premier. He won four out of five and is generally considered to be the politician who 'modernized' Britain.

2nd October, 1972

The Publishers gratefully acknowledge Press Association Images, from whose extensive archives the photographs in this book have been selected. Personal copies of the photographs in this book, and many others, may be ordered online at www.prints.paphotos.com

AMMONITE
PRESS

PRESS
ASSOCIATION
Images